INTRODUCTION
TO
CALCULUS

INTRODUCTION TO CALCULUS

2nd Edition

Joan Van Glabek, Ph.D.

Edison College, FL

Collins

An Imprint of HarperCollinsPublishers

An American BookWorks Corporation Production

HarperCollins books may be purchased for educational, business, or sales promotional use. For information please write: Special Markets Department, HarperCollins Publishers, 10 East 53rd Street, New York, NY 10022.

Library of Congress Catalog-in-Publication Data has been applied for.

ISBN: 13: 978-0-06-088150-4
ISBN: 10: 0-06-088150-X

06 07 08 09 10 CW 10 9 8 7 6 5 4 3 2 1

Contents

Preface

This book is provided as a supplement to a standard Calculus textbook. Although a knowledge of intermediate algebra and trigonometry is assumed, as many steps as possible are provided to help the reader follow the logic involved in solving the various types of problems encountered in a first semester Calculus course. Theorems are stated without proof, and are often restated in words or symbols more easily understood by my own students. A set of exercises and answers appear at the end of each chapter to allow the reader to practice and receive immediate feedback. Keep pencil and paper handy—reading and working through this book will help you succeed in calculus.

The new edition contains calculator references as well as many new practice problems at the end of each chapter. There are additional review topics that were appreciated by many of my students.

Introductory Topics

This chapter contains a short review of some of the algebraic topics that will be encountered in the remainder of the book. We review the real number system, interval notation, solving inequalities, and graphing in the Cartesian plane.

REAL NUMBERS, INEQUALITIES AND ABSOLUTE VALUE

REAL NUMBERS

The study of calculus involves real numbers. The union of the set of **rational numbers** (numbers that can be written as a ratio of two integers) and the set of **irrational numbers** (numbers that cannot be written as a terminating or repeating decimal) is the set of real numbers. Use a number line to picture the real numbers:

Irrationals $-\sqrt{3}, \sqrt{2}, e, \pi$.

Rationals $-2.5, \dfrac{1}{3}, 2$

ORDER

Compare real numbers using the following symbols:

- $<$ less than
- \leq less than or equal to
- $>$ greater than
- \geq greater than or equal to

For example, $\dfrac{1}{3} < \sqrt{2}$ means $\dfrac{1}{3}$ lies to the left of $\sqrt{2}$ on the number line.

INTERVAL NOTATION AND SET NOTATION

In this book, we use subsets of the real numbers as solutions to equations or inequalities. These subsets are usually described using either interval notation or set notation as demonstrated in the following table.

Interval Notation	Set Notation	Graph
$(-1, 3)$	$\{x: -1 < x < 3\}$	
$[-1, 3]$	$\{x: -1 \leq x \leq 3\}$	
$(-1, 3]$	$\{x: -1 < x \leq 3\}$	
$[-1, 3)$	$\{x: -1 \leq x < 3\}$	

Notice that a parenthesis corresponds to an endpoint that is *not* included in the set (you may have graphed these as open dots in the past). A bracket corresponds to an endpoint that *is* included in the set (graphed as a closed dot in the past). The set notation "$\{x:$" is read, "the set of all x such that."

Example 1.1

Graph each set on a number line.

 a) $(-2, 0)$
 b) $[1, 3]$
 c) $(-\sqrt{5}, 1]$

Solution 1.1

a)
 −2 0

b)
 1 3

c)
 −√5 1

Notice that the endpoints on each graph match the endpoint notation for the intervals.

Example 1.2

Write each set in interval notation, and then graph each set on a number line.

a) $\{x: 3 \leq x \leq 5\}$

b) $\{x: -1 < x < 2\}$

c) $\{x: -\sqrt{2} \leq x < \sqrt{2}\}$

Solution 1.2

a) [3, 5] Because the endpoints are included in the solution, use brackets.

 3 5

Endpoints on the graph match the interval notation.

b) (−1, 2) Because the endpoints are *not* included in the solution, use parentheses.

 −1 2

Endpoints on the graph match the interval notation.

c) $[-\sqrt{2}, \sqrt{2})$ Because $x \geq -\sqrt{2}$, use a bracket on the left. Because $x < \sqrt{2}$, use a parenthesis on the right.

 −√2 √2

Endpoints on the graph match the interval notation.

UNBOUNDED INTERVALS

To represent unbounded sets of numbers, use the symbols ∞, or $+\infty$ (positive infinity) and $-\infty$ (negative infinity). The following table contains examples of unbounded intervals.

Interval Notation	Set Notation	Graph
$[2, \infty)$	$\{x: x \geq 2\}$	
$(-\infty, 1)$	$\{x: x < 1\}$	
$(-\infty, -1) \cup (3, \infty)$	$\{x: x < -1 \text{ or } x > 3\}$	

Note that ∞ and $-\infty$ can *never* be included as endpoints.

Example 1.3

Complete the following table.

Interval Notation	Set Notation	Graph
$[-1, 4)$		
	$\{x: x \geq -1\}$	

Solution 1.3

Interval Notation	Set Notation	Graph
$[-1, 4)$	$\{x: -1 \leq x < 4\}$	
$[-1, \infty)$	$\{x: x \geq -1\}$	
$[-\infty, 2)$	$\{x: x < 2\}$	

SOLVING FIRST-DEGREE AND COMPOUND INEQUALITIES

Solve inequalities such as $2x - 5 < 7$ as though the $<$ were an $=$. Recall that the only exception occurs when you multiply or divide both sides of an inequality by a negative number, in which case you must reverse the inequality symbol. Compare the following solutions.

$2x - 5 < 7$		$-2x - 5 < 7$
$2x - 5 + 5 < 7 + 5$	Add 5 to both sides	$-2x - 5 + 5 < 7 + 5$
$2x < 12$	Simplify	$-2x < 12$
$\dfrac{2x}{2} < \dfrac{12}{2}$	Divide by the coefficient of x, which is -2 and reverse the inequality sign	$-\dfrac{2x}{2} < \dfrac{12}{-2}$
$x < 6$		$x > -6$

Remember to reverse the inequality symbol when multiplying or dividing by a negative number.

Example 1.4

Solve each inequality. Write the solutions using interval notation.

a) $3x - 2 \geq 5x + 6$

b) $-\dfrac{2}{3}x - 3 \leq 5$

c) $-4 < 2x + 1 < 7$

Solution 1.4

a) $3x - 2 + 2 \geq 5x + 6 + 2$

$3x - 2 + 2 \geq 5x + 6 + 2$	Add 2 to both sides.
$3x \geq 5x + 8$	Simplify.
$3x - 5x \geq 5x + 8 - 5x$	Subtract $5x$ from both sides.
$-2x \geq 8$	Combine similar terms.
$\dfrac{-2x}{-2} \leq \dfrac{8}{-2}$	Divide both sides by -2, and reverse the inequality sign.
$x \leq -4$	Reverse the inequality symbol.

$x \leq -4$ is written as $(-\infty, -4]$ in interval notation.

b) $3\left[-\dfrac{2}{3}x - 3\right] \leq 3[5]$	Multiply both sides by 3 to clear fractions.
$-2x - 9 \leq 15$	Simplify.
$-2x - 9 + 9 \leq 15 + 9$	Add 9 to both sides of the equation.
$-2x \leq 24$	Simplify.
$-\dfrac{1}{2}(-2x) \geq -\dfrac{1}{2}(24)$	Multiply both sides by $-1/2$. Reverse the inequality symbol.

$x \geq -12$ is written as $[-12, \infty)$ in interval notation.

c) $-4 < 2x + 1 < 7$

This inequality means $-4 < 2x + 1$ *and* $2x + 1 < 7$. You could solve each inequality separately, but as a shortcut, we solve this inequality by working on all three parts at the same time.

$-4 - 1 < 2x + 1 - 1 < 7 - 1$ Subtract 1 from all three parts.

$-5 < 2x < 6$ Combine similar terms.

$$-\frac{5}{2} < \frac{2x}{2} < \frac{6}{2}$$ Divide all three parts by 2.

$$-\frac{5}{2} < x < 3$$

$-\frac{5}{2} < x < 3$ is written as $(-\frac{5}{2}, 3)$ in interval notation.

ABSOLUTE VALUE

The distance of a number a from zero is its absolute value, written $|a|$. For example, $|-3| = 3$, $|6| = 6$, $|0| = 0$. The following properties of absolute value are used in this text:

$|ab| = |a||b|$

$|\frac{a}{b}| = \frac{|a|}{|b|}, b \neq 0$

$|a| = \sqrt{a^2}$

$|a + b| \leq |a| + |b|$

$|x| = a$ if and only if $x = a$ or $x = -a$

$|x| < a$ if and only if $-a < x < a$

$|x| > a$ if and only if $x > a$ or $x < -a$

Example 1.5

Write each equation in interval notation, if possible.

 a) $|3x + 5| = 8$

 b) $|4x - 1| < 7$

 c) $|6 - 2x| \geq 6$

 d) $|5x - 1| < -2$

Solution 1.5

 a) $|3x + 5| = 8$

 $3x + 5 = 8$ or $3x + 5 = -8$ Write the equivalent form without absolute value.

 $3x + 5 - 5 = 8 - 5$ $3x + 5 - 5 = -8 - 5$ Solve each equation.

 $3x = 3$ $3x = -13$ Divide by 3.

 $x = 1$ or $x = -\frac{13}{3}$

The solution set is $\{1, -\frac{13}{3}\}$. Because this solution consists of two points, *not* an interval, the answer cannot be written in interval notation.

b) $|4x - 1| < 7$ Given form of $|x| < a$.

 $-7 < 4x - 1 < 7$ Write the equivalent form without absolute value.

 $-7 + 1 < 4x - 1 + 1 < 7 + 1$ Add 1 to all three parts.

 $-6 < 4x < 8$ Combine similar terms.

 $-\dfrac{6}{4} < \dfrac{4x}{4} < \dfrac{8}{4}$ Divide by 4.

 $-\dfrac{3}{2} < x < 2$ Simplify.

 $-\dfrac{3}{2} < x < 2$ is written as $(-\dfrac{3}{2}, 2)$ in interval notation.

c) $|6 - 2x| \geq 6$ Given form of $|x| \geq a$.

 $6 - 2x \geq 6$ or $6 - 2x \geq -6$ Write the equivalent form without absolute value.

 $6 - 2x - 6 \geq 6 - 6$ or $6 - 2x - 6 \leq -6 - 6$ Solve each inequality.

 $-2x \geq 0$ or $-2x \leq -12$

 $\dfrac{-2x}{-2} \leq \dfrac{0}{-2}$ or $\dfrac{-2x}{-2} \geq \dfrac{-12}{-2}$ Divide by –2. Reverse the inequality symbol.

 $x \leq 0$ or $x \geq 6$

$x \leq 0$ is written as $(-\infty, 0]$. $x \geq 6$ is written as $[6, \infty)$. Using \cup for union (or), the solution set is written $(-\infty, 0] \cup [6, \infty)$.

d) $|5x - 1| < -2$

This problem can be solved by inspection, if you realize that an absolute value cannot be less than –2. Thus the solution is the empty set, { } or \varnothing. However, if you solve using the equivalent form, proceed as follows:

 $|5x - 1| < -2$ Given form of $|x| < a$.

 $2 < 5x - 1 < -2$ Write the equivalent form without absolute value.

 $2 + 1 < 5x - 1 + 1 < -2 + 1$ Add 1 to all three parts.

 $3 < 5x < -1$ Combine similar terms.

 $\dfrac{3}{5} < x < -\dfrac{1}{5}$ Divide by 5.

But this answer implies that a negative number is greater than a positive number, which is not possible. The solution is \varnothing.

FACTORING

Factoring is used throughout this book; for example, to solve quadratic inequalities, as a part of the process of completing the square, and to solve trigonometric equations. The following are some of the factoring formulas needed in this book.

$x^2 - y^2 = (x - y)(x + y)$ Difference of two squares

$x^2 + y^2$ does not factor Sum of two squares

$x^2 \pm 2xy + y^2 = (x \pm y)^2$ Perfect square trinomial

$x^3 \pm y^3 = (x \pm y)(x^2 \mp xy + y^2)$ Sum/difference of two cubes

Consider the following general guidelines for factoring:

1. Find a common factor first, if possible.

2. Factor by one of the formulas just listed, if possible.

3. If the expression has three terms, try trial and error by factoring the first term and the third term into two sets of parentheses. Multiply as a check.

4. If the expression has four terms, factor by grouping either two terms at a time, or by grouping three terms together as a perfect square trinomial and then applying the formula for the difference of two squares.

Example 1.6

Write each expression in factored form.

a) $x^2 - 4x + 4$

b) $5x^2 - 20$

c) $27x^3 + 8y^3$

d) $2x^2 - 5x - 3$

e) $x^2 - 4x + 4 - y^2$

Solution 1.6

a) $x^2 - 4x + 4$ There are no common factors.

$x^2 - 2(x)(2) + (2)^2$ Recognize the expression as a perfect square trinomial.

$(x - 2)^2$ Factor using the formula for a perfect square trinomial.

b) $5x^2 - 20 = 5(x^2 - 4)$ Factor the common factor of 5 from each term.

$x^2 - 4 = (x)^2 - (2)^2$ Recognize the expression in parentheses as a difference of two squares.

$(x - 2)(x + 2)$ Use the formula for the difference of two squares.

$5(x - 2)(x + 2)$ Be careful to include the common factor in your answer.

c) $27x^3 + 8y^3$ There are no common factors.

$(3x)^3 + (2y)^3$ Recognize the expression as a sum of two cubes.

$(3x + 2y)((3x)^2 - (3x)(2y) + (2y)^2)$ Use the formula for the sum of two cubes.

$(3x + 2y)(9x^2 - 6xy + 4y^2)$ Simplify.

d) $2x^2 - 5x - 3$ The expression is not one of the types listed in the formulas. There are three terms, so try trial and error.

$2x^2 = 2x \cdot x, -3 = 1 \cdot -3, -1 \cdot 3$ Find factors of the first and third terms.

$(2x + 1)(x - 3)$

$(2x - 1)(x + 3)$ Place pairs of factors into two sets of parentheses.

$(2x + 1)(x - 3) = 2x^2 - 6x + x - 3 = 2x^2 - 5x - 3$

$(2x - 1)(x + 3) = 2x^2 + 6x - x - 3 = 2x^2 + 5x - 3$ Multiply each pair to determine which answer is correct.

$2x^2 - 5x - 3 = (2x + 1)(x - 3)$

e) $x^2 - 4x + 4 - y^2$ The expression is not one of the types listed in the formulas. There are four terms, so try grouping.

$(x - 2)^2 - y^2$ Notice the first three terms were factored in part a).

$[(x - 2) - y][(x - 2) + y]$ Recognize the difference of two squares and use the formula.

$(x - 2 - y)(x - 2 + y)$ Simplify inside the brackets.

QUADRATIC INEQUALITIES

The technique we use to solve quadratic inequalities $ax^2 + bx + c \ \square \ 0$, where the box contains $<, >, \leq$ or \geq can also be used in working with graphing functions. Don't just follow the rules; instead, try to understand why this technique works.

To solve quadratic inequalities, do the following:

1. Isolate 0 on the right side of the inequality.

2. Replace the inequality symbol with an equal sign and solve the resulting equation by factoring.

3. Use the solutions from Step 2 as split points on a number line.

4. Choose a number in each region created by the split points, substitute the number into each factor, and record the resulting sign (+ or –) on the number line.

5. Use the sign rules for products to determine the regions to be shaded for the solution. Use brackets on split points to be included in the solution (\leq or \geq). Use parentheses on split points that are not included in the solution ($<$ or $>$).

Note that if the quadratic equation in Step 2 does *not* factor, you can use the quadratic formula to find the split points.

The solutions to $ax^2 + bx + c = 0$, $a \neq 0$ are $x = \dfrac{-b \pm \sqrt{b^2 - 4ac}}{2a}$

Note that it will be easier to substitute a number from each region into the original inequality, shading the regions(s) that results in true statements, rather than to write factors and substitute into them (See Example 1.7).

Example 1.7

Solve each inequality and graph the solution on a number line.

a) $x^2 - x > 6$

b) $2x^2 \leq 5x + 3$

c) $4x^2 + 20x + 7 \geq 0$

Solution 1.7

a) $x^2 - x > 6$

$x^2 - x - 6 > 0$	Isolate 0 by subtracting 6 from both sides.
$(x - 3)(x + 2) = 0$	Change > to = and solve to find the split points.
$x - 3 = 0$ or $x + 2 = 0$	Set each factor equal to 0.
$x = 3 \qquad x = -2$	These are the split points.

$x - 3$

$x + 2$

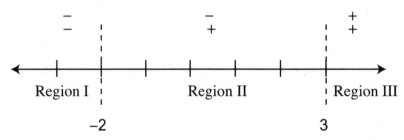

Region I Region II Region III

-2 3

Use a number from each region, substitute into each factor, and record the resulting sign.

- In region I, $- \bullet - = +$
- In region II, $- \bullet + = -$
- In region III, $+ \bullet + = +$

Use the sign rules for products to determine the sign for each region.

We need positive answers, because $x^2 - x - 6 > 0$ (greater than 0 implies positive), so our solution includes Region I and Region III:

$-2 \qquad 0 \qquad 3$

Shade Regions I and III. Use parentheses on split points because they are not included in the solution.

b) $2x^2 \leq 5x + 3$

$2x^2 - 5x - 3 \leq 0$	Isolate 0.
$(2x + 1)(x - 3) = 0$	Change \leq to = and solve to find the split points.
$2x + 1 = 0$ or $x - 3 = 0$	Set each factor equal to 0 and solve.
$2x = -1$	
$x = -\dfrac{1}{2} \qquad x = 3$	These are the split points.

$\dfrac{2x+1}{x-3}$

$-$		$+$	$+$
$-$		$-$	$+$

 −1 0 1 2 3 4

 Region I Region II Region III

 −½ 3

Use a number from each region, substitute it into each factor, and record the resulting sign.

In region I, $-\bullet- = +$

In region II, $-\bullet+ = -$

In region III, $+\bullet+ = +$

Use the sign rules for products to determine the shading for each region.

We need negative answers and answers equal to 0 since $2x^2 - 5x - 3 \le 0$, so our solution includes Region II and the split points:

 −½ 3

Shade Region II. Use brackets on the split points because they are included in the solution.

c) $4x^2 + 20x + 7 \ge 0$ \qquad\qquad 0 is already isolated.

Because the quadratic equation $4x^2 + 20x + 7 \ge 0$ does not factor, use the quadratic formula:

$a = 4, b = 20, c = 7$ \qquad Identify a, b, and c.

$x = \dfrac{-20 \pm \sqrt{(20)^2 - 4(4)(7)}}{2(4)}$ \qquad Substitute a, b, and c into $x = \dfrac{-b \pm \sqrt{b^2 - 4ac}}{2a}$.

$x = \dfrac{-20 \pm \sqrt{400 - 112}}{8}$ \qquad Simplify the radicand.

$x = \dfrac{-20 \pm \sqrt{288}}{8}$ \qquad Simplify the radicand. $\sqrt{288} = \sqrt{144 \cdot 2} = 12\sqrt{2}$

$x = \dfrac{-20 \pm 12\sqrt{2}}{8}$

$x = \dfrac{4(-5 \pm 3\sqrt{2})}{8}$ \qquad Factor the numerator.

$x = \dfrac{-5 \pm 3\sqrt{2}}{2}$ \qquad Reduce $\dfrac{4}{8} = \dfrac{1}{2}$.

$x = \dfrac{-5 + 3\sqrt{2}}{2} \approx -0.4$ or $x = \dfrac{-5 - 3\sqrt{2}}{2} \approx -4.6$

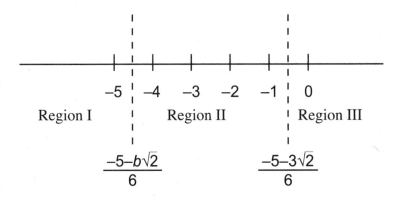

Use the split points and a number line to set up regions.

Region I: Let $x = -5$ Choose a number in Region I.

 $4(-5)^2 + 20(-5) + 7 \geq 0$ Substitute into the original inequality.

 $4(25) - 100 + 7 \geq 0$ Simplify.

 $7 \geq 0$ A true statement, so we include Region I in the solution.

Region II: Let $x = -1$ Choose a number in Region II.

 $4(-1)^2 + 20(-1) + 7 \geq 0$ Substitute into the original inequality.

 $4(1) - 20 + 7 \geq 0$ Simplify.

 $4 - 20 + 7 \geq 0$

 $-9 \geq 0$ A false statement, so we do *not* include Region II in the solution.

Region III: Let $x = 0$ Choose a number in Region III.

 $4(0)^2 + 20(0) + 7 \geq 0$ Substitute into the original inequality.

 $7 \geq 0$ A true statement, so we include Region III in the solution.

Shade Regions I and III. Use brackets on the split points. The solution in interval notation

is $\left(-\infty, \dfrac{-5 - 3\sqrt{2}}{2} \right] \cup \left[\dfrac{-5 + 3\sqrt{2}}{2}, \infty \right)$

THE CARTESIAN PLANE

An **ordered pair** (x, y) consists of two numbers in a specific order in parentheses. The first number is called the **x-coordinate** or **abscissa**, and the second number is called the **y-coordinate** or **ordinate.**

Use a Cartesian plane consisting of two number lines at right angles to graph ordered pairs. The horizontal number line is usually the x-axis, and the vertical number line is usually the y-axis. The axes meet at the **origin** $(0, 0)$. The four regions formed by the axes are called **quadrants** and are labeled counterclockwise as shown. The ordered pair $(2, 4)$ is graphed or plotted by locating the point where $x = 2$ and $y = 4$:

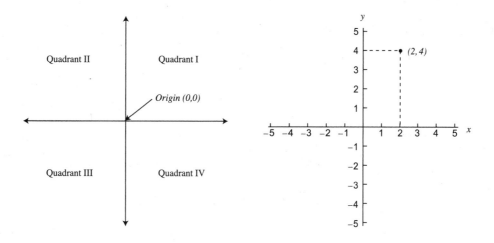

Example 1.8

Plot the points (–2, 5), (–2, –3), (1, –4), (3, 0) and (0, –2) on the same set of axes.

Solution 1.8

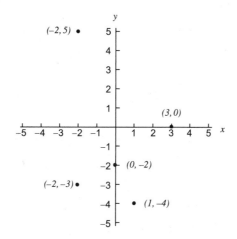

THE DISTANCE AND MIDPOINT FORMULAS

The distance formula allows us to find the length of a line segment given the endpoints of that line segment. The midpoint formula is used to find the coordinates of the midpoint of a line segment. Given (x_1, y_1) and (x_2, y_2), the endpoints of a line segment, the distance between (x_1, y_1) and (x_2, y_2) is

$$d = \sqrt{\left(x_2 - x_1\right)^2 + \left(y_2 - y_1\right)^2}$$

The midpoint of the line segment from (x_1, y_1) to (x_2, y_2) is

$$M = \left(\frac{x_1 + x_2}{2}, \frac{y_1 + y_2}{2}\right)$$

Example 1.9

Find the distance between the points, and then find the midpoint of the line segment joining the points.

 a) $(3, -1)$ and $(-3, 4)$

 b) $(\sqrt{2}, 2)$ and $(-3, \sqrt{2}, -5)$

 c) $\left(\dfrac{1}{2}, -3\right)$ and $\left(-\dfrac{1}{6}, -\dfrac{1}{2}\right)$

Solution 1.9

a) Let $(x_1, y_1) = (3, -1)$ and $(x_2, y_2) = (-3, 4)$

$d = \sqrt{(x_2 - x_1)^2 + (y_2 - y_1)^2}$	Write the distance formula.
$d = \sqrt{(-3-3)^2 + (4-(-1)^2)}$	Substitute $x_1 = 3, y_1 = -1, x_2 = -3, y_2 = 4$.
$d = \sqrt{(-6)^2 + (5)^2}$	Simplify inside parentheses.
$d = \sqrt{36 + 25}$	Simplify under the square root.
$d = \sqrt{61}$	Add.
$M = (\dfrac{x_1 + x_2}{2}, \dfrac{y_1 + y_2}{2})$	Write the midpoint formula.
$M = (\dfrac{3 + (-3)}{2}, \dfrac{-1 + 4}{2})$	Substitute $x_1 = 3, y_1 = -1, x^2 = -3, y_2 = 4$.
$M = (\dfrac{0}{2}, \dfrac{3}{2})$	Simplify.
$M = (0, \dfrac{3}{2})$	

b) Let $(x_1, y_1) = (\sqrt{2}, 2)$ and $(x_2, y_2) = (-3\sqrt{2}, -5)$

$d = \sqrt{(x_2 - x_1)^2 + (y_2 - y_1)^2}$	Write the distance formula.
$d = \sqrt{(-3\sqrt{2} - \sqrt{2})^2 + (-5-2)^2}$	Substitute $x_1 = \sqrt{2}, y_1 = 2, x_2 = -3\sqrt{2}, y_2 = -5$.
$d = \sqrt{(-4\sqrt{2})^2 + (-7)^2}$	Simplify inside the parentheses.
	$(-4\sqrt{2})^2 = (-4)^2(\sqrt{2})^2 = 16(2) = 32$.
$d = \sqrt{32 + 49}$	
$d = \sqrt{81}$	Add.
$d = 9$	Simplify the square root.
$M = \left(\dfrac{x_1 + x_2}{2}, \dfrac{y_1 + y_2}{2}\right)$	Write the midpoint formula.

$$M = \left(\frac{\sqrt{2} + (-3\sqrt{2})}{2}, \frac{2 + (-5)}{2} \right)$$ Substitute $x_1 = \sqrt{2}, y_1 = 2, x_2 = -3\sqrt{2}, y_2 = -5$.

$$M = \left(\frac{-2\sqrt{2}}{2}, -\frac{3}{2} \right)$$ Simplify.

$$M = \left(-\sqrt{2}, -\frac{3}{2} \right)$$ Reduce.

c) Let $(x_1, y_1) = \left(\dfrac{1}{2}, -3 \right)$ and $(x_2, y_2) = \left(-\dfrac{1}{6}, -\dfrac{1}{2} \right)$.

$$d = \sqrt{(x_2 - x_1)^2 + (y_2 - y_1)^2}$$ Write the distance formula.

$$d = \sqrt{\left(-\frac{1}{6} - \frac{1}{2} \right)^2 + \left(-\frac{1}{2} - (-3) \right)^2}$$ Substitute.

$$d = \sqrt{\left(-\frac{2}{3} \right)^2 + \left(\frac{5}{2} \right)^2}$$ Combine the fractions and reduce $-\dfrac{4}{6} = -\dfrac{2}{3}$.

$$d = \sqrt{\frac{4}{9} + \frac{25}{4}}$$ Square each fraction.

$$d = \sqrt{\frac{16 + 225}{36}}$$ Use 36 as the LCD.

$$d = \frac{\sqrt{241}}{\sqrt{36}} = \frac{\sqrt{241}}{6}$$ Simplify.

$$M = \left(\frac{x_1 + x_2}{2}, \frac{y_1 + y_2}{2} \right)$$ Write the midpoint formula.

$$M = \left(\frac{\frac{1}{2} + \left(-\frac{1}{6} \right)}{2}, \frac{-3 + \left(-\frac{1}{2} \right)}{2} \right)$$ Substitute.

$$M = \left(\frac{\frac{3}{6} + \left(-\frac{1}{6} \right)}{2}, \frac{-\frac{6}{2} + \left(-\frac{1}{2} \right)}{2} \right)$$ Use common denominators.

$$M = \left(\frac{\frac{2}{6}}{2}, \frac{-\frac{7}{2}}{2} \right)$$ Combine fractions.

$$M = \left(\frac{1}{6}, -\frac{7}{4} \right)$$ Invert and multiply by 1/2.

Note in Example 1.9a) that you could have chosen either ordered pair to represent (x_1, y_1). Try Example 1.9a) on your own, letting $(x_1, y_1) = (-3, 4)$ and $(x_2, y_2) = (3, -1)$.

CIRCLES

A circle is the set of all points in a plane that are equally distant from a given point called the **center.** The distance from the center to a point on the circle is called the **radius.** The **diameter** of a circle is a line segment with endpoints on the circle and passing through the center of the circle. The standard form of the equation of a circle with center (h, k) and radius r is $(x - h)^2 + (y - k)^2 = r^2$.

If you know (or can find) the center of a circle and its radius, you can use the standard form of the equation of a circle to write an equation that represents that circle. Notice that the coordinates of the center are *subtracted* from x and y in the standard form.

Example 1.10

Write the equation of each circle in standard form.

a) Center $(2, 3)$ and radius 4.

b) Center at the origin and radius 1.

c) Center $(-1, -2)$ and radius 3.

d) Endpoints of a diameter: $(-2, 2)$, $(-6, -2)$

Solution 1.10

a) $(h, k) = (2, 3)\ r = 4$ Identify h, k, and r.

 $(x - h)^2 + (y - k)^2 = r^2$ Write the standard form of the equation of a circle.

 $(x - 2)^2 + (y - 3)^2 = 4^2$ Substitute for h, k, and r.

 $(x - 2)^2 + (y - 3)^2 = 16$ Simplify.

b) $(h, k) = (0, 0)\ r = 1$ Center at the origin means $(h, k) = (0, 0)$.

 $(x - h)^2 + (y - k)^2 = r^2$ Write the standard form of the equation of a circle.

 $(x - 0)^2 + (y - 0)^2 = 1^2$ Substitute for h, k, and r.

 $x^2 + y^2 = 1$ Simplify.

Note that a circle with center $(0, 0)$ and radius 1 is called a **unit circle.**

c) $(h, k) = (-1, -2)\ r = 3$ Identify h, k, and r.

 $(x - h)^2 + (y - k)^2 = r^2$ Write the standard form of the equation of a circle.

 $(x - (-1))^2 + (y - (-2))^2 = 3^2$ Substitute for h, k, and r.

 $(x + 1)^2 + (y + 2)^2 = 9$ Simplify.

d) The center of a circle is the midpoint of a diameter of the circle. By finding the midpoint of the segment from $(-2, 2)$ to $(-6, -2)$, we'll find the center of the circle. Let $(x_1, y_1) = (-2, 2)$ and $(x_2, y_2) = (-6, -2)$.

$$M = \left(\frac{x_1 + x_2}{2}, \frac{y_1 + y_2}{2} \right)$$ Write the formula for the midpoint.

$$M = \left(\frac{-2+(-6)}{2}, \frac{2+(-2)}{2}\right) \qquad \text{Substitute.}$$

$$M = \left(-\frac{8}{2}, \frac{0}{2}\right) \qquad\qquad \text{Simplify.}$$

$$M = (-4, 0) \qquad\qquad\qquad \text{Simplify.}$$

Because the radius is the distance from the center to any point on the circle, we'll find the distance from the center $(-4, 0)$ to $(-2, 2)$.

$$d = \sqrt{(x_2 - x_1)^2 + (y_2 - y_1)^2} \qquad \text{Write the distance formula.}$$

$$d = \sqrt{(-4-(-2))^2 + (0-2)^2} \qquad \text{Substitute.}$$

$$d = \sqrt{(-2)^2 + (-2)^2} \qquad\qquad \text{Simplify.}$$

$$d = \sqrt{4+4}$$

$$d = \sqrt{8}$$

$$(h, k) = (-4, 0) \quad r = \sqrt{8} \qquad\qquad \text{Identify } h, k, \text{ and } r.$$

$$(x - h)^2 + (y - k)^2 = r^2 \qquad\qquad \text{Write the standard form of the equation of a circle.}$$

$$(x-(-4))^2 + (y-0)^2 = (\sqrt{8})^2 \qquad \text{Substitute for } h, k, \text{ and } r.$$

$$(x + 4)^2 + y^2 = 8 \qquad\qquad \text{Simplify.}$$

FINDING THE CENTER AND RADIUS

When the equation of a circle is written in standard form, we can read the center and radius from the equation. However, often the equation of a circle will be given in **general form:**

$$Ax^2 + Ay^2 + Cx + Dy + F = 0, A \neq 0$$

Complete the square on both x and y to convert from general form to standard form. To complete the square, divide both sides of the equation by the coefficient of x^2 and add (1/2 times the coefficient of x)2 and (1/2 times the coefficient of y)2 to both sides. Note that the coefficient of x^2 and y^2 must be equal for the equation to represent a circle.

Example 1.11

Find the center and radius of each circle.

a) $x^2 + y^2 - 4x + 2y - 4 = 0$

b) $2x^2 + 2y^2 + 12y + 10 = 0$

c) $3x^2 + 3y^2 + 6x - 4y = 0$

Solution 1.11

a) $(x^2 - 4x) + (y^2 + 2y) = 4$ Group the x^2 and x terms, y^2 and y terms and add 4 and add 1 to both sides.

$(x^2 - 4x + \mathbf{4}) + (y^2 + 2y + \mathbf{1}) = 4 + \mathbf{4} + \mathbf{1}$

$$\left(\frac{1}{2} \cdot -4\right)^2 = (-2)^2 = 4$$

$$\left(\frac{1}{2} \cdot 2\right)^2 = (1)^2 = 1$$

$(x - 2)^2 + (y + 1)^2 = 9$ Factor.

$(x - 2)^2 + (y - (-1))^2 = 3^2$ Write in the form $(x - h)^2 + (y - k)^2 = r^2$.

The center is at $(2, -1)$ and the radius is 3.

b) $2x^2 + 2y^2 + 12y + 10 = 0$

$x^2 + y^2 + 6y + 5 = 0$ Divide by 2.

$x^2 + (y^2 + 6y) = -5$ Group the y^2 and y term and subtract 5 from both sides.

$x^2 + (y^2 + 6y + \mathbf{9}) = -5 + \mathbf{9}$

$$\left(\frac{1}{2} \cdot 6\right)^2 = (3)^2 = 9.$$

$x^2 + (y + 3)^2 = 4$ Factor.

$(x - 0)^2 + (y - (-3))^2 = 2^2$ Write in the form $(x - h)^2 + (y - k)^2 = r^2$.

The center is at $(0, -3)$ and the radius is 2.

c) $3x^2 + 3y^2 + 6x - 4y = 0$

$x^2 + y^2 + 2x - \dfrac{4}{3}y = 0$ Divide by 3.

$(x^2 + 2x) + \left(y^2 - \dfrac{4}{3}y\right) = 0$ Group the x^2 and x terms, y^2 and y terms.

$\left(x^2 + 2x + 1\right) + \left(y^2 - \dfrac{4}{3}y + \dfrac{4}{9}\right) = 0 + 1 + \dfrac{4}{9}$ $\left(\dfrac{1}{2} \cdot 2\right)^2 = 1, \left(\dfrac{1}{2} \cdot -\dfrac{4}{3}\right)^2 = \dfrac{4}{9}.$

$(x + 1)^2 + \left(y - \dfrac{2}{3}\right)^2 = \dfrac{13}{9}$ Factor.

The center is at $\left(-1, \dfrac{2}{3}\right)$ and the radius is $\sqrt{\dfrac{13}{9}} = \dfrac{\sqrt{13}}{3}$.

LINES

There are many formulas associated with linear equations, some of which are presented in the following table. These formulas should be memorized.

Name	Formula	Notes
Slope of a line	$m = \dfrac{y_2 - y_1}{x_2 - x_1}$	Also $\dfrac{rise}{run}$. (x_1, y_1) and (x_2, y_2) represent any two points on the line.
Standard form of a line	$Ax + By = C$	The constant is isolated.
General form of a line	$Ax + By + C = 0$	Zero is on the right side.
Point-slope form of a line	$y - y_1 = m(x - x_1)$	Replace y_1, m, and x_1.
Slope-intercept form of a line	$y = mx + b$	Replace m and b, where b is the y-intercept.
Vertical line through (a, b)	$x = a$	Vertical lines have undefined slope.
Horizontal line through (a, b)	$y = b$	Horizontal lines have 0 slope.

SLOPE

Given two points on a line, we find slope using $m = \dfrac{y_2 - y_1}{x_2 - x_1}$. Given an equation of a line, we find slope by first writing the equation in $y = mx + b$ form. In this form, the coefficient of x is the slope, m.

Example 1.12

Find the slope of the line

 a) passing through $(5, -1)$ and $(-6, -3)$

 b) $y = \dfrac{2}{3}x + 6$

 c) $2x - 5y = 10$

Solution 1.12

 a) Let $(x_1, y_1) = (5, -1)$ and $(x_2, y_2) = (-6, -3)$

$$m = \frac{y_2 - y_1}{x_2 - x_1}$$ Write the formula for slope.

$$m = \frac{-3-(-1)}{-6-5}$$ Substitute.

$$m = \frac{-2}{-11} = \frac{2}{11}$$ Simplify.

b) $y = \frac{2}{3}x + 6$ The line is already in $y = mx + b$ form.

$$m = \frac{2}{3}$$ Slope is the coefficient of x.

c) $2x - 5y = 10$ Write the equation in $y = mx + b$ form.

$-5y = -2x + 10$ Isolate y.

$$y = \frac{2}{5}x - 2$$ Divide by –5.

$$m = \frac{2}{5}$$ Slope is the coefficient of x.

WRITING EQUATIONS OF LINES

The table below will help you decide when to use each form of a linear equation.

Given This Data …	Use This Form …	Name of the Form
Slope m and y-intercept b	$y = mx + b$	Slope-intercept
Point (x_1, y_1) and slope m	$y - y_1 = m(x - x_1)$	Point-slope
Two points (x_1, y_1) and (x_2, y_2)	First find $m = \dfrac{y_2 - y_1}{x_2 - x_1}$ and then use $y - y_1 = m(x - x_1)$	Slope Point-slope
Vertical line through (a, b)	$x = a$	
Horizontal line through (a, b)	$y = b$	

Example 1.13

Write the equation of the line using the given information.

 a) $m = \frac{3}{4}$, containing the point $(0, 2)$.

 b) containing the points $(5, -1)$ and $(-6, -3)$.

 c) m undefined, containing the point $(-1, 4)$.

 d) $m = 0$, containing the point $(2, -6)$.

Solution 1.13

a) Note that in the ordered pair (0, 2), 2 is the *y*-intercept, *b*.

$y = mx + b$ — Use the slope-intercept form.

$y = \dfrac{3}{4}x + 2$ — Substitute $m = \dfrac{3}{4}$, $b = 2$.

If you had not recognized (0, 2) as the *y*-intercept, you could use the point-slope formula:

$(x_1, y_1) = (0, 2)$, $m = \dfrac{3}{4}$

$y - y_1 = m(x - x_1)$ — Write the point-slope form.

$y - 2 = \dfrac{3}{4}(x - 0)$ — Substitute.

$y - 2 = \dfrac{3}{4}x$ — Simplify.

$y = \dfrac{3}{4}x + 2$ — Same solution.

b) Let $(x_1, y_1) = (5, -1)$ and $(x_2, y_2) = (-6, -3)$

$m = \dfrac{y_2 - y_1}{x_2 - x_1} = \dfrac{2}{11}$ — Find *m* (see Example 1.12a)

Then use

$y - y_1 = m(x - x_1)$ — Write the point-slope form.

$y - (-1) = \dfrac{2}{11}(x - 5)$ — Substitute.

$y + 1 = \dfrac{2}{11}x - \dfrac{10}{11}$ — Simplify.

$y = \dfrac{2}{11}x - \dfrac{21}{11}$ — The answer is written in slope-intercept form.

c) *m* undefined means this is a vertical line.

$x = a$ — Write the form for a vertical line.

$x = -1$ — $(a, b) = (-1, 4)$

d) $m = 0$ means this is a horizontal line.

$y = b$ — Write the form for a horizontal line.

$y = -6$ — $(a, b) = (2, -6)$

PARALLEL AND PERPENDICULAR LINES

Recall from geometry that **parallel lines** are distinct lines in the same plane that do not intersect. **Perpendicular lines** are lines in the same plane that intersect at right angles. The slopes of parallel and perpendicular lines are related as follows.

- Parallel lines have equal slopes.
- Perpendicular lines have slopes that are negative reciprocals of each other (a and $-1/a$ for $a \neq 0$).

Example 1.14

Find an equation of the line

 a) containing the point $(-2, 5)$ and perpendicular to $y = \dfrac{3}{4}x + 6$

 b) containing $(\dfrac{1}{2}, \dfrac{3}{4})$ and parallel to $2x - 3y = 6$

 c) containing $(-1, -3)$ and perpendicular to $x = 4$

 d) containing $(2, -5)$ and parallel to $y = 3$

Solution 1.14

 a) The slope of $y = \dfrac{3}{4}x + 6$ is $\dfrac{3}{4}$. The slope of a line perpendicular to $y = \dfrac{3}{4}x + 6$ is

$$m = -\frac{4}{3}$$

$$(x_1, y_1) = (-2, 5)$$

$y - y_1 = m(x - x_1)$	Write the point-slope form.
$y - 5 = -\dfrac{4}{3}(x - (-2))$	Substitute.
$y - 5 = -\dfrac{4}{3}x - \dfrac{8}{3}$	Simplify.
$y = -\dfrac{4}{3}x + \dfrac{7}{3}$	$-\dfrac{8}{3} + \dfrac{5}{1} = -\dfrac{8}{3} + \dfrac{15}{3} = \dfrac{7}{3}.$

 b) Find the slope of $2x - 3y = 6$:

$-3y = -2x + 6$	Isolate y.
$y = \dfrac{2}{3}x - 2$	Divide by -3.

$m = \dfrac{2}{3}$, and any line parallel to this line has slope $m = \dfrac{2}{3}$.

$$(x_1, y_1) = (\frac{1}{2}, \frac{3}{4}) \quad m = \frac{2}{3}$$

$y - y_1 = m(x - x_1)$	Write the point-slope form.
$y - \dfrac{3}{4} = \dfrac{2}{3}(x - \dfrac{1}{2})$	Substitute.

$$y - \frac{3}{4} = \frac{2}{3}x - \frac{1}{3}$$ Simplify.

$$y = \frac{2}{3}x + \frac{5}{12}$$ $$-\frac{1}{3} + \frac{3}{4} = -\frac{4}{12} + \frac{9}{12} = \frac{5}{12}$$

c) Note that $x = 4$ is a vertical line, and any line perpendicular to it must be a horizontal line.

$y = b$ Write the form for a horizontal line.

$y = -3$ $(a, b) = (-1, -3)$

d) Note that $y = 3$ is a horizontal line, and any line parallel to it must also be a horizontal line.

$y = b$ Write the form for a horizontal line.

$y = -5$ $(a, b) = (2, -5)$

GRAPHING EQUATIONS

GRAPHING BY PLOTTING POINTS

Probably your first encounter with graphing involved a table of values, where you substituted x-values into a given equation, found y-values, and then plotted those points. That method is still useful, especially when you don't recognize the type of equation. If you have plotted several points and still cannot connect them with a smooth curve, *plot more points*.

Example 1.15

Graph

a) $y = x^2 - 4$

b) $y = \sqrt{3 - x}$

Solution 1.15

a) $y = x^2 - 4$

Let us complete the table:

x	y
-3	
-2	
-1	
0	
1	
2	
3	

If $x = -3$, $y = (-3)^2 - 4 = 9 - 4 = 5$
If $x = -2$, $y = (-2)^2 - 4 = 4 - 4 = 0$
If $x = -1$, $y = (-1)^2 - 4 = 1 - 4 = -3$
If $x = 0$, $y = (0)^2 - 4 = 0 - 4 = -4$
If $x = 1$, $y = (1)^2 - 4 = 1 - 4 = -3$
If $x = 2$, $y = (2)^2 - 4 = 4 - 4 = 0$
If $x = 3$, $y = (3)^2 - 4 = 9 - 4 = 5$

The table becomes:

x	y
−3	5
−2	0
−1	−3
0	−4
1	−3
2	0
3	5

Plot the points and connect with a smooth curve:

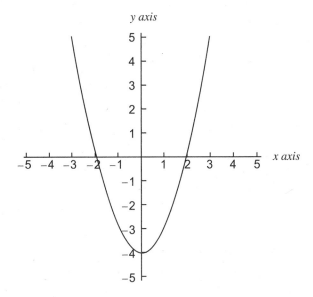

b) $y = \sqrt{3-x}$. Complete the table:

x	Y
−3	
−2	
−1	
0	
1	
2	
3	

If $x = -3, y = \sqrt{3-(-3)} = \sqrt{3+3} = \sqrt{6}$

If $x = -2, y = \sqrt{3-(-2)} = \sqrt{3+2} = \sqrt{5}$

If $x = -1, y = \sqrt{3-(-1)} = \sqrt{3+1} = 2$

If $x = 0, y = \sqrt{3-(0)} = \sqrt{3}$

If $x = 1, y = \sqrt{3-(1)} = \sqrt{2}$

If $x = 2, y = \sqrt{3-(2)} = \sqrt{1} = 1$

If $x = 3, y = \sqrt{3-(3)} = \sqrt{0} = 0$

The table becomes:

x	y
−3	$\sqrt{6} \approx 2.4$
−2	$\sqrt{5} \approx 2.2$
−1	2
0	$\sqrt{3} \approx 1.7$
1	$\sqrt{2} \approx 1.4$
2	1
3	0

Plot the points and connect with a smooth curve:

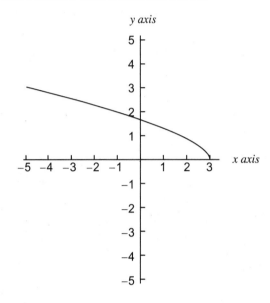

GRAPHING LINES AND CIRCLES

Although a table of values can be used to graph any equation, it can be time consuming. Recognizing the basic shape of the graph saves time. For example, you can graph lines and circles using their features.

To graph lines using $y = mx + b$

1. Put a point on the y-axis at the y-intercept b.

2. From b, use $m = \dfrac{rise}{run}$ to locate a second point on the line.

3. Draw a line through the two points.

Example 1.16

Graph each line.

a) $y = 3x - 4$

b) $3x + 4y = 8$

Solution 1.16

a) $y = 3x - 4$ The equation is already written in $y = mx + b$ form.

$m = 3 = \dfrac{3}{1}$ and $b = -4$ Identify m and b.

Start at $(0, -4)$. $m = 3 = \dfrac{3}{1} = \dfrac{rise}{run}$, so rise 3 units and run 1 unit to the right:

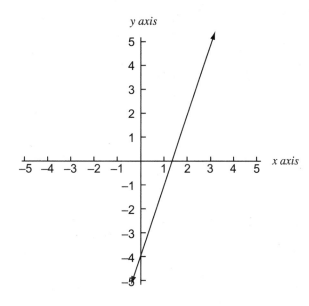

b) $3x + 4y = 8$ Write the equation in $y = mx + b$ form.

$4y = -3x + 8$ Subtract $3x$ from both sides.

$y = -\dfrac{3}{4}x + 2$ Divide by 4.

$m = \dfrac{-3}{4},\ b = 2$ Identify m and b.

Start at (0, 2). $m = \dfrac{-3}{4}$ so fall 3 units and run 4 units to the right:

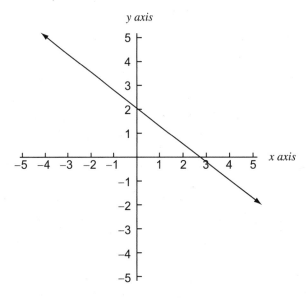

If you know the center and radius of a circle, you can plot the center and the four points that are horizontally and vertically a distance of r from the center.

Example 1.17
Graph

a) $x^2 + y^2 = 9$

b) $(x - 2)^2 + (y + 1)^2 = 16$

Solution 1.17

a) $x^2 + y^2 = 9$ is a circle with center (0, 0) and radius $r = 3$. Plot the center and the points (3, 0), (0, 3), (−3, 0), and (0, −3)

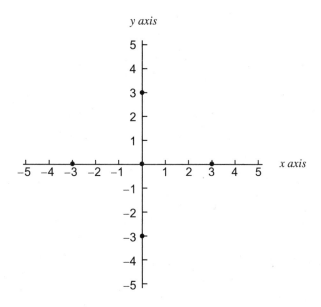

Now connect the four points on the circle (the center is not a point on the circle).

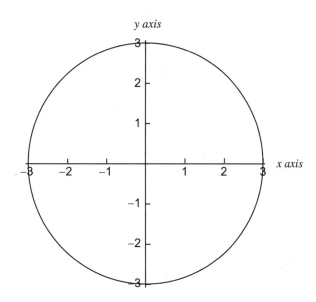

b) $(x - 2)^2 + (y + 1)^2 = 16$ is a circle with center $(2, -1)$ and radius $r = 4$. Plot the center and the four points that are 4 units away horizontally and vertically:

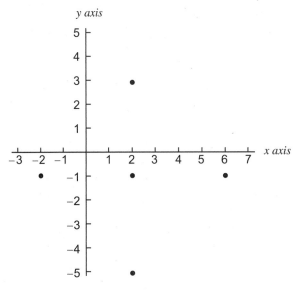

Now connect the four points on the circle:

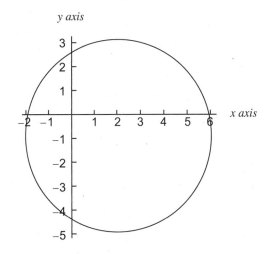

SYMMETRY

One of the aids used in graphing is symmetry. If you know a graph is symmetric with respect to the *y*-axis, origin, or *x*-axis, the table of values can be limited and the remainder of the graph can be sketched using symmetry. Study the table that follows.

Type of Symmetry	Test	Graph
Symmetry with respect to the *y*-axis	Replacing *x* with −*x* yields an equivalent equation.	Graph folds onto itself if folded along the *y*-axis.
Symmetry with respect to the *x*-axis	Replacing *y* with −*y* yields an equivalent equation.	Graph folds onto itself if folded along the *x*-axis.
Symmetry with respect to the origin	Replacing *x* with −*x* and *y* with −*y* yields an equivalent equation.	Graph folds onto itself if folded along the *x*-axis then the *y*-axis.

Example 1.18

Determine whether the graph is symmetric with respect to the *y*-axis, *x*-axis, origin, or none of these.

a) $x^2 + y^2 = 4$

b) $y = 4x^4 - 2x^2$

c) $x = 4y^2 - 1$

d) $y = 2x + 3$

Solution 1.18

a) $x^2 + y^2 = 4$

Test for symmetry with respect to the y-axis:

$(-x)^2 + y^2 = 4$ Replace x with $-x$.

$x^2 + y^2 = 4$ Equivalent equation.

Therefore, this graph is symmetric with respect to the y-axis.

Test for symmetry with respect to the x-axis:

$x^2 + (-y)^2 = 4$ Replace y with $-y$.

$x^2 + y^2 = 4$ Equivalent equation.

Therefore this graph is symmetric with respect to the x-axis.

Test for symmetry with respect to the origin:

$(-x)^2 + (-y)^2 = 4$ Replace x with $-x$ and y with $-y$.

$x^2 + y^2 = 4$ Equivalent equation.

Therefore this graph is symmetric with respect to the origin. If you realized the equation represented the graph of a circle with center $(0, 0)$ and radius 2, you already knew which symmetries were present.

b) $y = 4x^4 - 2x^2$

Test for symmetry with respect to the y-axis:

$y = 4(-x)^4 - 2(-x)^2$ Replace x with $-x$.

$y = 4x^4 - 2x^2$ Equivalent equation.

Therefore, this graph is symmetric with respect to the y-axis.

Test for symmetry with respect to the x-axis:

$(-y) = 4x^4 - 2x^2$ Replace with y with $-y$.

$y = 4x^4 - 2x^2$ *Not* an equivalent equation.

Therefore, this graph is *not* symmetric with respect to the x-axis.

Test for symmetry with respect to the origin:

$(-y) = 4(-x)^4 - 2(-x)^2$ Replace x with $-x$ and y with $-y$.

$-y = 4x^4 - 2x^2$ Simplify.

$y = -4x^4 + 2x^2$ *Not* an equivalent equation.

Therefore, this graph is *not* symmetric with respect to the origin.

c) $x = 4y^2 - 1$

Test for symmetry with respect to the y-axis:

$(-x) = 4y^2 - 1$ Replace x with $-x$.

$-x = 4y^2 - 1$ Simplify.

$x = -4y^2 + 1$ *Not* an equivalent equation.

Therefore, this graph is *not* symmetric with respect to the y-axis.

Test for symmetry with respect to the x-axis:

$x = 4(-y)^2 - 1$ Replace y with $-y$.

$x = 4y^2 - 1$ An equivalent equation.

Therefore, this graph is symmetric with respect to the x-axis.

Test for symmetry with respect to the origin:

$(-x) = 4(-y)^2 - 1$ Replace x with $-x$ and y with $-y$.

$-x = 4y^2 - 1$ Simplify.

$x = -4y^2 + 1$ *Not* an equivalent equation.

Therefore, this graph is *not* symmetric with respect to the origin.

d) $y = 2x + 3$

Test for symmetry with respect to the y-axis:

$y = 2(-x) + 3$ Replace x with $-x$.

$y = -2x + 3$ Simplify.

$y = -2x + 3$ *Not* an equivalent equation.

Therefore, this graph is *not* symmetric with respect to the y-axis.

Test for symmetry with respect to the x-axis:

$(-y) = 2x + 3$ Replace y with $-y$.

$-y = 2x + 3$ Simplify.

$y = -2x - 3$ *Not* an equivalent equation.

Therefore, this graph is *not* symmetric with respect to the x-axis.

Test for symmetry with respect to the origin:

$(-y) = 2(-x) + 3$ Replace x with $-x$ and y with $-y$.

$-y = -2x + 3$ Simplify.

$y = 2x - 3$ *Not* an equivalent equation.

Therefore, this graph is *not* symmetric with respect to the origin.

Note from this example that a graph may be symmetric with respect to no axes, one axis, or both axes.

Example 1.19

Use symmetry to help graph the following equations.

a) $y = 2x^2 + 1$

b) $x = y^4 - 3$

Solution 1.19

a) $y = 2x^2 + 1$ is symmetric with respect to the y-axis:

$y = 2(-x)^2 + 1$ Replace x with $-x$.

$y = 2x^2 + 1$ Equivalent equation.

Therefore, our table of values need only contain 0 and positive values for x:

x	y
0	
1	
2	

If $x = 0$, $y = 2(0)^2 + 1 = 1$
If $x = 1$, $y = 2(1)^2 + 1 = 3$
If $x = 2$, $y = 2(2)^2 + 1 = 9$
The table becomes

x	y
0	1
1	3
2	9

Plot these points and their reflections across the y-axis:

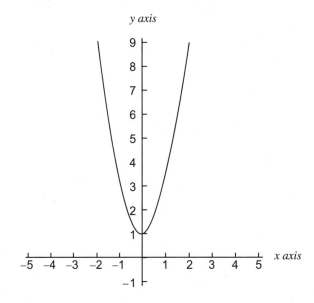

b) $x = y^4 - 3$

This graph is symmetric with respect to the x-axis:

$x = (-y)^4 - 3$ Replace y with $-y$.
$x = y^4 - 3$ Equivalent equation.

Therefore, our table of values need only contain 0 and positive y values:

x	y
	0
	1
	2

If $y = 0$, $x = (0)^4 - 3 = -3$
If $y = 1$, $x = (1)^4 - 3 = -2$
If $y = 2$, $x = 2^4 - 3 = 16 - 3 = 13$

Our table becomes

x	y
−3	0
−2	1
13	2

Plot these points and their reflections across the *x*-axis:

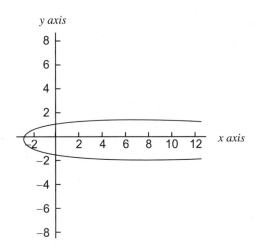

A FEW NOTES ABOUT TECHNOLOGY

Many Calculus classes make use of technology such as graphing calculators, software, or sites available on the Internet. Become familiar with whatever your course requires.

If you are using a graphing calculator, typical skills include graphing functions, setting the viewing window, zooming in and out, finding the intersection of two curves using trace and/or intersect, graphing a scatter diagram, finding a linear or quadratic regression equation and correlation coefficient. For calculator help, you may want to use the Internet (for Texas Instrument calculators for example, see http://education.ti.com).

Example 1.20

a) Use the linear regression capabilities of a TI-83 Plus calculator to find a linear model to fit the given data representing the number of hours spent studying for a Calculus test and the corresponding score on the test.

Hours Spent Studying	Score on Test
2	46
4.5	50
6	72
8	83
12	94

b) Use your model to predict the score of a person who studies 7 hours for the test.

Solution 1.20

a) The following keystrokes would be used:

STAT

EDIT

Enter the first column in L1 (List 1), pressing enter after each entry.

Press the right arrow to enter data in L2 (List 2), again pressing enter after each entry.

QUIT (2nd Mode)

STAT

CALC

Arrow down to LinReg $(ax + b)$

Enter

Enter

Then on the screen you will find

$y = ax + b$

$a = 5.236842109$

$b = 34.96052632$

If diagnostics have been turned on (Catalog, DiagonosticOn, enter, enter), you will also find

$r^2 = .8845...$

$r = .9405...$

which tells you that because the r value is close to 1, the relationship is such that in general, the longer a student studies, the higher his or her grade on the test.

So, our linear model (rounded to three decimal places) is:

$y = 5.237x + 34.961$

b) To predict the score of a person who studies 7 hours, find y when $x = 7$ by either replacing x with 7 or first graphing the equation and using Value or Table.
$$y = 5.237(7) + 39.961 = 76.62$$
The student should score approximately 77.

SUMMARY

This chapter reviewed several important algebraic topics and formulas. A list of the formulas used in this chapter follows.

Difference of two squares: $x^2 - y^2 = (x - y)(x + y)$

Sum of two squares: $x^2 + y^2$ does not factor

Perfect square trinomial: $x^2 \pm 2xy + y^2 = (x \pm y)^2$

Sum/difference of two cubes: $x^3 \pm y^3 = (x \pm y)(x^2 \mp xy + y^2)$

The quadratic formula: $x = \dfrac{-b \pm \sqrt{b^2 - 4ac}}{2a}$

The distance formula: $d = \sqrt{(x_2 - x_1)^2 + (y_2 - y_1)^2}$

The midpoint formula: $M = \left(\dfrac{x_1 + x_2}{2}, \dfrac{y_1 + y_2}{2}\right)$

Equation of a circle in standard form: $(x - h)^2 + (y - k)^2 = r^2$

Slope: $m = \dfrac{y_2 - y_1}{x_2 - x_1}$

Standard form of a line: $Ax + By = C$

General form of a line: $Ax + By + C = 0$

Point-slope form of a line: $y - y_1 = m(x - x_1)$

Slope-intercept form of a line: $y = mx + b$

TEST YOURSELF

1) Solve each inequality. Write each solution using interval notation.
 a) $2x - 5 \le 5x + 7$
 b) $-\dfrac{1}{5}x + 4 > 1$
 c) $-1 < 3x - 4 < 1$

2) Solve. Write each solution in interval notation whenever possible.
 a) $|2x - 1| = 7$
 b) $|3x + 2| \le 2$
 c) $|2 - 4x| > 6$
 d) $|6x + 4| > -2$
 e) $|8x - 1| < -1$

3) Factor.
 a) $4x^2 + 12xy + 9y^2$
 b) $64x^3 - 125$
 c) $2x^2 - 9x - 5$
 d) $3x^2 - 3x - 60$
 e) $16x^2 - 25$

4) Solve each inequality. Write each solution in interval notation.
 a) $x^2 - x \le 12$
 b) $3x^2 > -8x + 3$
 c) $x^2 + 14x + 9 \le 0$

5) Find the distance between the given points. Give exact answers.
 a) $(3, -6)$ and $(-7, -2)$
 b) $(2\sqrt{3}, -1)$ and $(5\sqrt{3}, 4)$
 c) $\left(\dfrac{1}{4}, 2\right)$ and $\left(-\dfrac{1}{2}, 3\right)$

6) Find the midpoint of the line segment joining the points.
 a) $(2, -3)$ and $(-6, -1)$
 b) $(5, -3\sqrt{2})$ and $(-3, \sqrt{2})$
 c) $\left(\dfrac{2}{3}, \dfrac{4}{5}\right)$ and $\left(\dfrac{1}{4}, 3\right)$

7) Write the equation of each circle in standard form.
 a) center $(-1, 3)$ and radius 2
 b) center at the origin and radius 5
 c) center $(-4, -1)$ and radius 4
 d) endpoints of a diameter: $(1, 0)$, $(1, -6)$

8) Find the center and radius of each circle.
 a) $x^2 + y^2 + 6x - 4y - 12 = 0$
 b) $3x^2 + 3y^2 - 24x - 6y - 24 = 0$
 c) $4x^2 + 4y^2 - 2x + 8y - 2 = 0$
 d) $2x^2 + 2y^2 + x - 6 = 0$

9) Find the slope of each line.
 a) The line containing $(6, -2)$ and $(-3, 4)$
 b) $y = -2x + 3$
 c) $4x - 3y = 6$

10) Write the equation of the line using the given information. Write each answer in $y = mx + b$ form whenever possible.
 a) $m = -\dfrac{2}{3}$, containing the point $(0, 1)$
 b) containing the points $(-2, 3)$ and $(1, -6)$
 c) m undefined, containing the point $(2, -1)$
 d) $m = 0$, containing the point $(-3, -4)$

11) Find an equation of the line
 a) containing $(-2, -1)$ and perpendicular to $y = \dfrac{1}{4}x + 7$
 b) containing $(\dfrac{2}{3}, -\dfrac{1}{2})$ and parallel to $3x + 2y = 4$
 c) containing $(2, -6)$ and perpendicular to $y = 3$
 d) containing $(5, -3)$ and parallel to $x = 2$

12) Graph.

a) $y = x^2 + 2$

b) $y = \sqrt{x+1}$

c) $y = \dfrac{3}{2}x - 3$

d) $2x + 5y = 10$

e) $x^2 + y^2 = 25$

f) $(x + 1)^2 + (y - 3)^2 = 16$

13) Determine whether each graph is symmetric with respect to the y-axis, the x-axis, the origin, or none of these.

a) $x^2 + y^2 = 1$

b) $y = 3x^4 + x^2$

c) $x = y^4 - 2$

d) $y = x^3 - 2x^2 + 3x$

14)

a) Find a linear model to fit the given data. Round answers to three decimal places.

Height in inches	Weight in pounds
48	90
54	95
60	120
62	140
65	130
67	135

b) Use your model to approximate the weight of a person who is 72 inches tall.

15)

a) Find a quadratic model to fit the given data. Round to three decimal places.

y	x
.5	110
1	109
2	87
3	33
4	−56

b) Use your model to approximate y when $x = 2.5$ (round to the nearest whole number).

TEST YOURSELF ANSWERS

1)
 a) $[-4, \infty)$
 b) $(-\infty, 15)$
 c) $(1, \dfrac{5}{3})$

2)
 a) $\{-3, 4\}$
 b) $\left[-\dfrac{4}{3}, 0\right]$
 c) $(-\infty, -1) \cup (2, \infty)$
 d) $(-\infty, \infty)$
 e) \varnothing

3)
 a) $(2x + 3y)^2$
 b) $(4x - 5)(16x^2 + 20x + 25)$
 c) $(2x + 1)(x - 5)$
 d) $3(x + 4)(x - 5)$
 e) $(4x - 5)(4x + 5)$

4)
 a) $[-3, 4]$
 b) $(-\infty, -3) \cup (\dfrac{1}{3}, \infty)$
 c) $[-7 - 2\sqrt{10}, -7 + 2\sqrt{10}]$

5)
 a) $2\sqrt{29}$
 b) $2\sqrt{13}$
 c) $\dfrac{5}{4}$

6)
 a) $(-2, -2)$
 b) $(1, -\sqrt{2})$
 c) $\left(\dfrac{11}{24}, \dfrac{19}{10}\right)$

7)
 a) $(x + 1)^2 + (y - 3)^2 = 4$
 b) $x^2 + y^2 = 25$
 c) $(x + 4)^2 + (y + 1)^2 = 16$
 d) $(x - 1)^2 + (y + 3)^2 = 9$

8)
 a) center $(-3, 2)$ $r = 5$
 b) center $(4, 1)$ $r = 5$
 c) center $\left(\dfrac{1}{4}, -1\right)$ $r = \dfrac{5}{4}$
 d) center $\left(-\dfrac{1}{4}, 0\right)$ $r = \dfrac{7}{4}$

9)
 a) $-\dfrac{2}{3}$
 b) -2
 c) $\dfrac{4}{3}$

10)
 a) $y = -\dfrac{2}{3}x + 1$
 b) $y = -3x - 3$
 c) $x = 2$
 d) $y = -4$

11)
 a) $y = -4x - 9$
 b) $y = -\dfrac{3}{2}x + \dfrac{1}{2}$
 c) $x = 2$
 d) $x = 5$

12)

a)

b)

c)

d)

e)

f)

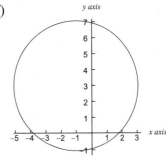

13)

　　a) y-axis, x-axis, and origin

　　b) y-axis

　　c) x-axis

　　d) none of these

14)

　　a) $y = 2.735x - 43.943$

　　b) 152.977

15)

　　a) $y = -16.224x^2 + 25.916x + 100.333$

　　b) 64

Functions, Limits, and Continuity

This chapter continues to review some pre-calculus topics, including a review of functions and trigonometry. We then begin the first calculus topics of limits and continuity.

2.1 FUNCTIONS AND GRAPHS OF FUNCTIONS

The theorems and definitions in our study of Calculus involve functions. A thorough understanding of functions, function notation, and operations on functions is essential to your success. A **function** is a set of ordered pairs in which no x-coordinate is repeated. Study the following examples and counterexamples.

Function	Not a Function
$\{(0, 1), (2, 3), (3, 4)\}$	$\{(0, 1), (1, 2), (1, 3)\}$

Notice in the counterexamples that an x-coordinate is repeated: In the set of ordered pairs, 1 is paired with 2 and 3. In the graph, two points line up vertically, such as $(4, 2)$ and $(4, -2)$. This observation leads to the **vertical line test:** If a vertical line can be drawn through more than one point on a graph, that graph does *not* represent a function.

Example 2.1

Identify the functions.

a)

b)

c)

d)

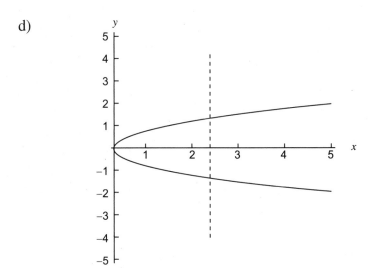

Solution 2.1

a) Is a function.

b) Is a function.

c) Is not a function, because a vertical line intersects the graph at more than one point.

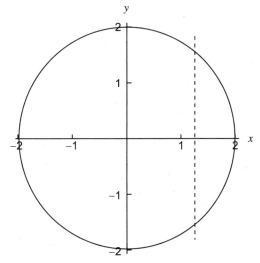

d) Is not a function, because a vertical line intersects more than one point.

DOMAIN AND RANGE

Now that we can determine what represents a function, we return to the concept of **domain** (the set of x-coordinates) and **range** (the set of y-coordinates). If the domain of a function is *not* stated, it is assumed to be the largest set of real numbers that can be used as x values.

Because we do not allow division by 0 or negative numbers as the radicand of an even-indexed root such as a square root, the following steps can be used to find the domain of a function when given an equation.

1. If there are no variables in the denominator or variables under a square root symbol (or the even-indexed root), the domain is generally all real numbers.

2. If there is a variable in a denominator, set the denominator equal to 0 and solve. The domain is all real numbers *except* the values that make the denominator 0.

3. If there is a variable under a square root symbol (or even indexed root), set the radicand greater than or equal to 0, and solve. The solution to the inequality is the domain.

Example 2.2

Find the domain. Write the answer in interval notation (see Chapter 1 for details).

a) $y = 2x + 1$

b) $y = \dfrac{4}{x-2}$

c) $y = \sqrt{3x+2}$

d) $y = \dfrac{\sqrt{x-2}}{x-3}$

Solution 2.2

a) $y = 2x + 1$

The domain is the set of all real numbers, because there are no variables in the denominator and no square roots. In interval notation write $(-\infty, \infty)$.

b) $y = \dfrac{4}{x-2}$

$x - 2 = 0$ Set the denominator equal to 0.

$x = 2$ Solve by adding 2 to both sides.

The domain is the set of all real numbers except 2. Write $(-\infty, 2) \cup (2, \infty)$ in interval notation.

c) $y = \sqrt{3x+2}$ Set the radicand greater than or equal to 0.

$3x + 2 \geq 0$

$3x \geq -2$ Subtract 2 from both sides.

$x \geq -\dfrac{2}{3}$ Divide by 3.

The domain is the set of all real numbers greater than or equal to $-\dfrac{2}{3}$, written $\left[-\dfrac{2}{3}, \infty\right)$.

d) $y = \dfrac{\sqrt{x-2}}{x-3}$

$x - 2 \geq 0$ Set the radicand greater than or equal to 0.

$x \geq 2$ Add 2 to both sides.

$x - 3 = 0$ Set the denominator equal to 0.

$x = 3$ Solve by adding 3 to both sides.

The domain must contain x values that are greater than or equal to 2 *and not* equal to 3. Therefore, the domain is $[2,3) \cup (3, \infty)$.

FUNCTION NOTATION

The line $y = 2x + 1$ is a function. We use special notation for functions (called **function notation**) so that

$y = 2x + 1$ in function notation is $f(x) = 2x + 1$

$y = x^2$ in function notation is $f(x) = x^2$

$y = \sqrt{x}$ in function notation is $f(x) = \sqrt{x}$

$f(x)$ is read "f of x". We often use lower case letters f, g, or h for functions. Thus, $g(x)$ would be read "g of x" (not g times x).

"Find $f(3)$" means find the value of the function (the y-coordinate) when $x = 3$. You are being asked to substitute 3 for x and simplify the results. For the function $f(x) = 2x^2 - x + 1$

$f(3) = 2(3)^2 - (3) + 1$	Substitute $x = 3$.
$\quad = 2(9) - 3 + 1$	Simplify.
$\quad = 16$	Add.

Example 2.3

If $g(x) = 3x^2 + 2x - 1$, find the following.

a) $g(0)$

b) $g(-2)$

c) $g(x + h)$

Solution 2.3

a) $g(0) = 3(0)^2 + 2(0) - 1$	Substitute $x = 0$.
$\quad = 0 + 0 - 1$	Simplify.
$\quad = -1$	
b) $g(-2) = 3(-2)^2 + 2(-2) - 1$	Substitute $x = -2$.
$\quad = 3(4) - 4 - 1$	Simplify exponents before multiplying.
$\quad = 12 - 4 - 1$	Multiply.
$\quad = 7$	
c) $g(x + h) = 3(x + h)^2 + 2(x + h) - 1$	Substitute $x = x + h$.
	$(x + h)^2 = (x + h)(x + h)$
	$\quad = x^2 + 2xh + h^2$
$\quad = 3x^2 + 6xh + 3h^2 + 2x + 2h - 1$	Use the distributive property.

GRAPHS OF FUNCTIONS

Several types of functions are used frequently in examples and exercises. Each of these graphs can be derived from a table of values (by hand), using a graphing calculator, or computer software (for example, Winplot from Peanut Software for Windows machines is free). Because graphing is an important part of Calculus, familiarity with graphs and the techniques for basic transformations allows you to spend your time more productively.

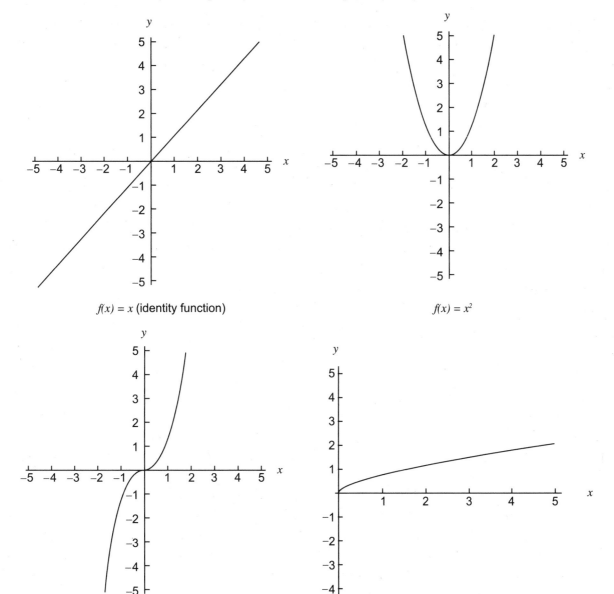

$f(x) = x$ (identity function)

$f(x) = x^2$

$f(x) = x^3$

$f(x) = \sqrt{x}$

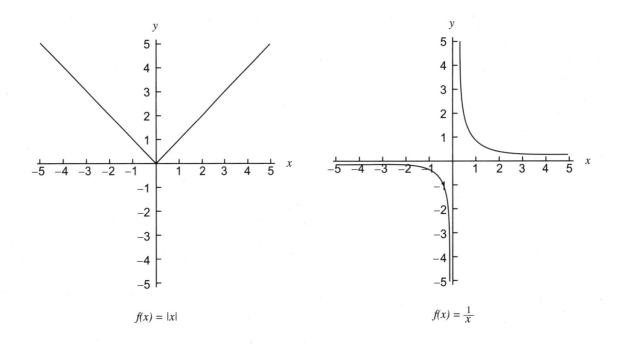

$$f(x) = |x| \qquad\qquad\qquad f(x) = \tfrac{1}{x}$$

SHIFTING AND REFLECTING GRAPHS

Table 2.1 contains some general transformations that allow you to quickly sketch the graphs of familiar functions with transformations. In this table, we use an original function of $f(x) = x^2$ and $a > 0$. Following the table are sketches of the graphs.

Table 2.1 Transformations

Description of Transformation	$f(x)$ Changed to:	Example
Shift upward a units	$f(x) + a$	$f(x) = x^2 + 2$
Shift downward a units	$f(x) - a$	$f(x) = x^2 - 1$
Shift right a units	$f(x - a)$	$f(x) = (x - 2)^2$
Shift left a units	$f(x + a)$	$f(x) = (x + 1)^2$
Reflect about the x-axis	$-f(x)$	$f(x) = -x^2$

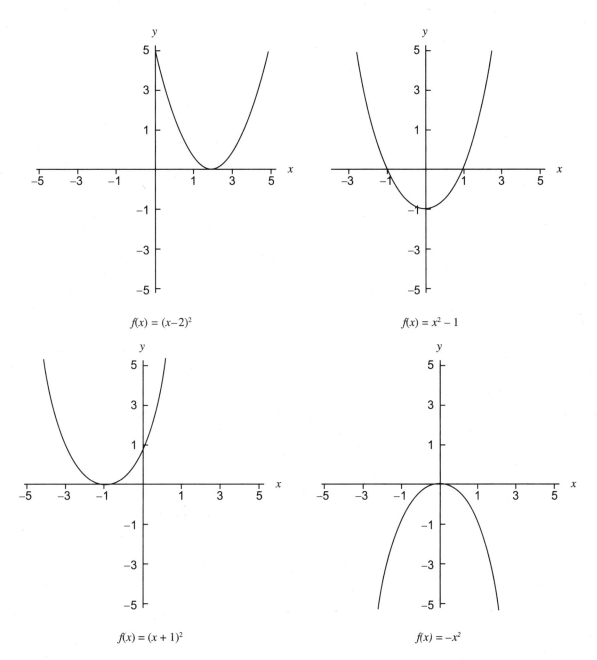

$f(x) = (x-2)^2$

$f(x) = x^2 - 1$

$f(x) = (x + 1)^2$

$f(x) = -x^2$

Note that several transformations can be combined to shift a graph up or down and to the right or left. Study Example 2.4.

Example 2.4

Describe each transformation, and then sketch the function.

a) $f(x) = x^3 + 1$

b) $f(x) = \sqrt{x} - 3$

c) $f(x) = |x - 3|$

d) $f(x) = |x + 1| - 4$

e) $f(x) = -x^2 + 2$

Solution 2.4

a) $f(x) = x^3 + 1$ shifts the graph of $f(x) = x^3$ upward 1 unit.

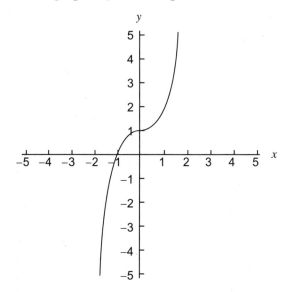

b) $f(x) = \sqrt{x} - 3$ shifts the graph of $f(x) = \sqrt{x}$ downward 3 units.

c) $f(x) = |x - 3|$ shifts the graph of $f(x) = |x|$ to the right 3 units.

 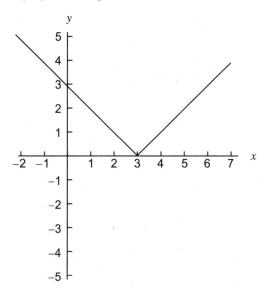

d) $f(x) = |x + 1| - 4$ shifts the graph of $f(x) = |x|$ to the left 1 unit and downward 4 units.

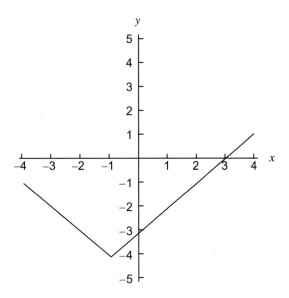

e) $f(x) = -x^2 + 2$ reflects the graph of $f(x) = x^2$ about the x-axis and upward 2 units.

Example 2.5

Use the graph of $f(x) = x^2$ to determine a formula for the given function.

a)

b)

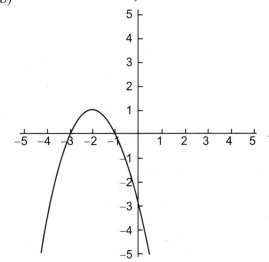

Solution 2.5

a) Because the curve has been shifted to the right 2 units and down 3 units, the equation of the graph is $f(x) = (x - 2)^2 - 3$.

b) Because the curve has been reflected about the x-axis, shifted to the left 2 units, and shifted up 1 unit, the equation of the graph is $f(x) = -(x + 2)^2 + 1$.

OPERATIONS WITH FUNCTIONS

Just as you can add, subtract, multiply, and divide numbers, you can add, subtract, multiply, and divide functions. If f and g are functions,

- $(f + g)(x) = f(x) + g(x)$
- $(f - g)(x) = f(x) - g(x)$
- $(fg)(x) = f(x)\,g(x)$
- $\left(\dfrac{f}{g}\right)(x) = \dfrac{f(x)}{g(x)},\ g(x) \neq 0$

Example 2.6

If $f(x) = 2x + 5$ and $g(x) = x^2 - 2x + 1$, find

a) $(f + g)(3)$

b) $(fg)(-1)$

c) $\left(\dfrac{f}{g}\right)(0)$

Solution 2.6

a) $(f + g)(3)$

$\quad = f(3) + g(3)$ Use $(f + g)(x) = f(x) + g(x)$

$\quad = 2(3) + 5 + (3)^2 - 2\,(3) + 1$ Substitute $x = 3$.

$\quad = 6 + 5 + 9 - 6 + 1$ Simplify.

$\quad = 15$

b) $(fg)(-1)$

$\quad = f(-1)\,g\,(-1)$ Use $(fg)(x) = f(x)g(x)$.

$\quad = [2\,(-1) + 5]\,[(-1)^2 - 2\,(-1) + 1]$ Substitute $x = -1$.

$\quad = (3)(4)$ Simplify inside each set of brackets.

$\quad = 12$

c) $\left(\dfrac{f}{g}\right)(0) = \dfrac{f(0)}{g(0)}$ Use $\left(\dfrac{f}{g}\right)(x) = \dfrac{f(x)}{g(x)}, g(x) \neq 0$.

$\quad = \dfrac{2(0) + 5}{(0)^2 - 2(0) + 1}$ Substitute $x = 0$.

$\quad = \dfrac{5}{1} = 5$ Simplify.

Example 2.7

If $f(x) = 3x^2 - 5x - 4$ and $g(x) = 2x + 3$, find

a) $(f - g)(x)$

b) $(fg)(x)$

c) $\left(\dfrac{f}{g}\right)(x)$

Solution 2.7

a) $(f - g)(x)$

$= f(x) - g(x)$	Use the definition of subtraction of functions.
$= (3x^2 - 5x - 4) - (2x + 3)$	Substitute.
$= 3x^2 - 5x - 4 - 2x - 3$	Subtract.
$= 3x^2 - 7x - 7$	Combine similar terms.

b) $(fg)(x)$

$= f(x)g(x)$	Use the definition of multiplication of functions.
$= (3x^2 - 5x - 4)(2x + 3)$	Substitute.
$= 6x^3 + 9x^2 - 10x^2 - 15x - 8x - 12$	Distribute.
$= 6x^3 - x^2 - 23x - 12$	Combine similar terms.

c) $\left(\dfrac{f}{g}\right)(x)$

$= \dfrac{f(x)}{g(x)}$ Use the definition of division of functions.

$= \dfrac{3x^2 - 5x - 4}{2x + 3}$

COMPOSITION OF FUNCTIONS

In addition to the four basic operations (addition, subtraction, multiplication, division), you can also form the composition of functions. The **composition of functions** f and g, written $f \circ g$, is $f \circ g = f(g(x))$. The composition of functions indicates an order of evaluating the functions. $(f \circ g)(3) = f(g(3))$ means first evaluate $g(3)$, and then evaluate f at the resulting value.

Example 2.8

If $f(x) = 3x + 1$ and $g(x) = -2x - 4$, find $(f \circ g)(3)$.

Solution 2.8

$(f \circ g)(3) = f(g(3))$	Use the definition of composition of functions.
$g(3) = -2(3) - 4 = -10$	Find $g(3)$.
$= f(-10)$	Now evaluate $f(-10)$.
$= 3(-10) + 1$	Substitute $x = -10$ in f.
$= -29$	

Example 2.9

If $f(x) = 3x + 1$ and $g(x) = -2x - 4$, find $(g \circ f)(3)$.

Solution 2.9

$(g \circ f)(3) = g\,(f\,(3))$

$f(3) = 3(3) + 1 = 10$	Find $f\,(3)$.
$= g(10)$	Now evaluate $g(10)$.
$= -2(10) - 4$	Substitute $x = 10$ in g.
$= -24$	

Notice from example 2.8 and 2.9 that in general $g \circ f \neq f \circ g$.

Example 2.10

If $f(x) = x^2 - 1$ and $g(x) = 3x + 4$, find $f \circ g$ and $g \circ f$.

Solution 2.10

$f \circ g$ means $(f \circ g)(x) = f(g(x))$.
We know $g(x) = 3x + 4$, so we must find $f(3x + 4)$.
$f(3x + 4)$

$= (3x + 4)^2 - 1$	Replace x with $(3x + 4)$ in f.
$= 9x^2 + 24x + 16 - 1$	$(3x + 4)^2 = (3x)^2 + 2(3x)(4) + (4)^2$.
$= 9x^2 + 24x + 15$	Add similar terms.

$g \circ f = (g \circ f)(x) = g(f(x))$
We know $f(x) = x^2 - 1$, so we must find $g(x^2 - 1)$.
$g(x^2 - 1)$

$= 3(x^2 - 1) + 4$	Replace x with $(x^2 - 1)$ in g.
$= 3x^2 - 3 + 4$	Multiply.
$= 3x^2 + 1$	Add similar terms.

2.2 REVIEW OF THE TRIGONOMETRIC FUNCTIONS

The trigonometry topics in this section are presented as a review. The formulas and definitions are those that you will use in the remainder of this text. The trigonometric functions are usually defined using either a right triangle or a point on the terminal side of an angle. Both definitions are presented in this section.

DEFINITIONS OF THE TRIGONOMETRIC FUNCTIONS

Given a right triangle with side lengths labeled as shown,

$$\sin\theta = \frac{\text{opposite}}{\text{hypotenuse}} \qquad\qquad \csc\theta = \frac{\text{hypotenuse}}{\text{opposite}}$$

$$\cos\theta = \frac{\text{adjacent}}{\text{hypotenuse}} \qquad\qquad \sec\theta = \frac{\text{hypotenuse}}{\text{adjacent}}$$

$$\tan\theta = \frac{\text{opposite}}{\text{adjacent}} \qquad\qquad \cot\theta = \frac{\text{adjacent}}{\text{opposite}}$$

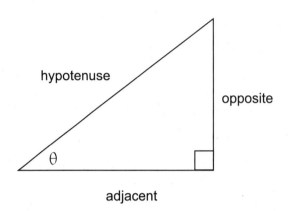

Given a point (x, y) on the terminal side of an angle θ where $r = \sqrt{x^2 + y^2}$,

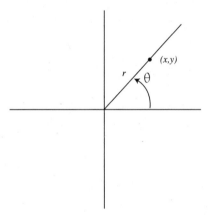

$$\sin\theta = \frac{y}{r} \qquad\qquad \csc\theta = \frac{r}{y}$$

$$\cos\theta = \frac{x}{r} \qquad\qquad \sec\theta = \frac{r}{x}$$

$$\tan\theta = \frac{y}{x} \qquad\qquad \cot\theta = \frac{x}{y}$$

FUNDAMENTAL IDENTITIES

The fundamental identities can be derived from the definitions just stated. The **fundamental identities** include reciprocal identities, quotient identities, Pythagorean identities, and a few various other identities and formulas.

Reciprocal Identities

$$\sin\theta = \frac{1}{\csc\theta} \qquad \csc\theta = \frac{1}{\sin\theta}$$

$$\cos\theta = \frac{1}{\sec\theta} \qquad \sec\theta = \frac{1}{\cos\theta}$$

$$\tan\theta = \frac{1}{\cot\theta} \qquad \cot\theta = \frac{1}{\tan\theta}$$

Quotient Identities

$$\tan\theta = \frac{\sin\theta}{\cos\theta} \qquad \cot\theta = \frac{\cos\theta}{\sin\theta}$$

Pythagorean Identities

$$\sin^2\theta + \cos^2\theta = 1$$

$$1 + \tan^2\theta = \sec^2\theta$$

$$1 + \cot^2\theta = \csc^2\theta$$

Miscellaneous Other Identities

The following identities will also be useful in this course.

Negative angles:

$$\sin(-\theta) = -\sin\theta$$

$$\cos(-\theta) = -\cos\theta$$

$$\tan(-\theta) = -\tan\theta$$

Sum or difference of two angles:

$$\sin(a \pm b) = \sin a \cos b \pm \cos a \sin b$$

$$\cos(a \pm b) = \cos a \cos b \mp \sin a \sin b$$

$$\tan(a \pm b) = \frac{\tan a \pm \tan b}{1 \mp \tan a \tan b}$$

Double-angle formulas:

$$\sin 2\theta = 2\sin\theta\cos\theta$$

$$\cos 2\theta = 2\cos^2\theta - 1 = 1 - 2\sin^2\theta = \cos^2\theta - \sin^2\theta$$

Half-angle formulas:

$$\sin\frac{\theta}{2} = \pm\sqrt{\frac{1-\cos\theta}{2}}$$

$$\cos\frac{\theta}{2} = \pm\sqrt{\frac{1+\cos\theta}{2}}$$

$$\tan\frac{\theta}{2} = \pm\sqrt{\frac{1-\cos\theta}{1+\cos\theta}}$$

SPECIAL ANGLES

You should also memorize the trigonometric function values of the **special angles,** $\pi/6$ or 30°, $\pi/4$ or 45°, $\pi/3$ or 60°.

	$\frac{\pi}{6}$ or 30°	$\frac{\pi}{4}$ or 45°	$\frac{\pi}{3}$ or 60°
sin	$\frac{1}{2}$	$\frac{\sqrt{2}}{2}$	$\frac{\sqrt{3}}{2}$
cos	$\frac{\sqrt{3}}{2}$	$\frac{\sqrt{2}}{2}$	$\frac{1}{2}$
tan	$\frac{\sqrt{3}}{3}$	1	$\sqrt{3}$

Two quick sketches will help you remember the values of the trigonometric functions at these special angles.

- For 30° and 60°, draw an equilateral triangle measuring 2 units on each side. Draw in the altitude to form a 30°, 60°, 90° triangle as shown:

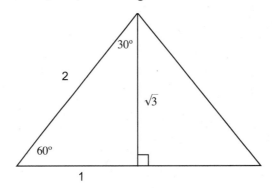

- For 45°, draw a square measuring 1 unit on each side. Draw in a diagonal to form a 45°, 45°, 90° triangle as shown:

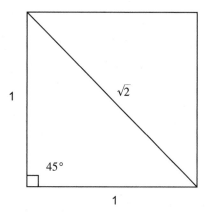

The **hypotenuse** (the side opposite the right angle) has been found in each case by using the Pythagorean theorem ($c^2 = a^2 + b^2$).

QUADRANTAL ANGLES

Using a **unit circle** (a circle with radius 1) and the trigonometric function definitions for a point on the terminal side of any angle, trigonometric functions for quadrantal angles can be quickly derived. Memorization is best, but use the following as an aid.

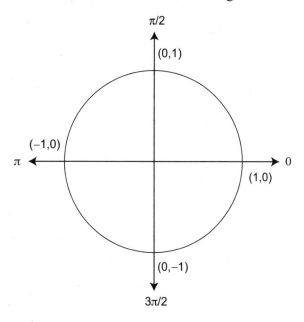

For example, $\sin \dfrac{\pi}{2} = \dfrac{y}{r} = \dfrac{1}{1} = 1$, $\cos \pi = \dfrac{x}{r} = \dfrac{-1}{1} = -1$, $\tan \dfrac{\pi}{2} = \dfrac{y}{x} = \dfrac{1}{0} =$ undefined (usually shown as error on the calculator screen).

REFERENCE ANGLES

You can find the values of the trigonometric functions for angles in quadrants other than quadrant I using reference angles and a sign chart. The reference angle for an angle θ is the positive acute angle measured from the terminal side of θ to the x-axis. Study the following chart.

For $0 < \theta < 2\pi$, locate the terminal side of θ in a quadrant. Then the reference angle θ_{ref} equals:

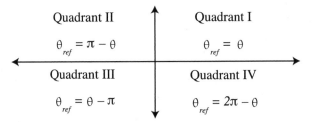

To find the appropriate sign of each function, use the following chart. The indicated functions and their reciprocals are positive, and the other functions are negative. Many students remember this chart by remembering "<u>A</u>ll <u>S</u>tudents <u>T</u>ake <u>C</u>alculus."

$$
\begin{array}{c|c}
\text{Sin +} & \text{All +} \\
\hline
\text{Tan +} & \text{Cos +}
\end{array}
$$

RADIANS AND DEGREES

Angles are generally measured using radians in Calculus. To convert from radians to degrees or degrees to radians use the following conversion factors.

- To convert degrees to radians, multiply by $\dfrac{\pi}{180°}$

- To convert radians to degrees, multiply by $\dfrac{180°}{\pi}$

When using a calculator, remember that the calculator must be in the appropriate mode, either radian or degree. If no degree symbol is shown, radian mode is implied. Thus, sin 2 means the sine of 2 radians.

Example 2.11

Express each angle in radian measure as a multiple of π.

a) $210°$

b) $315°$

Solution 2.11

a) $210° = 210° \cdot \dfrac{\pi}{180°}$ Multiply by $\dfrac{\pi}{180°}$.

$\quad = \dfrac{7}{6}\pi$ or $\dfrac{7\pi}{6}$ Reduce $\dfrac{210}{180} = \dfrac{7}{6}$.

b) $315° = 315° \cdot \dfrac{\pi}{180°}$ Multiply by $\dfrac{\pi}{180°}$.

$\quad = \dfrac{7}{4}\pi$ or $\dfrac{7\pi}{4}$ Reduce $\dfrac{315}{180} = \dfrac{7}{4}$.

Example 2.12

Express each angle in degrees.

a) $\dfrac{\pi}{2}$

b) $-\dfrac{2}{3}\pi$

Solution 2.12

a) $\dfrac{3}{2}\pi = \dfrac{3\pi}{2} \cdot \dfrac{180°}{\pi}$ Multiply by $\dfrac{180°}{\pi}$.

$\quad = 270°$ $\dfrac{3}{2} \cdot 180 = 270°$.

b) $-\dfrac{2}{3}\pi = -\dfrac{2\pi}{3} \cdot \dfrac{180°}{\pi}$ Multiply by $\dfrac{180°}{\pi}$.

$\quad = -120°$ $-\dfrac{2}{3} \cdot 180 = -120°$

SOLVING TRIGONOMETRIC EQUATIONS

Although some trigonometric equations can be solved using values you have memorized, others may need to be simplified first.

- To solve a trigonometric equation where the trigonometric function is raised to the first-degree, isolate the trigonometric function. Use memorized values to find answers in correct quadrants, if possible. Otherwise, use the inverse function keys on a scientific calculator to find the reference angle.
- To solve a trigonometric equation where there is one trigonometric function raised to the second degree, use quadratic equation rules depending on the form.

For example, $x^2 - a = 0$. First, isolate x^2, take the square root of both sides, using \pm on one side of the equation. If $x^2 + bx + c = 0$, factor, if possible. Set each factor equal to 0 and solve. If it is not factorable, use the quadratic formula.

- If the equation has more than one trigonometric function, get 0 on one side of the equation, and then factor, if possible. Set each factor equal to 0 and solve. Use identities to simplify to one trigonometric function and follow the preceding rules.

Example 2.13

Solve each equation for $\theta, 0 \le \theta < 2\pi$.

a) $2\cos\theta + 1 = 0$

b) $4\sin^2\theta - 1 = 0$

c) $\sin^2\theta + \cos\theta = 1$

d) $\tan\theta\cos\theta = \cos\theta$

e) $2\sin^2\theta - 5\sin\theta - 3 = 0$

Solution 2.13

a) $2\cos\theta = -1$ Isolate the trigonometric function.

$\cos\theta = -\dfrac{1}{2}$ Divide both sides by 2.

The reference angle is $\pi/3$, because $\cos\dfrac{\pi}{3} = \dfrac{1}{2}$. The cosine is negative in quadrants II and III.

In quadrant II, $\pi - \dfrac{\pi}{3} = \dfrac{3\pi}{3} - \dfrac{\pi}{3} = \dfrac{2\pi}{3}$

In quadrant III, $\dfrac{\pi}{3} + \pi = \dfrac{\pi}{3} + \dfrac{3\pi}{3} = \dfrac{4\pi}{3}$

$\theta = \dfrac{2\pi}{3}, \dfrac{4\pi}{3}$

b) $4\sin^2\theta - 1 = 0$ This is a quadratic equation.

$(2\sin\theta - 1)(2\sin\theta + 1) = 0$ Factor.

$2\sin\theta - 1 = 0$ or $2\sin\theta + 1 = 0$ Set each factor equal to 0.

$\sin\theta = \dfrac{1}{2}$ or $\sin\theta = -\dfrac{1}{2}$ Solve each equation.

Referring to the special angles, the reference angle is $\dfrac{\pi}{6}$ (or 30°), because $\sin\dfrac{\pi}{6} = \dfrac{1}{2}$.

$\sin\theta = \dfrac{1}{2}$ if θ is in quadrant I or II.

In quadrant II: $\pi - \dfrac{\pi}{6} = \dfrac{6\pi}{6} - \dfrac{1\pi}{6} = \dfrac{5\pi}{6}$.

$\sin\theta = -\dfrac{1}{2}$ if θ is in quadrant III or IV.

In quadrant III: $\pi + \dfrac{\pi}{6} = \dfrac{6\pi}{6} + \dfrac{1\pi}{6} = \dfrac{7\pi}{6}$.

In quadrant IV: $2\pi - \dfrac{\pi}{6} = \dfrac{12\pi}{6} - \dfrac{1\pi}{6} = \dfrac{11\pi}{6}$.

So $\theta = \dfrac{\pi}{6}, \dfrac{5\pi}{6}, \dfrac{7\pi}{6}$ or $\dfrac{11\pi}{6}$.

c) $\sin^2\theta + \cos\theta = 1$ — Use rules for more than one trigonometric function.

$1 - \cos^2\theta + \cos\theta - 1 = 0$ — Use the Pythagorean identity $\sin^2\theta = 1 - \cos^2\theta$ to replace $\sin^2\theta$.

$-\cos^2\theta + \cos\theta = 0$ — Add similar terms.

$-\cos\theta(\cos\theta - 1) = 0$ — Factor.

$-\cos\theta = 0$ or $\cos\theta - 1 = 0$ — Set each factor equal to 0.

$\cos\theta = 0$ or $\cos\theta = 1$ — Solve each equation.

$\theta = \dfrac{\pi}{2}$ or $\dfrac{3\pi}{2}$ or $\theta = 0$ — Note that $\theta \neq 2\pi$ because $0 \leq \theta < 2\pi$.

So $\theta = \dfrac{\pi}{2}, \dfrac{3\pi}{2}$ or 0.

d) $\tan\theta\cos\theta = \cos\theta$

$\tan\theta\cos\theta - \cos\theta = 0$ — Get 0 on one side.

$\cos\theta(\tan\theta - 1) = 0$ — Factor.

$\cos\theta = 0$ or $\tan\theta - 1 = 0$ — Set each factor equal to 0.

$\cos\theta = 0$ or $\tan\theta = 1$ — Solve each equation.

$\cos\theta = 0$ when $\theta = \dfrac{\pi}{2}$ or $\dfrac{3\pi}{2}$.

$\tan\theta = 1$ means the reference angle is $\dfrac{\pi}{4}$, because $\tan\dfrac{\pi}{4} = 1$.

The tangent is positive in quadrants I and III.

In quadrant III, $\pi + \dfrac{\pi}{4} = \dfrac{4\pi}{4} + \dfrac{1\pi}{4} = \dfrac{5\pi}{4}$.

So $\theta = \dfrac{\pi}{2}, \dfrac{3\pi}{2}, \dfrac{\pi}{4}$, or $\dfrac{5\pi}{4}$.

e) $2\sin^2\theta - 5\sin\theta - 3 = 0$ This is a quadratic equation that factors.

$(2\sin\theta + 1)(\sin\theta - 3) = 0$ Factor.

$2\sin\theta + 1 = 0$ or $\sin\theta - 3 = 0$ Set each factor equal to 0.

$\sin\theta = -\dfrac{1}{2}$ or $\sin\theta = 3$ Solve each equation.

$\sin\theta = -\dfrac{1}{2}$ means the reference angle is $\dfrac{\pi}{6}$. The sine is negative in quadrants III and IV.

In quadrant III, $\pi + \dfrac{\pi}{6} = \dfrac{6\pi}{6} + \dfrac{\pi}{6} = \dfrac{7\pi}{6}$.

In quadrant IV, $2\pi - \dfrac{\pi}{6} = \dfrac{12\pi}{6} - \dfrac{\pi}{6} = \dfrac{11\pi}{6}$.

Because the sine cannot be greater than 1, $\sin\theta = 3$ has no solutions. Therefore, $\theta = \dfrac{7\pi}{6}, \dfrac{11\pi}{6}$.

2.3 LIMITS AND LIMIT PROOFS

When you look at a graph of $f(x) = x^2$, you observe that the point (2, 4) is on the graph. If you remove this point, leaving a small hole in the graph, you can use the concept of a **limit** to describe the fact that the y value gets close to 4 as the x value gets close to 2. Using limits, we say,

$$\lim_{x \to 2} x^2 = 4$$

 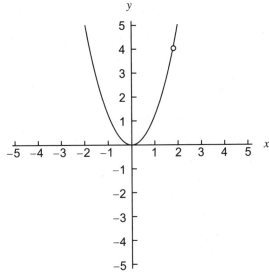

THE $\varepsilon - \delta$ DEFINITION OF A LIMIT

The $\varepsilon - \delta$ **(epsilon-delta) definition** of a limit can be used to prove that a y value approaches or gets sufficiently close to some number L when the x value approaches or gets sufficiently close to some number c.

DEFINITION OF A LIMIT

The statement $\lim\limits_{x \to c} f(x) = L$ means that for each $\varepsilon > 0$ there exists a $\delta > 0$ such that if $0 < |x - c| < \delta$, then $|f(x) - L| < \varepsilon$.

Because this definition is in the if-then form, we must start with the "if" statement and end at the "then" statement. However, it's often easier to work on scratch paper with $|f(x) - L| < \varepsilon$ and find the necessary relationship between ε and δ.

Example 2.14

Use the $\varepsilon - \delta$ definition to prove $\lim\limits_{x \to 4} (3x - 2) = 10$.

Solution 2.14

Begin by writing the $\varepsilon - \delta$ definition with $f(x) = 3x - 2$, $c = 4$ and $L = 10$:

If $0 < |x - 4| < \delta$, then $|(3x - 2) - 10| < \varepsilon$.

On scratch paper:

$	(3x - 2) - 10	< \varepsilon$	Work on $	f(x) - L	< \varepsilon$.						
$	3x - 12	< \varepsilon$	Simplify.								
$	3(x - 4)	< \varepsilon$	Factor.								
$	3		x - 4	< \varepsilon$	Use $	ab	=	a	\cdot	b	$.
$	x - 4	< \dfrac{\varepsilon}{3}$	$	3	= 3$. Divide both sides by 3.						

The proof:

Let $\delta = \dfrac{\varepsilon}{3}$									
$	x - 4	< \delta$	Begin with the "if" statement.						
$	x - 4	< \dfrac{\varepsilon}{3}$	Replace δ with $\dfrac{\varepsilon}{3}$.						
$	3		x - 4	< \varepsilon$	Multiply both sides by 3.				
$	3		x - 4	< \varepsilon$	$3 =	3	$.		
$	3(x - 4)	< \varepsilon$	Use $	a	\cdot	b	=	ab	$.
$	3x - 12	< \varepsilon$	Use the distributive property.						
$	(3x - 2) - 10	< \varepsilon$	Write -12 as $-2 -10$.						

Example 2.15

Use the $\varepsilon - \delta$ definition to prove that $\lim\limits_{x \to 2} (x^2 - 3x + 1) = -1$.

Solution 2.15

Write the $\varepsilon - \delta$ definition with $f(x) = x^2 - 3x + 1$, $c = 2$, and $L = -1$:

If $0 < |x - 2| < \delta$ then $|(x^2 - 3x + 1) - (-1)| < \varepsilon$.

On scratch paper:

$	(x^2 - 3x + 1) - (-1)	< \varepsilon$	Work on $	f(x) - L	< \varepsilon$.						
$	x^2 - 3x + 2	< \varepsilon$	Simplify.								
$	(x - 2)(x - 1)	< \varepsilon$	Factor.								
$	x - 2		x - 1	< \varepsilon$	Use $	ab	=	a	\cdot	b	$.

We know we can make $|x - 2|$ as small as we wish, for example let $\delta \leq 1$.

Then

$	x - 2	< 1$	$	x - 2	< \delta$.
$-1 < x - 2 < 1$	Use $	x	< a \Leftrightarrow -a < x < a$.		
$1 < x < 3$	Add 2.				
$1 - 1 < x - 1 < 3 - 1$	Subtract 1.				
$0 < x - 1 < 2$	Simplify.				
$	x - 1	< 2$			

Because $|x - 2| < \delta$ and $|x - 1| < 2$, if we require $\delta < \dfrac{\varepsilon}{2}$, then

$$|x - 2||x - 1| < \varepsilon.$$

The proof:

Let δ be the minimum of $\dfrac{\varepsilon}{2}$ and 1.

$	x - 2	< \delta$	Begin with the "if" statement.								
$	x - 2		x - 1	< \delta	x - 1	$	Multiply by $	x - 1	$.		
$	(x - 2)(x - 1)	< \delta	x - 1	$	Use $	a		b	=	ab	$.
$	x^2 - 3x + 2	< \delta	x - 1	< \dfrac{\varepsilon}{2}(2)$	Use $\delta = \dfrac{\varepsilon}{2}$ and the fact that $	x - 1	< 2$.				
$	x^2 - 3x + 2	< \varepsilon$									
$	(x^2 - 3x + 1) - (-1)	< \varepsilon$	Write $2 = 1 - (-1)$.								

2.4 EVALUATING LIMITS

Using the $\varepsilon-\delta$ definition to prove that a limit exists can be tedious (to say the least). Fortunately, there are many theorems that allow you to simplify the process of evaluating a limit. These theorems can be found in any standard text and are summarized by the following guidelines:

To evaluate $\lim\limits_{x\to c} f(x)$

1. Substitute c for x in $f(x)$.

2. If the resulting answer exists, that answer is the limit.

3. If the substitution results in a division by 0, use algebraic techniques to produce an equivalent function that can be evaluated by substitution.

Example 2.16

Find each limit.

a) $\lim\limits_{x\to 3} (2x^2 + 1)$

b) $\lim\limits_{x\to -1} \dfrac{x-2}{x+3}$

c) $\lim\limits_{x\to -\frac{\pi}{2}} \sin 2x$

Solution 2.16

a) $\lim\limits_{x\to 3} (2x^2 + 1) = 2\,(3)^2 + 1$ Substitute 3 for x.

 $= 2\,(9) + 1$ Simplify exponents.

 $= 19$ Multiply, and then add.

b) $\lim\limits_{x\to -1} \dfrac{x-2}{x+3} = \dfrac{(-1)-2}{(-1)+3}$ Substitute -1 for x.

 $= -\dfrac{3}{2}$ Simplify.

c) $\lim\limits_{x\to -\frac{\pi}{2}} \sin 2x = \sin 2(-\dfrac{\pi}{2})$ Substitute $-\pi/2$ for x.

 $= \sin (-\pi)$ Simplify.

 $= 0$

Example 2.17

Find each limit.

a) $\lim\limits_{x\to 2} \dfrac{x^2-4}{x-2}$

b) $\lim\limits_{x\to 0} \dfrac{\sqrt{x+9}-3}{x}$

c) $\lim\limits_{x \to 5} \dfrac{2x^2 - 9x - 5}{x^2 - x - 20}$

d) $\lim\limits_{x \to 1/2} \dfrac{8x^3 - 1}{2x - 1}$

e) $\lim\limits_{x \to 3} \dfrac{\dfrac{1}{x} - \dfrac{1}{3}}{x - 3}$

Solution 2.17

a) $\lim\limits_{x \to 2} \dfrac{x^2 - 4}{x - 2} = \dfrac{(2)^2 - 4}{(2) - 2}$ 　　　Substitute 2 for x.

$= \dfrac{0}{0}$ 　　　Division by 0 is not defined.

Substitution resulted in division by 0. Use algebraic techniques, in this case factoring.

$\lim\limits_{x \to 2} \dfrac{x^2 - 4}{x - 2} = \lim\limits_{x \to 2} \dfrac{(x - 2)(x + 2)}{x - 2}$ 　　Factor.

$= \lim\limits_{x \to 2} (x + 2)$ 　　　$\dfrac{x - 2}{x - 2} = 1$ when $x \neq 2$.

$= (2) + 2$ 　　　Substitute 2 for x.

$= 4$

b) $\lim\limits_{x \to 0} \dfrac{\sqrt{x + 9} - 3}{x}$

Substituting 0 for x will result in division by 0. Use algebraic techniques.

$\lim\limits_{x \to 0} \dfrac{\sqrt{x + 9} - 3}{x} \cdot \dfrac{\sqrt{x + 9} + 3}{\sqrt{x + 9} + 3}$ 　　Multiply by the conjugate of the numerator.

$= \lim\limits_{x \to 0} \dfrac{x + 9 - 9}{x(\sqrt{x + 9} + 3)}$ 　　Multiply the numerators. Leave the denominator in factored form.

$= \lim\limits_{x \to 0} \dfrac{x}{x(\sqrt{x + 9} + 3)}$ 　　Simplify the numerator.

$= \lim\limits_{x \to 0} \dfrac{1}{1(\sqrt{x + 9} + 3)}$ 　　Reduce. $x/x = 1$, $x \neq 0$.

$= \dfrac{1}{\sqrt{(0) + 9} + 3}$ 　　Substitute 0 for x.

$= \dfrac{1}{\sqrt{9} + 3} = \dfrac{1}{6}$ 　　Simplify the denominator.

c) $\lim\limits_{x\to5}\dfrac{2x^2-9x-5}{x^2-x-20}=\dfrac{0}{0}$ Substitute 5 for x.

Division by 0 is not defined. Use algebraic techniques.

$\lim\limits_{x\to5}\dfrac{(2x+1)(x-5)}{(x+4)(x-5)}$ Factor each trinomial. (See Chapter 1.)

$=\lim\limits_{x\to5}\dfrac{2x+1}{x+4}$ $\dfrac{x-5}{x-5}=1$ when $x\ne5$.

$=\dfrac{2(5)+1}{5+4}=\dfrac{11}{9}$ Substitute 5 for x.

d) $\lim\limits_{x\to1/2}\dfrac{8x^3-1}{2x-1}=\dfrac{0}{0}$ Substitute 1/2 for x.

Division by 0 is not defined. Use algebraic techniques.

$\lim\limits_{x\to1/2}\dfrac{(2x-1)(4x^2+2x+1)}{2x-1}$ Factor the difference of two cubes.

$=\lim\limits_{x\to1/2}(4x^2+2x+1)$ $\dfrac{2x-1}{2x-1}=1$ when $x\ne1/2$.

$=4\left(\dfrac{1}{2}\right)^2+2\left(\dfrac{1}{2}\right)+1$ Substitute 1/2 for x.

$=1+1+1=3$ Simplify.

e) $\lim\limits_{x\to3}\dfrac{\frac{1}{x}-\frac{1}{3}}{x-3}=\dfrac{0}{0}$ Substitute 3 for x.

Division by 0 is not defined. Use algebraic techniques.

$\lim\limits_{x\to3}\dfrac{\frac{3}{3}\cdot\frac{1}{x}-\frac{x}{x}\cdot\frac{1}{3}}{x-3}$ Use $3x$ as the LCD in the numerator.

$=\lim\limits_{x\to3}\dfrac{\frac{3-x}{3x}}{x-3}$ Subtract fractions in the numerator.

$=\lim\limits_{x\to3}\dfrac{3-x}{3x}\cdot\dfrac{1}{x-3}$ Invert and multiply.

$=\lim\limits_{x\to3}\left(-\dfrac{1}{3x}\right)$ Reduce: $\dfrac{3-x}{x-3}=\dfrac{-1(x-3)}{x-3}=-1$.

$=-\dfrac{1}{3(3)}=-\dfrac{1}{9}$ Substitute 3 for x.

TRIGONOMETRIC LIMITS

Some trigonometric functions can be evaluated by direct substitution (see Example 2.16c). Others may require the use of the fundamental trigonometric identities (see Section 2.2) or the use of the following **special limits.**

$$\lim_{x \to 0} \frac{\sin x}{x} = 1 \qquad\qquad \lim_{x \to 0} \frac{1 - \cos x}{x} = 0$$

Note that direct substitution in each of these two limit statements results in division by 0. The proofs of these limit statements can be found in most textbooks. These statements should be memorized.

Example 2.18

Find each limit.

a) $\displaystyle \lim_{x \to \pi} \frac{\sin x}{\cos x}$

b) $\displaystyle \lim_{x \to \frac{\pi}{2}} \frac{\cot x}{\cos x}$

c) $\displaystyle \lim_{x \to 0} \frac{\sin 5x}{x}$

d) $\displaystyle \lim_{x \to 0} \frac{1 - \cos^2 x}{x}$

Solution 2.18

a) $\displaystyle \lim_{x \to \pi} \frac{\sin x}{\cos x} = \frac{\sin \pi}{\cos \pi}$ Substitute π for x.

$\displaystyle = \frac{0}{-1}$ Evaluate.

$= 0$ Simplify.

b) $\displaystyle \lim_{x \to \frac{\pi}{2}} \frac{\cot x}{\cos x} = \frac{\cot(\dfrac{\pi}{2})}{\cos(\dfrac{\pi}{2})}$ Substitute $\pi/2$ for x.

$\displaystyle = \frac{0}{0}$ Division by 0 is not defined.

Substitution resulted in division by 0. Use the fundamental trigonometric identities.

$\displaystyle \lim_{x \to \frac{\pi}{2}} \frac{\cot x}{\cos x} = \lim_{x \to \frac{\pi}{2}} \frac{\dfrac{\cos x}{\sin x}}{\dfrac{\cos x}{1}}$ Write $\cot x = \dfrac{\cos x}{\sin x}$.

$\displaystyle = \lim_{x \to \frac{\pi}{2}} \frac{\cos x}{\sin x} \cdot \frac{1}{\cos x}$ Invert and multiply.

$$= \lim_{x \to \frac{\pi}{2}} \frac{1}{\sin x} \qquad \frac{\cos x}{\cos x} = 1 \text{ when } x \neq \pi/2.$$

$$= \frac{1}{\sin\left(\dfrac{\pi}{2}\right)} \qquad \text{Substitute } \pi/2 \text{ for } x.$$

$$= \frac{1}{1} = 1 \qquad \text{Simplify.}$$

c) $\displaystyle\lim_{x \to 0} \frac{\sin 5x}{x}$

Substituting 0 for x will result in division by 0. We'll use $\displaystyle\lim_{x \to 0} \frac{\sin x}{x}$.

$$= \lim_{x \to 0} \frac{5}{5} \cdot \frac{\sin 5x}{x} \qquad \text{Multiply by a form of 1.}$$

$$= \lim_{x \to 0} \frac{5 \sin 5x}{5x} \qquad \text{Multiply the numerators and denominators.}$$

$$= 5 \lim_{x \to 0} \frac{\sin 5x}{5x} \qquad \text{Factor out the 5.}$$

$$= 5(1) \qquad \lim_{x \to 0} \frac{\sin 5x}{5x} = 1$$

$$= 5$$

Note that as $x \to 0, 5x \to 0$, so the limit theorem applies.

d) $\displaystyle\lim_{x \to 0} \frac{1 - \cos^2 x}{x}$

Substituting 0 for x will result in division by 0. We'll use

$$\lim_{x \to 0} \frac{1 - \cos x}{x} = 0.$$

$$= \lim_{x \to 0} \frac{(1 - \cos x)(1 + \cos x)}{x} \qquad \text{Factor the difference of two squares.}$$

$$= \lim_{x \to 0} \left(\frac{1 - \cos x}{x}\right)(1 + \cos x) \qquad \text{Write } \frac{ab}{c} = \frac{a}{c} \cdot b.$$

$$= 0(1 + \cos 0) \qquad \text{Use } \lim_{x \to 0} \frac{1 - \cos x}{x} = 0.$$

$$= 0(2) \qquad \text{Substitute 0 for } x.$$
$$= 0 \qquad \text{Simplify.}$$

This trigonometric limit can be solved using the following:

$$\lim_{x \to 0} \frac{1 - \cos^2 x}{x} = \lim_{x \to 0} \frac{\sin^2 x}{x} = \lim_{x \to 0} \frac{\sin x}{x} \cdot \sin x = 1 \cdot \sin 0 = 1 \cdot 0 = 0, \text{ using a Pythagorean}$$

Identity $(1 - \cos^2 x = \sin^2 x)$ and the theorem $\displaystyle\lim_{x \to 0} \frac{\sin x}{x} = 1$.

2.5 ONE-SIDED LIMITS

A graphing interpretation of $\displaystyle\lim_{x \to c} f(x) = L$ means that the function $f(x)$ approaches a y-value of L as x approaches c from both the left side and right side. If we wish to restrict our view to one side of x, we use the following.

Notation	**Meaning**
$\displaystyle\lim_{x \to c^+} f(x) = M$	As x approaches c *from the right*, $f(x)$ approaches M.
$\displaystyle\lim_{x \to c^-} f(x) = N$	As x approaches c *from the left*, $f(x)$ approaches N.

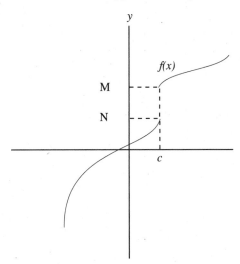

Note that $f(c)$ could equal M, or $f(c)$ could equal N (one closed dot), or both could be open dots—and the limit statements above would still hold true.

Example 2.19

Find each limit for the function f.

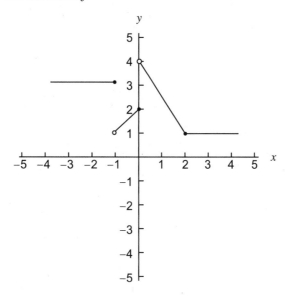

a) $\lim\limits_{x \to 0^+} f(x)$

b) $\lim\limits_{x \to 0^-} f(x)$

c) $\lim\limits_{x \to 2^-} f(x)$

d) $\lim\limits_{x \to -1^+} f(x)$

e) $\lim\limits_{x \to -1^-} f(x)$

Solution 2.19

a) $\lim\limits_{x \to 0^+} f(x) = 4$, because the y value approaches 4 as the x value approaches 0 from the right.

b) $\lim\limits_{x \to 0^-} f(x) = 2$, because the y value approaches 2 as the x value approaches 0 from the left.

c) $\lim\limits_{x \to 2^-} f(x) = 1$, because the y value approaches 1 as the x value approaches 2 from the left.

d) $\lim\limits_{x \to -1^+} f(x) = 1$, because the y value approaches 1 as the x value approaches -1 from the right.

e) $\lim\limits_{x \to -1^-} f(x) = 3$, because the y value approaches 3 as the x value approaches -1 from the left.

EVALUATING ONE-SIDED LIMITS

Recall the basic rules for evaluating limits: substitute whenever possible and use algebra otherwise. Those same principles apply to **one-sided limits.** Care must be taken not to substitute automatically. Study Example 2.20e carefully.

Example 2.20

Find each limit.

a) $\lim\limits_{x \to 1^-} \left(x^2 - 4x + 1\right)$

b) $\lim\limits_{x \to 3^+} \dfrac{x^2 - 9}{x - 3}$

c) $\lim\limits_{x \to 2^+} \dfrac{|x - 2|}{x - 2}$

d) $\lim\limits_{x \to 2^-} \dfrac{|x - 2|}{x - 2}$

e) $\lim\limits_{x \to 4^-} \sqrt{x - 4}$

Solution 2.20

a) $\lim\limits_{x \to 1^-} \left(x^2 - 4x + 1\right)$

$= (1)^2 - 4(1) + 1$ Substitute 1 for x.

$= -2$ Simplify.

b) $\lim\limits_{x \to 3^+} \dfrac{x^2 - 9}{x - 3}$

Substituting 3 for x results in division by 0. Use algebra to factor and reduce:

$\lim\limits_{x \to 3^+} \dfrac{x^2 - 9}{x - 3} = \lim\limits_{x \to 3^+} \dfrac{(x - 3)(x + 3)}{x - 3}$ Factor.

$= \lim\limits_{x \to 3^+} (x + 3)$ $\dfrac{x - 3}{x - 3} = 1,\ x \neq 3.$

$= 3 + 3$ Substitute 3 for x.

$= 6$ Simplify.

c) $\lim\limits_{x \to 2^+} \dfrac{|x - 2|}{x - 2}$

Substituting 2 for x results in division by 0. Because the numerator does not factor, we reason as follows: As x approaches 2 from the right, $x - 2 > 0$. This implies that $|x - 2| = x - 2$, because the number in the absolute value bars is positive. Then,

$\lim\limits_{x \to 2^+} \dfrac{|x - 2|}{x - 2} = \lim\limits_{x \to 2^+} \dfrac{x - 2}{x - 2} = \lim\limits_{x \to 2^+} 1 = 1.$

The limit of a constant is that constant.

d) $\lim\limits_{x \to 2^-} \dfrac{|x-2|}{x-2}$

As x approaches 2 from the left, $x - 2 < 0$. This implies that $|x-2| = -(x-2)$. Then

$$\lim\limits_{x \to 2^-} \dfrac{|x-2|}{x-2} = \lim\limits_{x \to 2^-} \dfrac{-(x-2)}{x-2} = -1.$$

e) $\lim\limits_{x \to 4^-} \sqrt{x-4}$

Substituting 4 for x would lead to the *incorrect answer* 0. Consider the graph of $f(x) = \sqrt{x-4}$:

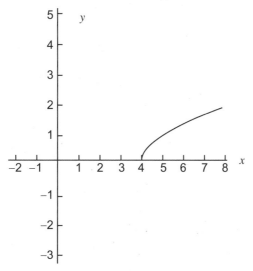

There is no graph as x approaches 4 from the left (the domain is $x \ge 4$). Therefore, $\lim\limits_{x \to 4^-} \sqrt{x-4}$ does not exist.

Note that $\lim\limits_{x \to c} f(x) = L$ means that both the limit from the left and the limit from the right as x approaches c must exist and be equal.

Example 2.21

Find $\lim\limits_{x \to 2} \dfrac{|x-2|}{x-2}$.

Solution 2.21

You found in Example 2.20 that $\lim\limits_{x \to 2^+} \dfrac{|x-2|}{x-2} = 1$ and $\lim\limits_{x \to 2^-} \dfrac{|x-2|}{x-2} = -1$. Because these limits are not equal, $\lim\limits_{x \to 2} \dfrac{|x-2|}{x-2}$ does not exist.

2.5 CONTINUITY

Continuity at $x = c$. A function is **continuous** when the graph can be drawn without breaks or holes. To link an algebraic meaning to this concept, you must meet three conditions for a function to be continuous at $x = c$:

1. The function must exist at $x = c$.
2. The limit as x approaches c must exist.
3. The function value and the limit value at $x = c$ must be equal.

Example 2.22

Determine whether the following functions are continuous at the given points.

a) $f(x) = x^2 + 3x - 1$ at $x = -1$

b) $f(x) = \dfrac{x^2 - 9}{x - 3}$ at $x = 3$

c) $f(x) = \begin{cases} x^2 - 1, & x \neq 1 \\ 3, & x = 1 \end{cases}$ at $x = 1$

Solution 2.22

a) $f(-1) = (-1)^2 + 3(-1) - 1 = -3$ Find $f(-1)$.

$$\lim_{x \to -1} \left(x^2 - 3x - 1 \right) = -3 \qquad \text{Find } \lim_{x \to -1} f(x).$$

Because $f(-1) = \lim_{x \to -1} f(x)$, the function is continuous at $x = -1$.

b) $f(3) = \dfrac{(3)^2 - 9}{(3) - 3} = \dfrac{0}{0}$ Find $f(3)$.

The function does not exist at $x = 3$ and, therefore, is not continuous at $x = 3$.

c) $f(1) = 3$ Find $f(1)$.

$$\lim_{x \to 1} \left(x^2 - 1 \right) = (1)^2 - 1 = 0 \qquad \text{Find } \lim_{x \to 1} f(x).$$

Because $f(1) \neq \lim_{x \to 1} f(x)$, the function is not continuous at $x = 1$.

CONTINUITY OF FUNCTIONS

Example 2.22 considered continuity at a specific x value. There are theorems that can help you decide where a function or combination of functions is continuous. Some results follow.

1. A polynomial function is continuous everywhere. For example, the following functions are continuous on $(-\infty, \infty)$:

$f(x) = 2x + 1$ linear function

$f(x) = x^2 + 4$ quadratic function

$f(x) = 4x^3 - 6x^2 + 2x + 3$ cubic function

2. A rational function is continuous everywhere except where the denominator equals 0. For example, $f(x) = \dfrac{3x-1}{x+5}$ is continuous everywhere except $x = -5$, written in interval notation as $(-\infty, -5) \cup (-5, \infty)$.

3. The sum, difference, or product of two continuous functions is continuous. For example, $f(x) = x + \sin x$ is continuous on $(-\infty, \infty)$, because it is the sum of two continuous functions.

4. The quotient of two continuous functions is continuous except where the denominator equals 0. Consider $f(x) = \dfrac{3x-1}{x+5}$ as a quotient of the two linear functions $g(x) = 3x - 1$ and $h(x) = x + 5$, and you see (as in Result 2, above) that the function is continuous on $(-\infty, -5) \cup (-5, \infty)$.

Example 2.23

At what values of x, if any, are the functions discontinuous?

a) $f(x) = x^3 - 1$

b) $f(x) = \dfrac{x-2}{x^2 - x - 12}$

c) $f(x) = \begin{cases} 2x, x < 0 \\ x^2, x \geq 0 \end{cases}$

d) $f(x) = \begin{cases} 2x, & x < 1 \\ 3x + 4, x \geq 1 \end{cases}$

e) $f(x) = 4x + 2 \tan x$

Solution 2.23

a) The function $f(x) = x^3 - 1$ has a domain of all real numbers. Thus, the function exists at all points. The limit at every point can be found by direct substitution without any resulting division by 0. Hence, the function has no discontinuities.

b) $f(x) = \dfrac{x-2}{x^2 - x - 12} = \dfrac{x-2}{(x-4)(x+3)}$ has a domain of all real number *except* 4 and –3. Because the function does not exist at these points, it has discontinuities at $x = 4$ and $x = -3$.

c) The two pieces of this function are continuous on their domains. To determine whether the pieces form a continuous function, consider the following graph:

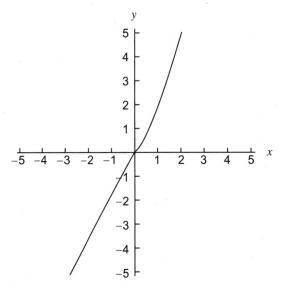

Check the x-value where the pieces are joined.

At $x = 0$

$$f(0) = 0^2 = 0$$

$$\lim_{x \to 0^+} f(x) = 0^2 = 0$$

$$\lim_{x \to 0^-} f(x) = 2(0) = 0$$

Because $f(0) = \lim_{x \to 0} f(x)$, the function is continuous at 0, and, hence, has no discontinuities.

d) Because $f(x) = 2x$ is continuous everywhere and $f(x) = 3x + 4$ is continuous everywhere, we need to check only $x = 1$.

$$f(1) = 3(1) + 4 = 7$$

$$\lim_{x \to 1^+} f(x) = 3(1) + 4 = 7$$

$$\lim_{x \to 1^-} f(x) = 2(1) = 2$$

Because the right-hand and left-hand limits are *not* equal, $\lim_{x \to 1} f(x)$ does not exist. Thus the function is discontinuous at $x = 1$.

e) $f(x) = 4x + 2 \tan x$

Because $f(x) = 4x$ is continuous everywhere, we need to check only $f(x) = 4 \tan x$. The tangent curve has asymptotes at . . . , $-\pi/2$, $\pi/2$, $3\pi/2$, Therefore, the graph will have discontinuities at $x = \dfrac{\pi}{2} + n\pi$, n an integer. The function formed from the sum of $4x + 2 \tan x$ will have the same discontinuities. Thus, the function is discontinuous at $x = \dfrac{\pi}{2} + n\pi$, n an integer.

TEST YOURSELF

1) Find the domain.
 a) $y = x^2 + 4$

 b) $y = \dfrac{x+1}{x^2 + 5x + 6}$

 c) $y = \sqrt{2x+1}$

 d) $y = \sqrt[3]{x-4}$

2) If $f(x) = \dfrac{x-3}{x+4}$, find

 a) $f(-2)$

 b) $f(0)$

 c) $f(x+h)$

3) If $g(x) = \dfrac{4}{x+1}$, find

 a) $g(3)$

 b) $g(-1)$

4) Sketch each graph making use of transformations.
 a) $f(x) = x^2 - 3$
 b) $f(x) = |x| + 2$
 c) $f(x) = -\sqrt{x-2}$
 d) $f(x) = -(x+1)^2 + 4$

5) If $f(x) = x^2 - 4x + 2$ and $g(x) = 2x + 1$, find
 a) $(f-g)(x)$
 b) $(fg)(x)$
 c) $(f \circ g)(x)$
 d) $(g \circ f)(x)$

6) If $f(x) = 3x - 5$ and $g(x) = \dfrac{x+5}{3}$, find
 a) $f \circ g$
 b) $g \circ f$

7) Convert each angle to radian measure.
 a) $135°$
 b) $330°$
 c) $210°$
 d) $270°$
 e) $315°$

8) Convert each angle to degree measure.
 a) $\dfrac{7\pi}{4}$

 b) $\dfrac{2\pi}{3}$

 c) $\dfrac{5\pi}{4}$

 d) $\dfrac{5\pi}{6}$

 e) $\dfrac{\pi}{2}$

9) Solve each equation for $0 \le \theta < 2\pi$. Round answer(s) to three decimal places.
 a) $2\sin\theta - \sqrt{2} = 0$

 b) $4\cos^2\theta - 1 = 0$

 c) $\sin\theta\cos\theta = \sin\theta$

 d) $\tan^2\theta - \sec\theta - 1 = 0$

 e) $2\cos^2\theta - 3\cos\theta - 1 = 0$

10) Use the $\varepsilon - \delta$ definition of limit to prove each of the following.
 a) $\lim\limits_{x \to 3}(4x - 2) = 10$

 b) $\lim\limits_{x \to -1}(6x - 1) = -7$

11) Evaluate each limit.

a) $\lim_{x \to 2} (x^2 - 6x)$

b) $\lim_{x \to 1} \sqrt{3x + 5}$

c) $\lim_{x \to \frac{\pi}{4}} \dfrac{\sin 2x}{\cos x}$

d) $\lim_{x \to 2} \dfrac{x - 2}{x + 6}$

12) Find each limit.

a) $\lim_{x \to 3} \dfrac{x^3 - 27}{x - 3}$

b) $\lim_{x \to -1} \dfrac{x^2 + 7x + 6}{x + 1}$

c) $\lim_{x \to 0} \dfrac{\dfrac{1}{x + 2} - \dfrac{1}{2}}{x}$

d) $\lim_{x \to -4} \dfrac{3x^2 + 10x - 8}{2x^2 + 15x + 28}$

e) $\lim_{x \to 0} \dfrac{\sqrt{x + 25} - 5}{x}$

f) $\lim_{x \to 2} \dfrac{x - 2}{x^4 - 16}$

13) Find each limit.

a) $\lim_{x \to 0} \dfrac{\sin 3x}{x}$

b) $\lim_{x \to 0} \dfrac{\sin 2x}{5x}$

c) $\lim_{x \to 0} \dfrac{\sin x - \sin x \cos x}{x^2}$

14) Find each limit.

a) $\lim_{x \to 1^+} \dfrac{6x - 1}{x + 2}$

b) $\lim_{x \to 3^+} \dfrac{x^2 - 6x + 9}{x - 3}$

c) $\lim_{x \to 2^-} \sqrt{2 - x}$

d) $\lim_{x \to 2^+} \sqrt{2 - x}$

e) $\lim_{x \to 2} \sqrt{2 - x}$

15) At what values of x, if any, are the functions discontinuous?

a) $f(x) = |x + 1|$

b) $f(x) = \dfrac{3x}{x^2 + 2x - 8}$

c) $f(x) = \begin{cases} -x, & x < 0 \\ 2x^2, & 0 \le x < 3 \\ 4, & x \ge 3 \end{cases}$

d) $f(x) = x^2 + 4 \sin x$

TEST YOURSELF ANSWERS

1)

 a) all real numbers

 b) all real numbers except –3 and –2

 c) $\left\{ x \mid x \geq -\dfrac{1}{2} \right\}$

 d) $(-\infty, \infty)$

2)

 a) –5/2

 b) –3/4

 c) $\dfrac{x+h-3}{x+h+4}$

3)

 a) 1

 b) not defined, cannot divide by 0

 c) $\dfrac{4}{x+h+1}$

4)

 a)

 b)

 c)

 d)

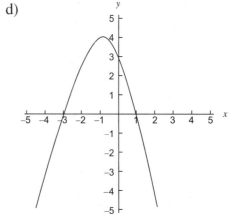

5)

 a) $x^2 - 6x + 1$

 b) $2x^3 - 7x^2 + 2$

 c) $4x^2 - 4x - 1$

 d) $2x^2 - 8x + 5$

6)

 a) x

 b) x

7)

 a) $\dfrac{3\pi}{4}$

 b) $\dfrac{11\pi}{6}$

 c) $\dfrac{7\pi}{6}$

 d) $\dfrac{3\pi}{2}$

 e) $\dfrac{7\pi}{4}$

8)

 a) $315°$

 b) $120°$

 c) $210°$

 d) $270°$

 e) $315°$

9)

 a) $\dfrac{\pi}{4}, \dfrac{3\pi}{4}$

 b) $\dfrac{\pi}{3}, \dfrac{2\pi}{3}, \dfrac{4\pi}{3}, \dfrac{5\pi}{3}$

 c) $0, \pi$

 d) $\dfrac{\pi}{3}, \pi, \dfrac{5\pi}{3}$

 e) $1.855, 4.428$

10)

 a) If $0 < |x-3| < \delta$ then

 $|(4x-2)-10| < \varepsilon$

 Let $\delta = \dfrac{\varepsilon}{4}$.

 $|x-3| < \delta \Rightarrow |x-3| < \dfrac{\varepsilon}{4}$

 $\Rightarrow 4|x-3| < \varepsilon$

 $\Rightarrow |4(x-3)| < \varepsilon$

 $\Rightarrow |(4x-2)-10| < \varepsilon$

 b) If $0 < |x+1| < \delta$ then

 $|(6x-1)+7| < \varepsilon$

 Let $\delta = \dfrac{\varepsilon}{6}$.

 $|x+1| < \delta \Rightarrow |x+1| < \dfrac{\varepsilon}{6}$

 $\Rightarrow 6|x+1| < \varepsilon$

 $\Rightarrow |6(x+1)| < \varepsilon$

 $\Rightarrow |(6x-1)+7| < \varepsilon$

11)

 a) -8

 b) $2\sqrt{2}$

 c) $\sqrt{2}$

 d) 0

12)

 a) 27

 b) 5

 c) $-1/4$

 d) 16

 e) 1/10

 f) 1/32

13)

 a) 3

 b) 2/5

 c) 0

14)

 a) 5/3

 b) 0

 c) does not exist

 d) 0

 e) does not exist

15)

 a) continuous everywhere

 b) discontinuous at $x = -4$ and $x = 2$

 c) discontinuous at $x = 3$

 d) continuous everywhere

Derivatives

This chapter introduces one of the building blocks of Calculus: derivatives. After a brief look at finding derivatives using the limit definition, we use shortcuts to find derivatives of a variety of functions, including the trigonometric functions.

3.1 TANGENT LINES AND RATES OF CHANGE

Although we can easily find the slope of a line if we know either the equation of the line (by putting the equation in $y = mx + b$ form) or if we know two points on the line (using $m = \dfrac{y_2 - y_1}{x_2 - x_1}$), we cannot easily find the slope of a line that is tangent to a given curve. The slope of such a line, called a **tangent line,** can be found using

$$m = \lim_{\Delta x \to 0} \frac{f(x + \Delta x) - f(x)}{\Delta x}$$

where the line is tangent to the curve $y = f(x)$ at the point $(x, f(x))$. To use this formula, follow these steps:

1. Find $f(x + \Delta x)$ by replacing x with $(x + \Delta x)$ in f.
2. Find $f(x)$.
3. Subtract and write the difference over Δx.
4. Find the limit as Δx approaches 0, using algebra to help evaluate the limit, as necessary.

FINDING THE SLOPE AT A SPECIFIC POINT

In Example 3.1, you find the slope of the tangent at a specific point. Remember to replace x with the given x-coordinate. Do *not* replace Δx until you're ready to evaluate the limit.

Example 3.1

Find the slope of the tangent to $f(x)$ at the given point.

 a) $f(x) = 4x - 6$ at $(1, -2)$

 b) $f(x) = x^2 - 3x$ at $(-1, 4)$

Solution 3.1

a) $f(1 + \Delta x) = 4(1 + \Delta x) - 6$ Find $f(1 + \Delta x)$.

$\qquad\qquad = 4 + 4\Delta x - 6$ Distribute.

$\qquad\qquad = 4\Delta x - 2$ Add similar terms.

$f(1) = 4(1) - 6$ Find $f(1)$.

$\qquad\quad = -2$ Simplify.

$$m = \lim_{\Delta x \to 0} \frac{4\Delta x - 2 - (-2)}{\Delta x}$$ Subtract and divide by Δx.

$$= \lim_{\Delta x \to 0} \frac{4\Delta x - 2 + 2}{\Delta x}$$ Find $\lim_{\Delta x \to 0}$.

$$= \lim_{\Delta x \to 0} \frac{4\Delta x}{\Delta x}$$ $\dfrac{\Delta x}{\Delta x} = 1, \Delta x \neq 0.$

$$= \lim_{x \to 0} 4 = 4$$

Thus the slope of the tangent to $f(x) = 4x - 6$ at the point $(1, -2)$ is 4.

b) $f(-1 + \Delta x) = (-1 + \Delta x)^2 - 3(-1 + \Delta x)$ Find $f(-1 + \Delta x)$.

$\qquad\qquad = (1 - 2\Delta x + (\Delta x)^2) + 3 - 3\Delta x$

$\qquad\qquad = -5\Delta x + (\Delta x)^2 + 4$ Simplify.

$f(-1) = (-1)^2 - 3(-1) = 4$ Find $f(-1)$.

$$m = \lim_{\Delta x \to 0} \frac{-5\Delta x + (\Delta x)^2 + 4 - (4)}{\Delta x}$$ Subtract and divide by Δx.

$$= \lim_{\Delta x \to 0} \frac{-5\Delta x + (\Delta x)^2}{\Delta x}$$ Add similar terms.

$$= \lim_{\Delta x \to 0} \frac{\Delta x(-5 + \Delta x)}{\Delta x}$$ Factor. $\dfrac{\Delta x}{\Delta x} = 1, \Delta x \neq 0.$

$$= \lim_{\Delta x \to 0} (-5 + \Delta x) = -5$$ Substitute 0 for Δx.

Thus the slope of the tangent to $f(x) = x^2 - 3x$ at the point $(-1, 4)$ is -5.

FINDING THE SLOPE IN GENERAL

If we need the slope of the tangent at several points on the curve $y = f(x)$, or if we want a formula for finding the slope anywhere, we do not replace x in the formula with a number.

Example 3.2

Find the slope of the tangent to $f(x)$.

a) $f(x) = 3x^2 - 2x + 1$

b) $f(x) = \dfrac{1}{x+1}$

c) $f(x) = \sqrt{x+2}$

Solution 3.2

a) $f(x + \Delta x) = 3(x + \Delta x)^2 - 2(x + \Delta x) + 1$ Find $f(x + \Delta x)$.

$\qquad\qquad = 3(x^2 + 2x\Delta x + (\Delta x)^2) - 2x - 2\Delta x + 1$ Simplify.

$\qquad\qquad = 3x^2 + 6x\Delta x + 3(\Delta x)^2 - 2x - 2\Delta x + 1$

$f(x) = 3x^2 - 2x + 1$ Find $f(x)$.

$$m = \lim_{\Delta x \to 0} \frac{3x^2 + 6x\Delta x + 3(\Delta x)^2 - 2x - 2\Delta x + 1 - (3x^2 - 2x + 1)}{\Delta x}$$

$$= \lim_{\Delta x \to 0} \frac{3x^2 + 6x\Delta x + 3(\Delta x)^2 - 2x - 2\Delta x + 1 - 3x^2 + 2x - 1}{\Delta x}$$

$$= \lim_{\Delta x \to 0} \frac{6x\Delta x + 3(\Delta x)^2 - 2\Delta x}{\Delta x}$$

$$= \lim_{\Delta x \to 0} \frac{\Delta x \left(6x + 3(\Delta x) - 2\right)}{\Delta x}$$ Factor.

$$= \lim_{\Delta x \to 0} \left(6x + 3\Delta x - 2\right)$$ $\dfrac{\Delta x}{\Delta x} = 1,\ \Delta x \neq 0$

$= 6x + 3(0) - 2$ Substitute 0 for Δx.

$= 6x - 2$ This is the slope of the tangent.

b) $f(x + \Delta x) = \dfrac{1}{(x + \Delta x) + 1}$ Find $f(x + \Delta x)$

$\qquad\qquad = \dfrac{1}{x + \Delta x + 1}$

$f(x) = \dfrac{1}{x+1}$ Find $f(x)$.

$$m = \lim_{\Delta x \to 0} \frac{\dfrac{1}{x + \Delta x + 1} - \dfrac{1}{x+1}}{\Delta x}$$ Subtract and divide by Δx.

$$= \lim_{\Delta x \to 0} \frac{\frac{x+1-(x+\Delta x+1)}{(x+\Delta x+1)(x+1)}}{\Delta x}$$

Find a common denominator to subtract the fractions.

$$= \lim_{\Delta x \to 0} \frac{\frac{x+1-x-\Delta x-1}{(x+\Delta x+1)(x+1)}}{\frac{\Delta x}{1}}$$

Distribute the subtraction sign. Write Δx as $\frac{\Delta x}{1}$.

$$= \lim_{\Delta x \to 0} \frac{-\Delta x}{(x+\Delta x+1)(x+1)} \cdot \frac{1}{\Delta x}$$

Simplify the numerator and invert and multiply.

$$= \lim_{\Delta x \to 0} \frac{-1}{(x+\Delta x+1)(x+1)}$$

$\frac{\Delta x}{\Delta x} = 1, \Delta x \neq 0.$

$$= \frac{-1}{(x+(0)+1)(x+1)}$$

Substitute 0 for Δx.

$$= \frac{-1}{(x+1)(x+1)} \text{ or } \frac{-1}{(x+1)^2}$$

This is the slope of the tangent.

c) $f(x+\Delta x) = \sqrt{x+\Delta x+2}$

Find $f(x+\Delta x)$.

$f(x) = \sqrt{x+2}$

Find $f(x)$.

$$m = \lim_{\Delta x \to 0} \frac{\sqrt{x+\Delta x+2} - \sqrt{x+2}}{\Delta x}$$

Subtract and divide by Δx.

To evaluate this limit, multiply by the conjugate of the numerator:

$$= \lim_{\Delta x \to 0} \frac{\sqrt{x+\Delta x+2} - \sqrt{x+2}}{\Delta x} \cdot \frac{\sqrt{x+\Delta x+2} + \sqrt{x+2}}{\sqrt{x+\Delta x+2} + \sqrt{x+2}}$$

Multiply the numerators. Leave the denominator in factored form.

$$= \lim_{\Delta x \to 0} \frac{x+\Delta x+2-(x+2)}{\Delta x(\sqrt{x+\Delta x+2} + \sqrt{x+2})}$$

Combine similar terms.

$$= \lim_{\Delta x \to 0} \frac{\Delta x}{\Delta x(\sqrt{x+\Delta x+2} + \sqrt{x+2})}$$

Reduce.

$$= \lim_{\Delta x \to 0} \frac{1}{\sqrt{x+\Delta x+2} + \sqrt{x+2}}$$

$\frac{\Delta x}{\Delta x} = 1, \Delta x \neq 0.$

$$= \frac{1}{\sqrt{x+0+2} + \sqrt{x+2}}$$

Substitute 0 for Δx.

$$= \frac{1}{2\sqrt{x+2}}$$

Add similar radicals.

VELOCITY

By examining the change in the distance an object travels divided by the change in time, we can form the limit definition of **velocity:** If $s(t)$ is the distance an object travels, the velocity of the object at time t is

$$\lim_{\Delta t \to 0} \frac{s(t + \Delta t) - s(t)}{\Delta t}.$$

This formula is equivalent to the earlier formula for slope of the tangent and can be evaluated in the same manner.

Example 3.3

An object travels along a line so that its distance traveled after t seconds is $s(t) = \sqrt{2t + 1}$. Find its velocity after 5 seconds.

Solution 3.3

You must find the velocity when $t = 5$.

$$s(5 + \Delta t) = \sqrt{2(5 + \Delta t) + 1} \qquad \text{Find } s(5 + \Delta t).$$

$$= \sqrt{10 + 2\Delta t + 1} \qquad \text{Simplify.}$$

$$s(5) = \sqrt{2(5) + 1} = \sqrt{11} \qquad \text{Find } s(5).$$

$$\lim_{\Delta t \to 0} \frac{\sqrt{10 + 2\Delta t + 1} - \sqrt{11}}{\Delta t} \qquad \text{Subtract and divide by } \Delta t.$$

To evaluate this limit, multiply by the conjugate of the numerator.

$$= \lim_{\Delta t \to 0} \frac{\sqrt{10 + 2\Delta t + 1} - \sqrt{11}}{\Delta t} \cdot \frac{\sqrt{10 + 2\Delta t + 1} + \sqrt{11}}{\sqrt{10 + 2\Delta t + 1} + \sqrt{11}}$$

$$= \lim_{\Delta t \to 0} \frac{10 + 2\Delta t + 1 - 11}{\Delta t \left(\sqrt{10 + 2\Delta t + 1} + \sqrt{11} \right)} \qquad \text{Multiply the numerator. Leave the denominator in factored form.}$$

$$= \lim_{\Delta t \to 0} \frac{2\Delta t}{\Delta t \left(\sqrt{10 + 2\Delta t + 1} + \sqrt{11} \right)} \qquad \text{Combine similar terms.}$$

$$= \lim_{\Delta t \to 0} \frac{2}{\left(\sqrt{10 + 2\Delta t + 1} + \sqrt{11} \right)} \qquad \frac{\Delta t}{\Delta t} = 1, \Delta t \neq 0.$$

$$= \frac{2}{\sqrt{10 + 2(0) + 1} + \sqrt{11}} \qquad \text{Substitute 0 for } \Delta t.$$

$$= \frac{2}{\sqrt{11} + \sqrt{11}} = \frac{2}{2\sqrt{11}} = \frac{1}{\sqrt{11}} \qquad \text{Simplify the denominator.}$$

Therefore, the velocity is $\dfrac{1}{\sqrt{11}}$ after 5 seconds, which may be written as $\dfrac{\sqrt{11}}{11}$.

3.2 THE DERIVATIVE

In the preceding section, we used a limit to find the slope of a tangent to a curve and to find velocity. These formulas are equivalent and, in general, are defined to be the derivative. The **derivative of a function f at x** is

$$f'(x) = \lim_{\Delta x \to 0} \frac{f(x + \Delta x) - f(x)}{\Delta x},$$

if this limit exists.

DERIVATIVE NOTATION

The following notation is used to signify a derivative of $f(x)$:

$f'(x)$	read, "f prime of x"
y'	read, "y prime"
$D_x(y)$	read, "the derivative of y with respect to x"
$\dfrac{d}{dx}(f(x))$	Read, "the derivative of f of x with respect to x"

DERIVATIVE SHORTCUTS

The limit definition of a derivative is time-consuming. Fortunately, there are several shortcuts (proofs are available in any standard textbook). The rules that follow must be memorized.

Function	Derivative	Derivative Rules
$f(x) = 5$	$f'(x) = 0$	The derivative of a constant is 0.
$f(x) = x^4$	$f'(x) = 4x^3$	The derivative of x^n is nx^{n-1} (this is called the **Power Rule**).
$f(x) = 5x^3$	$f'(x) = 5(3x^2)$ $= 15x^2$	The derivative of a constant times a function is the constant times the derivative of the function.
$f(x) = x^2 + x^5$	$f'(x) = 2x + 5x^4$	The derivative of a sum or difference of functions is the sum or difference of the derivatives, respectively.

Note that rules for finding derivatives of products and quotients are introduced in the next section.

Example 3.4

Find $f'(x)$.

a) $f(x) = 4x^3 - 7x^2 + 2$

b) $f(x) = \sqrt[3]{x} + \dfrac{5}{\sqrt{x}}$

c) $f(x) = \dfrac{1}{5x^2}$

d) $f(x) = (x^2 + 1)(2x + 3)$

Solution 3.4

a) $f'(x) = 4(3x^2) - 7(2x) + 0$ Find the derivative of each term.

 $= 12x^2 - 14x$

b) First rewrite the terms to make use of the Power Rule:

$$f(x) = x^{1/3} + \frac{5}{x^{1/2}}$$

$$= x^{1/3} + 5x^{-1/2}$$

Now take the derivative of each term:

$$f'(x) = \frac{1}{3}x^{-2/3} + 5(-\frac{1}{2}x^{-3/2}) \qquad \frac{1}{3} - 1 = \frac{1}{3} - \frac{3}{3} = -\frac{2}{3}$$

$$-\frac{1}{2} - 1 = -\frac{1}{2} - \frac{2}{2} = -\frac{3}{2}$$

$$= \frac{1}{3}x^{-2/3} - \frac{5}{2}x^{-3/2} \qquad \text{Simplify.}$$

c) $f(x) = \dfrac{1}{5x^2} = \dfrac{1}{5}x^{-2}$ Rewrite the function.

$f'(x) = \dfrac{1}{5}(-2x^{-3})$ Use the Power Rule.

$= -\dfrac{2}{5}x^{-3}$ or $-\dfrac{2}{5x^3}$ The answer may be written in either form.

d) Before using the Power Rule and the rule for sums, we must multiply:

$$f(x) = (x^2 + 1)(2x + 3)$$

$$= 2x^3 + 3x^2 + 2x + 3 \qquad \text{Multiply.}$$

$$f'(x) = 2(3x^2) + 3(2x) + 2(1x^0) + 0 \quad \text{Use the Power Rule.}$$

$$= 6x^2 + 6x + 2 \qquad \text{Simplify.}$$

Example 3.5

Find an equation of the tangent line to $f(x) = x^3 + 2x + 1$ at $(1, 4)$.

Solution 3.5

Because the slope of the tangent line equals the derivative, find $f'(x)$.

$$f'(x) = 3x^2 + 2 \qquad\qquad m = f'(x).$$

We need the slope at $x = 1$.

$$f'(1) = 3(1)^2 + 2 = 5$$

Now use the point-slope form of a line:

$$y - y_1 = m(x - x_1) \qquad\qquad \text{Substitute } (x_1, y_1) = (1, 4) \text{ and } m = 5.$$
$$y - 4 = 5(x - 1)$$
$$y - 4 = 5x - 5 \qquad\qquad \text{Simplify.}$$
$$y = 5x - 1$$

3.3 THE PRODUCT AND QUOTIENT RULES

In this section, we discuss finding derivatives when the function consists of a product or quotient of functions.

THE PRODUCT RULE

When a function consists of a product that can be easily multiplied, it is usually faster to multiply first and then find the derivative (see Example 3.4d). Otherwise, use the Product Rule. To find the derivative of $h(x) = f(x) \cdot g(x)$, do the following:

1. Find $f'(x)$ and $g'(x)$.

2. Write the functions on one line. Write the derivative of each function underneath. Cross-multiply and add. That is, set up the following:

$$f(x) \quad + \quad g(x)$$
$$f'(x) \qquad g'(x)$$

3. $h'(x) = g(x)f'(x) + f(x)g'(x)$

Example 3.6

Use the Product Rule to find $h(x)$.

a) $h(x) = (x^2 + 1)(2x + 3)$

b) $h(x) = (x^2 - 2x + 1)(4x^2 - 9)$

Solution 3.6

a) x^2+1 + $2x+3$ $f(x) = x^2 + 1$ and $g(x) = 2x + 3$

$2x$ 2 $f'(x) = 2x$ and $g'(x) = 2$

$$h'(x) = (2x +3)(2x) + (x^2 + 1)(2)$$ Use the Product Rule.
$$= 4x^2 + 6x + 2x^2 + 2$$ Simplify.
$$= 6x^2 + 6x + 2$$

Compare this answer to Example 3.4d.

b) $x^2 - 2x + 1$ + $4x^2 - 9$ $f(x) = x^2 - 2x + 1$ and $g(x) = 4x^2 - 9$

$2x - 2$ $8x$ $f'(x) = 2x - 2$ and $g'(x) = 8x$

$$h'(x) = (4x^2 - 9)(2x - 2) + (x^2 - 2x + 1)(8x)$$ Use the Product Rule.
$$= 8x^3 - 8x^2 - 18x + 18 + 8x^3 - 16x^2 + 8x$$ Multiply.
$$= 16x^3 - 24x^2 - 10x + 18$$ Simplify.

THE QUOTIENT RULE

If a fraction has a numerator or denominator that is a constant, it's faster to rewrite it and use the Power Rule (see Example 3.4c) or the Chain Rule (see Example 3.14b). Otherwise, use the Quotient Rule.

To find the derivative of $h(x) = \dfrac{f(x)}{g(x)}$:

1. Find $f'(x)$ and $g'(x)$.
2. Write the numerator and denominator on one line. Write each derivative underneath. Cross-multiply and subtract. Divide by the square of the denominator.
3. Set up the following

$f(x)$ – $g(x)$

$f'(x)$ $g'(x)$

4. $h'(x) = \dfrac{g(x)f'(x) - f(x)g'(x)}{[g(x)]^2}$

Note that the Quotient Rule uses subtraction rather than addition between $g(x)f'(x)$ and $f(x)g'(x)$ and that the denominator is always the original denominator squared.

Example 3.7

Use the Quotient Rule to find $h'(x)$.

a) $h(x) = \dfrac{2x+1}{4x-3}$

b) $h(x) = \dfrac{4x^3 - 2x^2 + 1}{x^2 - 9}$

Solution 3.7

a) 2x + 1　　−　　4x − 3

2 　　　　　　　4

$f(x) = 4x + 1, g(x) = 4x - 3.$

Find $f'(x)$ and $g'(x)$.

$h'(x) = \dfrac{(4x-3)(2)-(2x+1)(4)}{(4x-3)^2}$ 　　Use the Quotient Rule.

$= \dfrac{8x-6-8x-4}{(4x-3)^2}$ 　　Simplify.

$= \dfrac{-10}{(4x-3)^2}$ 　　Combine similar terms.

b) $4x^3 - 2x^2 + 1$　−　$x^2 - 9$ 　　State $f(x)$ and $g(x)$.

$12x^2 - 4x$　　　　$2x$ 　　Find $f'(x)$ and $g'(x)$.

$h'(x) = \dfrac{(x^2-9)(12x^2-4x)-(4x^3-2x^2+1)(2x)}{(x^2-9)^2}$ 　Use the Quotient Rule.

$= \dfrac{12x^4-4x^3-108x^2+36x-8x^4+4x^3-2x}{(x^2-9)^2}$ 　Simplify.

$= \dfrac{4x^4-108x^2+34x}{(x^2-9)^2}$ 　　Combine similar terms.

COMBINING THE PRODUCT AND QUOTIENT RULES

You may need both rules to work a problem if a product or quotient contains one or more products and/or quotients.

Example 3.8

Find the derivative.

a) $h(x) = \left(\dfrac{2x+1}{4x-3}\right)(x^2 + 4x)$

b) $h(x) = \dfrac{(x^2-4x+2)(x^2+3)}{x^2-1}$

Solution 3.8

a) This problem is a product where one of the factors is a quotient.

$$\frac{2x+1}{4x-3} \quad + \quad x^2+4x$$

Identify $f(x)$ and $g(x)$.

$$\frac{-10}{(4x-3)^2} \qquad 2x+4$$

Find $f'(x)$ (see Example 3.7a) and $g'(x)$.

$$h'(x) = (x^2+4x)\left(\frac{-10}{(4x-3)^2}\right) + \left(\frac{2x+1}{4x-3}\right)(2x+4) \quad \text{Use the Product Rule.}$$

$$= \frac{-10x^2-40x}{(4x-3)^2} + \frac{4x^2+10x+4}{4x-3} \qquad \text{Multiply.}$$

$$= \frac{-10^2-40x}{(4x-3)^2} + \frac{4x^2+10x+4}{4x-3} \cdot \frac{4x-3}{4x-3} \qquad \text{Use } (4x-3)^2 \text{ as the lowest common denominator (LCD).}$$

$$= \frac{-10x^2-40x}{(4x-3)^2} + \frac{16x^3+28x^2-14x-12}{(4x-3)^2} \qquad \text{Multiply.}$$

$$= \frac{16x^3+18x^2-54x-12}{(4x-3)^2} \qquad \text{Add the numerators.}$$

b) First find the derivative of $p(x) = (x^2-4x+2)(x^2+3)$ using the Product Rule.

$$x^2-4x+2 \quad + \quad x^2+3$$

Identify $f(x)$ and $g(x)$.

$$2x-4 \qquad 2x$$

Find $f'(x)$ and $g'(x)$.

$$p'(x) = (x^2+3)(2x-4) + (x^2-4x+2)(2x) \qquad \text{Use the Product Rule.}$$
$$= 2x^3-4x^2+6x-12+2x^3-8x^2+4x \qquad \text{Multiply.}$$
$$= 4x^3-12x^2+10x-12 \qquad \text{Combine similar terms.}$$

Now find $h'(x)$.

$$(x^2-4x+2)(x^2+3) \quad - \quad x^2-1$$

Identify $f(x)$ and $g(x)$.

$$4x^3-12x^2+10x-12 \qquad 2x$$

Find $f'(x)$ and $g'(x)$.

$$h'(x) = \frac{(x^2-1)(4x^3-12x^2+10x-12)-(x^2-4x+2)(x^2+3)(2x)}{(x^2-1)^2} \quad \text{Use the Quotient Rule.}$$

$$= \frac{2x^5-4x^4-4x^3+24x^2-22x+12}{(x^2-1)^2} \qquad \text{Multiply and combine similar terms.}$$

3.4 THE CHAIN RULE

The Chain Rule provides a method for finding derivatives of composite functions: If $y = (f \circ g)(x) = f(g(x))$, then $y' = f'(g(x))g'(x)$.

If you think of a composition as having an "inside" and an "outside," the Chain Rule says to multiply the derivative of the outside function times the derivative of the inside function. For example, to find the derivative of $y = (x^3 + 2)^2$, think of $x^3 + 2$ as the inside function. Imagine covering up the inside function $x^3 + 2$:

$y = (\rule{1cm}{0.3cm})^2$

Then $y' = 2(\rule{1cm}{0.3cm})^1$ Find the derivative of the outside function.

Now multiply times the derivative of the inside function:

$y' = 2(\rule{1cm}{0.3cm})^1 \cdot D_x[x^3 + 2]$

$y' = 2(\rule{1cm}{0.3cm})^1 \cdot 3x^2$

Now replace the inside function and simplify:

$y' = 2(x^3 + 2)^1(3x^2)$

$= 6x^2(x^3 + 2)$ Simplify the result.

Example 3.9

Find each derivative.

a) $y = (3x + 5)^4$

b) $y = \sqrt{4 - x^2}$

c) $h(x) = 3x(x^2 - 6)^4$

d) $y = \left(\dfrac{x - 2}{x + 1}\right)^3$

Solution 3.9

a) $y' = 4(3x + 5)^{4-1}D_x(3x + 5)$ Use the Chain Rule. You must multiply times the derivative of the inside function.

$y' = 4(3x + 5)^3 3 = 12(3x + 5)^3$ Simplify.

b) $y = (4 - x^2)^{1/2}$ Rewrite the square root.

$y' = \dfrac{1}{2}(4 - x^2)^{\frac{1}{2}-1}D_x(4 - x^2)$ Multiply times the derivative of $4 - x^2$.

$= \dfrac{1}{2}(4 - x^2)^{-1/2}(-2x)$ Simplify.

$= \dfrac{-x}{\sqrt{4 - x^2}}$ Simplify.

c) $h(x) = 3x(x^2 - 6)^4$ involves a product of two functions.

$3x \quad + \quad (x^2 - 6)^4$ Identify $f(x)$ and $g(x)$.

$3 \qquad \qquad 4(x^2 - 6)^3 (2x)$ Find $f'(x)$ and $g'(x)$.

$h'(x) = (x^2 - 6)^4(3) + 3x\,[4(x^2 - 6)^3(2x)]$ Use the Product Rule.

Rather than multiply, it will be easier to factor out the common factor $3(x^2 - 6)^3$:

$h'(x) = 3(x^2 - 6)^3[(x^2 - 6) + x(4)(2x)]$ Common factor.
$\quad = 3(x^2 - 6)^3[x^2 - 6 + 8x^2]$ Simplify inside the brackets.
$\quad = 3(x^2 - 6)^3(9x^2 - 6)$ Combine similar terms.
$\quad = 9(x^2 - 6)^3(3x^2 - 2)$ $9x^2 - 6 = 3(3x^2 - 2)$.

d) $y = \left(\dfrac{x-2}{x+1}\right)^3$

$y' = 3\left(\dfrac{x-2}{x+1}\right)^2 \cdot D_x\left(\dfrac{x-2}{x+1}\right)$ Use the Chain Rule.

$= 3\left(\dfrac{x-2}{x+1}\right)^2\left[\dfrac{(x+1)(1) - (x-2)(1)}{(x+1)^2}\right]$ Use the Quotient Rule.

$= 3\left(\dfrac{x-2}{x+1}\right)^2\left[\dfrac{3}{(x+1)^2}\right]$ Simplify the numerator.

$= 3\dfrac{(x-2)^2}{(x+1)^2} \cdot \dfrac{3}{(x+1)^2}$ Use exponent laws to write $\left(\dfrac{a}{b}\right)^2 = \dfrac{a^2}{b^2}$.

$= \dfrac{9(x-2)^2}{(x+1)^4}$ Add exponents: $(x+1)^2(x+1)^2 = (x+1)^4$.

3.5 DERIVATIVES OF TRIGONOMETRIC FUNCTIONS.

The **derivatives of the trigonometric functions** can now be stated using the Chain Rule:

$D_x[\sin u] = (\cos u)u'$

$D_x[\cos u] = -(\sin u)u'$

$D_x[\tan u] = (\sec^2 u)u'$

$D_x[\csc u] = -(\csc u \cot u)u'$

$D_x[\sec u] = (\sec u \tan u)u'$

$D_x[\cot u] = -(\csc^2 u)u'$

Note in each case we must multiply by u', the derivative of the angle. These formulas should be memorized.

Example 3.10

Find y'.

a) $y = \sin x^2$

b) $y = \cos(2x + 1)$

c) $y = 3\tan \pi x$

Solution 3.10

a) Let $u = x^2$. Then $u' = 2x$.

$\quad y' = \cos(x^2)(2x)$ Multiply times u'.

$\quad y' = 2x\cos x^2$ x^2 is the angle, and cannot be multiplied times the $2x$.

b) Let $u = 2x + 1$. Then $u' = 2$

$\quad y' = -\sin(2x + 1)(2)$ Multiply times u'.

$\quad y' = -2\sin(2x + 1)$ Simplify.

c) Let $u = \pi x$. Then $u' = \pi$.

$\quad y' = 3(\sec^2 \pi x)(\pi)$ Multiply times u'.

$\quad y' = 3\pi \sec^2 \pi x$

USING THE PRODUCT AND QUOTIENT RULES WITH TRIGONOMETRIC FUNCTIONS

We can now use the Product and Quotient Rules on functions that involve one or more trigonometric functions.

Example 3.11

Differentiate.

a) $y = x^3\sin x^2$

b) $y = \sin x \tan x$

c) $y = \dfrac{1 - \sin x}{\cos x}$

Solution 3.11

a) $x^3 \quad + \quad \sin x^2$ Identify $f(x)$ and $g(x)$.

$\quad\quad 3x^2 \quad\quad 2x\cos x^2$ Find $f'(x)$ and $g'(x)$.

$y' = (\sin x^2)(3x^2) + (x^3)(2x\cos x^2)$ Use the Product Rule.

$\quad = 3x^2\sin x^2 + 2x^4\cos x^2$

b) $\sin x \quad + \quad \tan x$

Identify $f(x)$ and $g(x)$.

$\cos x \qquad \sec^2 x$

Find $f'(x)$ and $g'(x)$.

$$y' = \tan x \cos x + \sin x \sec^2 x$$

Use the Product Rule.

$$= \frac{\sin x}{\cos x} \cdot \cos x + \sin x \sec^2 x$$

Use an identity, $\tan x = \frac{\sin x}{\cos x}$.

$$= \sin x + \sin x \sec^2 x$$

Simplify.

c) $1 - \sin x \quad - \quad \cos x$

Identify $f(x)$ and $g(x)$.

$-\cos x \qquad -\sin x$

Find $f'(x)$ and $g'(x)$.

$$y' = \frac{\cos x(-\cos x) - (1 - \sin x)(-\sin x)}{(\cos x)^2}$$

Use the Quotient Rule.

$$= \frac{-\cos^2 x + \sin x - \sin^2 x}{\cos^2 x}$$

Multiply.

$$= \frac{-\cos^2 x - \sin^2 x + \sin x}{\cos^2 x}$$

Change the order.

$$= \frac{-1 + \sin x}{\cos^2 x}$$

$-\cos^2 x - \sin^2 x = -(\cos^2 x + \sin^2 x) = -(1)$

DIFFERENTIATING POWERS OF TRIGONOMETRIC FUNCTIONS

The expression $\sin^2 x$ means $(\sin x)^2$. When differentiating powers of trigonometric functions, rewriting the power outside a set of parentheses helps remind you that the Chain Rule must be used. Study the examples that follow.

Example 3.12

Find the derivative of each function.

a) $y = \sin^2 x$

b) $y = \sec^3 4x^2$

c) $y = 2\sqrt{\cos 3x}$

Solution 3.12

a) $y = (\sin x)^2$

Rewrite the power outside the parentheses.

$y' = 2(\sin x)^1(\cos x)$

Use the Chain Rule.

$y' = 2\sin x \cos x$ or $\sin 2x$

Simplify by using a double-angle identity.

b) $y = (\sec 4x^2)^3$ Rewrite the power outside parentheses.

$\quad y' = 3(\sec 4x^2)^2 D_x[\sec 4x^2]$ Use the Chain Rule.

$\quad D_x[\sec 4x^2] = \sec 4x^2 \tan 4x^2 (8x)$ Find the derivative of $\sec 4x^2$.

So,

$$y' = 3(\sec 4x^2)^2 \sec 4x^2 \tan 4x^2 (8x)$$

$$y' = 24x(\sec 4x^2)^2 \sec 4x^2 \tan 4x^2 \qquad \text{Simplify.}$$

$$y' = 24x \sec^3 4x^2 \tan 4x^2 \qquad \text{Use exponent laws to multiply}$$
$$(\sec^2 u)(\sec u) = \sec^3 u.$$

c) $y = 2(\cos 3x)^{1/2}$ Rewrite the square root as a power.

$$y' = 2\left[\frac{1}{2}(\cos 3x)^{-1/2}\right] D_x(\cos 3x) \qquad \text{Use the Chain Rule.}$$

$$D_x(\cos 3x) = -\sin 3x(3) \qquad \text{Find the derivative of } \cos 3x.$$

So,

$$y' = (\cos 3x)^{-1/2}(-\sin 3x)(3) \qquad \text{Multiply.}$$

$$y' = \frac{-3\sin 3x}{\sqrt{\cos 3x}} \qquad \text{Rewrite.}$$

3.6 HIGHER-ORDER DERIVATIVES

We have used the first derivative to find the slope of a tangent to a curve and to find velocity. We can use higher-order derivatives to find acceleration and certain features of graphs. Higher-order derivatives are found by taking derivatives of derivatives. For example, if $f(x) = x^4$,

$f'(x) = 4x^3$	First derivative
$f''(x) = 12x^2$	Second derivative
$f'''(x) = 24x$	Third derivative
$f^{(4)}(x) = 24$	Fourth derivative
$f^{(5)}(x) = 0$	Fifth derivative

The following table contains some of the notation associated with higher-order derivatives.

Notation for Derivatives				
First Derivative	$f'(x)$	y'	$D_x(y)$	$\dfrac{d}{dx}[f(x)]$
Second Derivative	$f''(x)$	y''	$D_x^2(y)$	$\dfrac{d^2}{dx}[f(x)]$
Third Derivative	$f'''(x)$	y'''	$D_x^3(y)$	$\dfrac{d^3}{dx}[f(x)]$

Example 3.13

Find y''.

a) $y = 6x^3 + 3x^2 - 5x + 2$

b) $y = \sin 2x$

Solution 3.13

a) $y' = 18x^2 + 6x - 5$ Find y'.

 $y'' = 36x + 6$ Find y''.

b) $y' = \cos 2x(2)$ Find y'.

 $y' = 2\cos 2x$ Simplify.

 $y'' = 2[-\sin 2x(2)]$ Find y''.

 $y'' = -4\sin 2x$ Simplify.

Higher-order derivatives involving the Product and Quotient Rule can quickly become very large. Simplify each derivative as much as possible before finding the next derivative.

Example 3.14

Find the second derivative.

a) $y = x(x^2 - 1)^3$

b) $y = \dfrac{2x - 1}{x + 3}$

Solution 3.14

a) $x \quad + \quad (x^2 - 1)^3$ Identify $f(x)$ and $g(x)$.

 $1 \qquad\qquad 3(x^2 - 1)^2\,(2x)$ Find $f'(x)$ and $g'(x)$ using the Chain Rule.

$$y' = (x^2 - 1)^3(1) + x(3)(x^2 - 1)^2 (2x)$$ Use the Product Rule.

$$y' = (x^2 - 1)^2[(x^2 - 1) + x(3)(2x)]$$ Common factor.

$$y' = (x^2 - 1)^2(7x^2 - 1)$$ Combine similar terms.

Now find y'' using the Product Rule:

$(x^2 - 1)^2$ $+$ $7x^2 - 1$ Identify $f(x)$ and $g(x)$.

$2(x^2 - 1)^1(2x)$ $14x$ Find $f'(x)$ and $g'(x)$.

$$y'' = (7x^2 - 1)(2)(x^2 - 1)(2x) + (x^2 - 1)^2(14x)$$ Use the Product Rule.

$$y'' = 2x(x^2 - 1)[(7x^2 - 1)(2) + (x^2 - 1)(7)]$$ Find the common factor.

$$y'' = 2x(x^2 - 1)[14x^2 - 2 - 7x^2 - 7]$$ Multiply inside the brackets.

$$y'' = 2x(x^2 - 1)(21x^2 - 9)$$ Combine similar terms.

$$y'' = 6x(x^2 - 1)(7x^2 - 3)$$ $21x^2 - 9 = 3(7x^2 - 3)$

b) $2x - 1$ $-$ $x + 3$ Identify $f(x)$ and $g(x)$.

 2 1 Find $f'(x)$ and $g'(x)$.

$$y' = \frac{(x + 3)(2) - (2x - 1)(1)}{(x + 3)^2}$$ Use the Quotient Rule.

$$y' = \frac{2x + 6 - 2x + 1}{(x + 3)^2}$$ Multiply.

$$y' = \frac{7}{(x + 3)^2}$$

y'' can be found by using the Quotient Rule again or by rewriting y' as $y' = 7(x + 3)^{-2}$ and the using Power Rule and Chain Rule. We proceed with the Power Rule:

$$y' = 7(x + 3)^{-2}$$ Rewrite y'.

$$y'' = 7[-2(x + 3)^{-3}(1)]$$ Use the Power Rule.

$$y'' = -14(x + 3)^{-3}$$ Multiply.

$$y'' = \frac{-14}{(x + 3)^3}$$ Write the answer using positive exponents.

TRIGONOMETRIC FUNCTIONS AND HIGHER-ORDER DERIVATIVES

We can also find higher-order derivatives of the trigonometric functions. To review the rules of the first derivatives, see Section 3.5.

Example 3.15

Find the indicated derivative.

a) $\dfrac{d^3y}{dx^3}$ if $\dfrac{dy}{dx} = \sin x$

b) $D_x^2(y)$ if $y = x\cos x$

Solution 3.15

a) $\dfrac{d^3y}{dx^3}$ is notation for the third derivative. Notice that you are given the first derivative, not the original function.

$\dfrac{dy}{dx} = \sin x$ Given the first derivative.

$\dfrac{d^2y}{dx^2} = \cos x$ Find the second derivative.

$\dfrac{d^3y}{dx^3} = -\sin x$ Find the third derivative.

b) $D_x^2(y)$ is the second derivative. Because $x\cos x$ is a product, you must use the Product Rule.

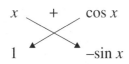

 Identify $f(x)$ and $g(x)$.

 Find $f'(x)$ and $g'(x)$.

$D_x(y) = (\cos x)(1) + (x)(-\sin x)$ Find the first derivative.

$D_x(y) = \cos x - x\sin x$ Simplify.

$D_x(y)$ is a difference of two functions, so take the derivative of each term. However, one of the terms is a product, whose derivative is found using the Product Rule.

$D_x^2(y) = D_x(\cos x) - D_x(x\sin x)$

$D_x^2(y) = -\sin x - [(\sin x)(1) + x\cos x]$

$x \quad + \quad \sin x$

$1 \qquad\qquad \cos x$

$D_x^2(y) = -\sin x - \sin x - x\cos x$ Distribute.

$D_x^2(y) = -2\sin x - x\cos x$ Combine similar terms.

3.7 IMPLICIT DIFFERENTIATION

The functions we have differentiated in this chapter have been solved explicitly for *y*. However, not all functions will be written (or even can be) written explicitly. When a function is written implicitly, we treat *x* and *y* as functions and use the Chain Rule to write each derivative of *y* as y'.

Example 3.16

Differentiate with respect to *x*.

a) x^3

b) y^3

c) $x^3 y^3$

Solution 3.16

a) $D_x[x^3] = 3x^2 \cdot D_x[x]$ Use the Chain Rule.

 $= 3x^2(1)$ $D_x[x] = 1$.

 $= 3x^2$ Simplify.

b) $D_x[y^3] = 3y^2 \cdot D_x[y]$ Use the Chain Rule.

 $= 3y^2 \cdot y'$ $D_x[y] = y'$.

c) $D_x[x^3 y^3]$ involves a product of x^3 and y^3. We use the Product Rule.

 Identify *f* and *g*.
 Find f' and g'.

$D_x[x^3 y^3] = y^3(3x^2) + x^3(3y^2 y')$ Use the Product Rule.

 $= 3x^2 y^3 + 3x^3 y^2 y'$ Simplify.

IMPLICIT DIFFERENTIATION

The following rules will help you find a derivative using implicit differentiation. Keep in mind that the goal is to solve for y'.

1. Find the derivative of both sides of the equation.

2. Collect all terms involving y' on the left side of the equation, and place all other terms on the right side of the equation.

3. Factor out y' on the left side.

4. Divide both sides of the equation by the coefficient of y'.

Example 3.17

Find y'.

a) $x^3 + x^3y^3 + y^3 = 6$

b) $x^2y^2 - y = 6x$

c) $x\sin y = 1$

d) $\cos(xy) + 4x = 8$

Solution 3.17

a) $D_x[x^3 + x^3y^3 + y^3] = D_x[6]$ Find the derivative of both sides.

$3x^2 + 3x^2y^3 + 3x^3y^2\ y' + 3y^2\ y' = 0$ See Example 3.16 for the left side. The derivative of a constant is 0.

$3x^3y^2\ y' + 3y^2\ y' = -3x^2 - 3x^2y^3$ Move all terms with y' to the left; move all other terms to the right.

$y'\ (3x^3y^2 + 3y^2) = -3x^2 - 3x^2y^3$ Factor out y'.

$y' = \dfrac{-3x^2 - 3x^2y^3}{3x^3y^2 + 3y^2}$ Divide both sides by the coefficient of y'.

$y' = \dfrac{-x^2 - x^2y^3}{x^3y^2 + y^2}$ Factor out 3 from numerator and denominator and simplify.

$y' = \dfrac{-x^2(y^3 + 1)}{y^2(x^3 + 1)}$ Simplify by factoring.

b) $D_x[x^2y^2 - y] = D_x[6x]$ Find the derivative of both sides.

$y^2(2x) + x^2(2y\ y') - y' = 6$

Move all terms with y' to the left; move all other terms to the right.

$2x^2y\ y' - y' = 6 - 2xy^2$

$y'\ (2x^2y - 1) = 6 - 2xy^2$ Factor out y'.

$y' = \dfrac{6 - 2xy^2}{2x^2y - 1}$ Divide both sides by the coefficient of y'.

c) $D_x\ [x\sin y] = D_x\ [1]$ Find the derivative of both sides.

$\sin y + x\cos y\ y' = 0$

$x\cos y\ y' = -\sin y$ Move all terms with y' to the left; move all other terms to the right.

$y' = \dfrac{-\sin y}{x\cos y}$ Divide both sides by the coefficient of y'.

$$y' = -\frac{1}{x}\tan y$$ Use trigonometric identities to write $\frac{\sin y}{\cos y} = \tan y$.

d) $D_x[\cos(xy) + 4x] = D_x[8]$ Take the derivative of both sides.

$D_x[\cos(xy)] + D_x[4x] = 0$ The derivative of a sum is the sum of the derivatives. The derivative of a constant is 0.

$-\sin(xy)[xy' + y] + 4 = 0$ Use the Chain Rule for $\cos(xy)$, and the Product Rule for the derivative of (xy).

$-xy'\sin(xy) - y\sin(xy) + 4 = 0$ Distribute.

$-xy'\sin(xy) = -4 + y\sin(xy)$ Move all terms with y' to the left; move all other terms to the right.

$$y' = \frac{-4 + y\sin(xy)}{-x\sin(xy)}$$ Divide both sides by the coefficient of y'.

SLOPE OF A TANGENT LINE

Recall from Sections 3.1 and 3.2 that the slope of a tangent line to a curve is the first derivative. If the equation of the curve is stated implicitly, find the slope of the tangent using implicit differentiation.

Example 3.18

Find the slope of the tangent line at the indicated point.

a) $x^2 + 4y^2 = 100$ at $(-8, 3)$

b) $4x^2 - 3y^2 + 8x + 16 = 0$ at $(0, \frac{4}{\sqrt{3}})$

Solution 3.18

a) Because the slope of the tangent line equals the first derivative, find y'.

$D_x[x^2 + 4y^2] = D_x[100]$ Find the derivative of both sides.

$2x + 8y\ y' = 0$ $D_x[4y^2] = 8yD_x[y] = 8yy'$.

$8y\ y' = -2x$ Isolate y'.

$$y' = \frac{-2x}{8y}$$ Divide both sides by $8y$.

$$y' = -\frac{x}{4y}$$ y' is the slope of the tangent.

Find the slope at $(-8, 3)$:

$$y' = -\frac{(-8)}{4(3)}$$ Substitute $x = -8$ and $y = 3$.

$$y' = \frac{2}{3}$$ Reduce.

b) $D_x[\,4x^2 - 3y^2 + 8x + 16] = D_x\,[0]$ Find the derivative of both sides.

$8x - 6y\ y' + 8 = 0$ $D_x\,[-3y^2] = -6y \cdot D_x[y] = -6y\ y'.$

$-6y\ y' = -8x - 8$ Isolate y'.

$y' = \dfrac{-8x - 8}{-6y}$ Divide both sides by $-6y$.

$y' = \dfrac{4x + 4}{3y}$ y' is the slope of the tangent.

Find the slope at $(0, \dfrac{4}{\sqrt{3}})$

$y' = \dfrac{4(0) + 4}{3(\dfrac{4}{\sqrt{3}})}$ Substitute $x = 0$, $y = \dfrac{4}{\sqrt{3}}$

$y' = \dfrac{4}{\dfrac{12}{\sqrt{3}}} = 4 \cdot \dfrac{\sqrt{3}}{12} = \dfrac{\sqrt{3}}{3}$ Simplify.

Example 3.19

Find the equation of the tangent line at the indicated point.

a) $x^2 + 4y^2 = 100$ at $(-8, 3)$

b) $4x^2 - 3y^2 + 8x + 16 = 0$ at $(0, \dfrac{4}{\sqrt{3}})$

Solution 3.19

a) We have already found the slope of the tangent at $(-8, 3)$ in Example 3.18a. Use the point-slope formula to find the equation of the tangent line.

$y - y_1 = m(x - x_1)$ Write the point-slope formula.

$y - 3 = \dfrac{2}{3}(x - (-8))$ Substitute $y_1 = 3$, $m = \dfrac{2}{3}$, $x_1 = -8$.

$y - 3 = \dfrac{2}{3}(x + 8)$ Simplify.

$y = \dfrac{2}{3}x + \dfrac{25}{3}$ $\dfrac{2}{3} \cdot 8 + 3 = \dfrac{16}{3} + \dfrac{9}{3} = \dfrac{25}{3}$

b) $y - y_1 = m(x - x_1)$ Write the point-slope formula.

$$y - \frac{4}{\sqrt{3}} = \frac{\sqrt{3}}{3}(x - 0)$$ Substitute $y_1 = \frac{4}{\sqrt{3}}$, $m = \frac{\sqrt{3}}{3}$, $x_1 = 0$.

$$y = \frac{\sqrt{3}}{3}x + \frac{4}{\sqrt{3}}$$ Solve for y.

or

$$y = \frac{\sqrt{3}x + 4\sqrt{3}}{3}$$ The answer may be written in this form.

HIGHER-ORDER DERIVATIVES USING IMPLICIT DIFFERENTIATION

When finding higher-order derivatives, it may be possible to replace y' with its equivalent and/or the original equation with its equivalent to help simplify the result. Example 3.20 uses both types of substitution to simplify the answer.

Example 3.20

Find y'' if $x^2 + y^2 = 9$.

Solution 3.20

$D_x[x^2 + y^2] = D_x[9]$ Find the derivative of both sides.

$2x + 2y\,y' = 0$ $D_x[y^2] = 2yD_x[y] = 2y\,y'$

$2y\,y' = -2x$ Isolate y'.

$$y' = -\frac{2x}{2y} = -\frac{x}{y}$$ Divide both sides by $2y$ and reduce.

To find y'', use the Quotient Rule.

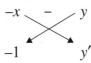

-1 y'

Identify f and g.
Find f' and g'.

$$y'' = \frac{y(-1) - (-x)(y')}{y^2}$$ Use the Quotient Rule.

$$= \frac{-y + xy'}{y^2}$$ Simplify.

$$= \frac{-y + x(-\frac{x}{y})}{y^2}$$ Substitute $y' = -\frac{x}{y}$.

$$= \frac{-y - \frac{x^2}{y}}{y}$$ Simplify.

$$= \frac{-y^2 - x^2}{y^3}$$ Multiply by $\frac{y}{y}$.

$$= -\frac{(y^2 + x^2)}{y^3} \qquad \text{Factor out } -1.$$

$$= \frac{-9}{y^3} \qquad \text{Use } x^2 + y^2 = 9.$$

This is the final answer.

SUMMARY

In this chapter, we introduced the limit definition of a derivative and various shortcuts to find derivatives of sums and differences, products, quotients, and the composition of functions. We also used implicit differentiation to find y' for functions that were not solved for y (implicit functions). We used derivatives to find the slope of the tangent line to a curve and to find velocity.

TEST YOURSELF

1) Use the limit definition of a derivative to find each derivative.
 a) $f(x) = x^2 - 3x$
 b) $f(x) = \sqrt{x-4}$
 c) $f(x) = \dfrac{3}{x-1}$
 d) $f(x) = 4x + 5$

2) Find each derivative.
 a) $y = \pi^2$
 b) $y = 8x^2$
 c) $y = \sqrt{x} + \dfrac{2}{\sqrt{x}}$
 d) $y = \dfrac{1}{7x^2}$
 e) $y = 4x^3 - 7x^2 + 2x + 1$
 f) $y = (3x - 1)(2x + 5)$

3) Use the Product Rule to find each derivative.
 a) $y = (3x + 1)(4x - 6)$
 b) $y = (x^2 + 2)(3x^2 - 5)$
 c) $y = \sqrt{x}(2x - 1)$

4) Use the Quotient Rule to find each derivative.
 a) $f(x) = \dfrac{x^2 - 2x - 4}{x - 1}$
 b) $f(x) = \dfrac{3x - 2}{\sqrt{x}}$

5) Differentiate.
 a) $y = (4x - 6)^3$
 b) $y = \sqrt{x^2 - 2x + 1}$
 c) $y = \sin^2 x$
 d) $f(\theta) = 6\sqrt{\cos\theta}$
 e) $y = \sin^2\theta + \cos^2\theta$

6) Find $f'(x)$.
 a) $f(x) = (2x + 1)^3(x - 1)$
 b) $f(x) = \dfrac{2x}{\sqrt{x^2 + 1}}$
 c) $f(x) = \left(\dfrac{2x - 1}{x + 6}\right)^3$

7) Find $\dfrac{dy}{dx}$.
 a) $y = \tan 2x$
 b) $y = 5\sin\pi x + 2\cos 3x$
 c) $y = \sec(3x)^2$
 d) $y = \dfrac{\sin x}{\sec x + 1}$
 e) $y = \csc^2 4x$
 f) $y = \dfrac{\cos 2x}{\sin 2x}$

8) Find the indicated derivative.
 a) y'' if $y = 6x^2 + 4x - 2$
 b) $D_x^{\ 2}(y)$ if $y = 4x^{2/3}$
 c) $\dfrac{d^3 y}{dx}$ if $y = \cos 2x$

9) Use implicit differentiation to find y'.
 a) $x^2 + y^2 = 36$
 b) $2x^2 + 4xy - y^2 = 9$
 c) $x^2\cos y = \sin x$
 d) $\tan(xy) + \sin x = 4$

10) Find the equation of the tangent line at the given point.
 a) $y = 4x^2 + 2x$ at $(3, 42)$
 b) $y = \sin 3x$ at $\left(\dfrac{\pi}{3}, 0\right)$
 c) $y = \dfrac{x}{2x - 1}$ at $\left(3, \dfrac{3}{5}\right)$
 d) $y = (3x - 1)^4$ at $(1, 16)$

TEST YOUR ANSWERS

1)

a) $2x - 3$

b) $\dfrac{1}{2\sqrt{x-4}}$

c) $-\dfrac{3}{(x-1)^2}$

d) 4

2)

a) 0

b) $16x$

c) $\dfrac{1}{2}x^{-1/2} - x^{-3/2}$

d) $-\dfrac{2}{7x^3}$

e) $12x^2 - 14x + 2$

f) $12x + 13$

3)

a) $24x - 14$

b) $12x^3 + 2x$

c) $\dfrac{6x-1}{2\sqrt{x}}$

4)

a) $\dfrac{x^2 - 2x + 6}{(x-1)^2}$

b) $\dfrac{3x+2}{2x^{3/2}}$

5)

a) $12(4x - 6)^2$

b) $\dfrac{x-1}{\sqrt{x^2 - 2x + 1}}$

c) $2\sin x \cos x$ or $\sin 2x$

d) $-3\dfrac{\sin\theta}{\sqrt{\cos\theta}}$ or $-3\tan\theta\sqrt{\cos\theta}$

e) 0

6)

a) $(2x + 1)^2(8x - 5)$

b) $\dfrac{2}{(x^2 + 1)^{3/2}}$

c) $\dfrac{39(2x-1)^2}{(x+6)^4}$

7)

a) $2\sec^2 2x$

b) $5\pi\cos\pi x - 6\sin 3x$

c) $18x\sec(3x)^2\tan(3x)^2$

d) $\dfrac{1 + \cos x - \tan^2 x}{(\sec x + 1)^2}$

e) $-8\csc^2 4x \cot 4x$

f) $-2\csc^2 2x$

8)

a) 12

b) $-\dfrac{8}{9}x^{-4/3}$

c) $8\sin 2x$

9)

a) $-\dfrac{x}{y}$

b) $\dfrac{2x + 2y}{y - 2x}$

c) $\dfrac{2x\cos y - \cos x}{x^2\sin y}$

d) $-\dfrac{y}{x} - \dfrac{1}{x}\cos x \cos^2(xy)$

10)

a) $y - 42 = 26(x - 3)$

b) $y = -3x + \pi$

c) $y = -\dfrac{1}{25}x + \dfrac{18}{25}$

d) $y = 96x - 80$

Applications of Derivatives

In this chapter, we use derivatives to solve word problems and to analyze features of graphs. We solve related-rates problems (that is, problems in which variables change over time) and maximum and minimum problems.

4.1 RELATED RATES

Related-rates problems involve one or more variables that change over time. Because the derivatives in these problems are taken with respect to time, rather than with respect to x, we use implicit differentiation (see Section 3.7). Thus, the statement, "the radius increases at a rate of 5 feet per second" is translated symbolically as $\dfrac{dr}{dt} = 5$ feet/sec, where r is the length of the radius.

EXAMPLE 4.1

Translate each statement into symbols.

a) The radius of a sphere is increasing at a rate of 10 feet per second.

b) The height of a cone is decreasing at a rate of 6 inches per second.

c) The angle of elevation is increasing at a rate of 12 radians per second.

SOLUTION 4.1

a) Let r = radius of the sphere.

Then $\dfrac{dr}{dt}$ = the rate of change of the radius.

The statement translates as $\dfrac{dr}{dt} = 10$ feet/sec.

b) Let h = height of the cone.

Then $\dfrac{dh}{dt}$ = the rate of change of the height.

The statement translates as $\dfrac{dh}{dt} = -6$ in/sec, where the negative sign indicates a decrease.

c) Let θ = the angle of elevation.

Then $\dfrac{d\theta}{dt}$ = the rate of change of the angle.

The statement translates as $\dfrac{d\theta}{dt} = 12$ rad/sec.

IMPLICIT DIFFERENTIATION AND RELATED RATES

Because related rates involve change with respect to time, we need implicit differentiation. Study Example 4.2.

EXAMPLE 4.2

Differentiate each equation with respect to t.

a) $A = \pi r^2$

b) $V = \dfrac{4}{3}\pi r^3$

c) $V = \dfrac{1}{3}\pi r^2 h$

d) $\tan \theta = cy$, where c is a constant.

SOLUTION 4.2

a) $A = \pi r^2$ Given equation.

$\dfrac{dA}{dt} = \pi(2r^1)\dfrac{dr}{dt}$ Find the derivative of each side.

$\dfrac{dA}{dt} = 2\pi r\dfrac{dr}{dt}$ Simplify.

b) $V = \dfrac{4}{3}\pi r^3$ Given equation.

$\dfrac{dV}{dt} = \dfrac{4}{3}\pi(3r^2)\dfrac{dr}{dt}$ Find the derivative of each side.

$\dfrac{dV}{dt} = 4\pi r^2\dfrac{dr}{dt}$ Simplify.

c) $V = \dfrac{1}{3}\pi r^2 h$ Given equation.

$\dfrac{dV}{dt} = \dfrac{1}{3}\pi \left[2hr\dfrac{dr}{dt} + r^2 \dfrac{dh}{dt} \right]$ Use the Product Rule.

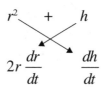

$\dfrac{dV}{dt} = \dfrac{2}{3}\pi rh\dfrac{dh}{dt} + \dfrac{1}{3}\pi r^2 \dfrac{dh}{dt}$ Simplify.

d) $\tan\theta = cy$ Given equation.

$\sec^2\theta \dfrac{d\theta}{dt} = c\dfrac{dy}{dt}$ Find the derivative of each side.

Here are some general guidelines for setting up related-rates problems:

1. Find an equation that describes the relationship between the variables.
2. Express the given information symbolically, taking care to represent each rate as a derivative with respect to time. Identify what you are looking for using symbols.
3. Differentiate both sides of the equation from Step 1 with respect to time.
4. Substitute the given information to find whatever is required.

RELATED RATES AND AREA

Generally you will need to use formulas from geometry such as $A = \pi r^2$ (area of a circle) or $A = LW$ (area of a rectangle) to set up a relationship between the variables. If a problem contains a shape whose area formula you don't recall, try checking the Internet, or check the front or back cover of your textbook.

EXAMPLE 4.3

Oil spills into a lake in a circular pattern. If the radius of the circle increases at a rate of 2 feet per second, how fast is the area of the spill increasing at the end of 30 minutes?

SOLUTION 4.3

$A = \pi r^2$ Use the formula for the area of a circle.

$\dfrac{dr}{dt} = 2$ feet/second Radius increases at a rate of 2 ft/sec.

Find $\dfrac{dA}{dt}$ when $t = 30$ minutes Identify what you're looking for.

$\dfrac{dA}{dt} = 2\pi r\dfrac{dr}{dt}$ Find the derivative with respect to time.

When $t = 30$ minutes $= 30(60)$ seconds $= 1,800$ seconds, $r = (2 \text{ ft/sec})(1,800 \text{ sec}) = 3,600$ feet

$$\frac{\text{feet}}{\text{seconds}} \cdot \text{seconds} = \text{feet}$$

$$\frac{dA}{dt}$$

$$\frac{dA}{dt} = 2\pi(3,600\text{ft})(2\text{ft/sec})$$ 　　Substitute values for r and $\frac{dr}{dt}$.

$$\frac{dA}{dt} = 14,400\pi \text{ ft}^2\text{/sec}$$ 　　Simplify.

RELATED RATES AND VOLUME

Some volume formulas you may need for these types of problems include the formula for the volume of a cube $V = x^3$ where x is the length of a side of the cube, the volume of a right circular cylinder $V = \pi r^2 h$, and the volume of a sphere $V = \frac{4}{3}\pi r^3$.

EXAMPLE 4.4

Air is being pumped into a spherical balloon at a rate of 6 cubic inches per minute. Find the rate of change of the radius when the radius is 1.5 inches.

SOLUTION 4.4

$$V = \frac{4}{3}\pi r^3$$ 　　Use the formula for the volume of a sphere.

$$\frac{dV}{dt} = 6 \text{ in}^3\text{/min}$$ 　　Volume increases at a rate of 6 in³/min.

Find $\frac{dr}{dt}$ when $r = 1.5$ in 　　Identify what you're looking for.

$$\frac{dV}{dt} = \frac{4}{3}\pi(3r^2)\frac{dr}{dt}$$ 　　Find the derivative with respect to time.

$$\frac{dV}{dt} = 4\pi r^2 \frac{dr}{dt}$$ 　　Simplify.

$$6 \text{ in}^3\text{/min} = 4\pi(1.5 \text{ in})^2 \frac{dr}{dt}$$ 　　Substitute the given information.

$$6 \text{ in}^3\text{/min} = 9\pi \text{ in}^2 \frac{dr}{dt}$$ 　　Simplify.

$$\frac{6\text{in}^3/\text{min}}{9\pi\text{in}^2} = \frac{dr}{dt}$$ 　　Solve for $\frac{dr}{dt}$.

$$\frac{2}{3\pi} \text{ in/min} = \frac{dr}{dt}$$ 　　Simplify.

Thus, the radius is increasing at a rate of $\frac{2}{3\pi}$ inches per minute.

EXAMPLE 4.5

Grain pours through a chute at a rate of 6 cubic feet per minute. It falls in the shape of a right circular cone ($V = \dfrac{\pi r^2 h}{3}$). If the diameter of the base of the cone is twice the height, how fast is the height of the pile of grain increasing when the height is 2 feet?

SOLUTION 4.5

Note that the volume formula contains three variables. To take the derivative of the right side would require using the Product Rule. But there is sufficient information to convert the formula to one containing only two variables.

$d = 2h$	The diameter is twice the height.
$2r = 2h$	Diameter of a circle equals twice the radius.
$r = h$	Solve for r.
$V = \dfrac{\pi (h)^2 h}{3}$	Substitute for r in the volume formula.
$V = \dfrac{1}{3}\pi h^3$	Simplify.
$\dfrac{dV}{dt} = \pi h^2 \dfrac{dh}{dt}$	Differentiate with respect to time.
$6\,\text{ft}^3 / \text{min} = \pi (2\,\text{ft})^2 \dfrac{dh}{dt}$	Substitute the given information.
$\dfrac{6\,\text{ft}^3 / \text{min}}{4\pi\,\text{ft}^2} = \dfrac{dh}{dt}$	Solve for $\dfrac{dh}{dt}$.
$\dfrac{3}{2\pi}\,\text{ft/min} = \dfrac{dh}{dt}$	Simplify.

Thus, the height is increasing at a rate of $\dfrac{3}{2\pi}$ ft/min.

RELATED RATES AND THE PYTHAGOREAN THEOREM

When using the Pythagorean theorem to solve related rates problems, often one of the sides is not changing with respect to time. If that is the case, the derivative of the variable you chose for that side will equal 0.

EXAMPLE 4.6

A 13-foot ladder is leaning against the wall of a house. The base of the ladder slides away from the wall at a rate of 0.5 feet per second. How fast is the top of the ladder moving down the wall when the base is 12 feet from the wall?

SOLUTION 4.6

A sketch will prove useful here.

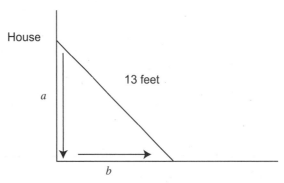

If we label the lengths as shown,

$13^2 = a^2 + b^2$ Use the Pythagorean theorem with $c = 13$.

$\dfrac{db}{dt} = 0.5$ ft/sec The base slides away at a rate of 0.5 ft/sec.

Find $\dfrac{da}{dt}$ when $b = 12$ Identify what you're looking for.

$0 = 2a\dfrac{da}{dt} + 2b\dfrac{db}{dt}$

Find the derivative with respect to time. The derivative of a constant is 0.

$0 = 2a\dfrac{da}{dt} + 2b(0.5 \text{ ft/sec})$ Substitute the given rate.

At this point, there are still too many variables to solve for $\dfrac{da}{dt}$. We can find a when $b = 12$ feet and $c = 13$ feet: $c^2 = a^2 + b^2$.

$13^2 = a^2 + 12^2$ Use the Pythagorean theorem.
$25 = a^2$ Substitute for c and b.
$a = 5$ feet Solve for a.
Then

$0 = 2(5 \text{ feet})\dfrac{db}{dt} + 2(12 \text{ feet})(0.5 \text{ ft/sec})$ Substitute the given and found values.

$0 = 10 \text{ feet }\dfrac{db}{dt} + 12 \text{ ft}^2/\text{sec}$ Simplify.

$\dfrac{-12 \text{ ft}^2/\text{sec}}{10 \text{ ft}} = \dfrac{db}{dt}$ Solve for $\dfrac{db}{dt}$.

$-1.2 \text{ ft/sec} = \dfrac{db}{dt}$

Thus, the top of the ladder is sliding down (note the negative sign in the answer) at a rate of 1.2 feet per second.

RELATED RATES AND ANGLES

When we are interested in how an angle changes over time, use trigonometric definitions to help you relate the variables. You may need to return to Chapter 1 for some review.

EXAMPLE 4.7

A weather balloon is released 50 feet from an observer. It rises at a rate of 8 feet per second. How fast is the angle of elevation changing when the balloon is 50 feet high?

SOLUTION 4.7

A sketch will prove useful here.

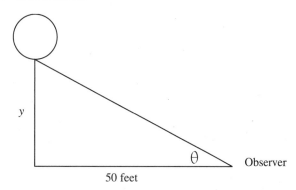

$\tan \theta = \dfrac{y}{50}$ Use the tangent to relate the angle of elevation to the given measures.

$\dfrac{dy}{dt} = 8$ ft/sec The balloon rises at a rate of 8 ft/sec.

Find $\dfrac{d\theta}{dt}$ when $y = 50$ feet Identify what you are looking for.

$\sec^2 \theta \dfrac{d\theta}{dt} = \dfrac{1}{50} \dfrac{dy}{dt}$ Find the derivative with respect to time.

$\sec^2 \theta \dfrac{d\theta}{dt} = \dfrac{1}{50}$ (8 ft/sec) Substitute $\dfrac{dy}{dt}$.

$\sec^2 \theta \dfrac{d\theta}{dt} = \dfrac{4}{25}$ ft/sec Simplify.

We cannot solve for $\dfrac{d\theta}{dt}$, because we still have an unknown quantity, $\sec^2\theta$.

But when $y = 50$ feet, $\tan \theta = \dfrac{50}{50}$, so $\tan \theta = 1$. Thus, $\theta = \dfrac{\pi}{4}$ radians.

$\sec^2(\dfrac{\pi}{4}) \dfrac{d\theta}{dt} = \dfrac{4}{25}$ Substitute $\dfrac{\pi}{4}$ for θ.

$(\sqrt{2})^2 \dfrac{d\theta}{dt} = \dfrac{4}{25}$ Sec $\dfrac{\pi}{4} = \sqrt{2}$. $(\sqrt{2})^2 = 2$.

$$\frac{d\theta}{dt} = \frac{4}{25} \cdot \frac{1}{2}$$ Solve for $\frac{d\theta}{dt}$.

$$\frac{d\theta}{dt} = \frac{2}{25} \text{ rad/sec}$$

Thus, the angle of elevation is increasing at a rate of $\frac{2}{25}$ radians per second.

4.2 DIFFERENTIALS

The **differential,** dy, is defined as the derivative $f'(x)$ times dx. Finding dy is straightforward.

1. Find $f'(x)$ (the derivative).
2. Multiply by dx. Leave dx in the answer.

EXAMPLE 4.8

Find dy for each function.

a) $y = 6x^3 - 2x^2 + 3x$

b) $y = \sqrt{2x+1}$

c) $y = x^2 \sin x$

d) $y = \dfrac{3x-1}{2x+5}$

SOLUTION 4.8

a) $y' = 18x^2 - 4x + 3$ Find y'.

 $dy = (18x^2 - 4x + 3)dx$ Multiply y' times dx.

b) $y = (2x + 1)^{1/2}$ Rewrite the square root using a fractional exponent.

 $y' = \dfrac{1}{2}(2x + 1)^{-1/2}(2)$ Use the Chain Rule to find y'.

 $dy = (2x + 1)^{-1/2}dx$ Multiply y' times dx.

c) $y' = \sin x(2x) + x^2\cos x$

$$x^2 \quad + \quad \sin x$$
$$\diagdown \diagup$$
$$2x \qquad \cos x$$

 $dy = [2x\sin x + x^2 \cos x]\, dx$ Multiply y' times dx.

d) $y' = \dfrac{3(2x+5)-(2)(3x-1)}{(2x+5)^2}$

$$3x - 1 \quad - \quad 2x + 5$$
$$\diagdown \diagup$$
$$3 \qquad 2$$

 $dy = \dfrac{17}{(2x+5)^2}\, dx$ Multiply y' times dx.

THE DIFFERENTIAL AS AN APPROXIMATION

We can demonstrate the relationship between dx, Δx, dy, and Δy graphically as follows:

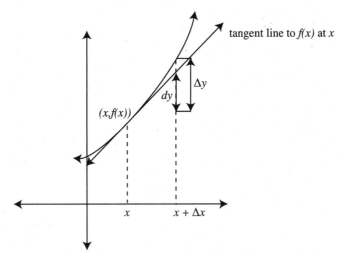

Thus, Δy represents the actual change in y values along the curve $f(x)$, and dy represents the change along the tangent line. We can use dy to approximate Δy, especially for small increments in x (that is, when Δx is small).

DIFFERENTIALS AS APPROXIMATIONS

$f(x + \Delta x) \approx f(x) + dy$

To approximate $f(x + \Delta x)$:

 1. Identify $f(x)$.

 2. Identify x and Δx.

 3. Find $dy = f'(x)dx$.

 4. Compute $f(x) + f'(x)\Delta x$.

EXAMPLE 4.9

Use differentials to approximate $\sqrt{9.6}$.

SOLUTION 4.9

We are interested in the square root of a number, so

$f(x) = \sqrt{x} = x^{1/2}$ Identify $f(x)$.

We know

$f(9) = \sqrt{9} = 3$, so

$f(9 + 0.6) = f(9) + dy$ $x = 9$ and $\Delta x = 0.6$

$dy = f'(x)dx$ This is the definition of dy.

$$dy = \frac{1}{2} x^{-1/2} \, dx$$ Multiply derivative times dx.

$$f(9 + 0.6) \approx f(9) + \frac{1}{2}(9)^{-1/2}(0.6)$$ Compute $f(x) + f'(x)\Delta x$.

$$f(9 + 0.6) \approx 3 + \frac{1}{2} \cdot \frac{1}{3}(0.6)$$ $9^{-1/2} = \frac{1}{9^{1/2}} = \frac{1}{\sqrt{9}} = \frac{1}{3}.$

$$f(9 + 0.6) \approx 3.1$$

A comparison to a calculator value of 3.0984 reveals that our approximation is off by about 0.00161.

4.3 INCREASING AND DECREASING INTERVALS AND RELATIVE EXTREMA

This section and the following three sections present techniques for analyzing functions using Calculus. We begin by examining intervals where functions increase and decrease.

INCREASING AND DECREASING INTERVALS

A function is increasing when y-values increase as x-values increase. A function is decreasing when y-values decrease as x-values increase. Observe that $f(x) = x^2$ decreases when $x < 0$ and increases when $x > 0$.

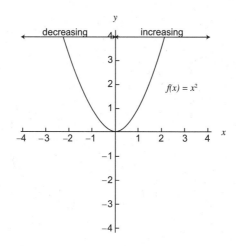

By sketching some tangent lines where $f(x) = x^2$ is decreasing and increasing, we note that the function decreases when the slope of the tangent is negative, and the function increases when the slope of the tangent is positive.

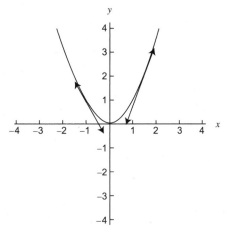

We have the following rules to determine when a differentiable function is increasing or decreasing. To determine intervals where $f(x)$ is increasing or decreasing:

1. Find $f'(x)$.
2. Find critical numbers; that is, where $f'(x) = 0$ or where $f'(x)$ is undefined and x is in the domain of the function.
3. Draw a number line, dot in the critical numbers, and determine the sign of $f'(x)$ within each region.
4. Where $f'(x) > 0$ (+ on the number line), $f(x)$ is increasing.
5. Where $f'(x) < 0$ (– on number line), $f(x)$ is decreasing.

EXAMPLE 4.10

Find the intervals on which $f(x) = x^3 - 4x^2 + 1$ is increasing or decreasing.

SOLUTION 4.10

$f'(x) = 3x^2 - 8x$ Find $f'(x)$.
$3x^2 - 8x = 0$ Set $f'(x) = 0$.
$x(3x - 8) = 0$ Factor.
$x = 0$ or $3x - 8 = 0$ Solve for critical numbers.

$$\begin{array}{c} + \mid - \mid + \\ \hline \; 0 \;\; 8/3 \end{array}$$

$f(x)$ is increasing on $(-\infty, 0)$ and $(\dfrac{8}{3}, \infty)$,

$f(x)$ is decreasing on $(0, \dfrac{8}{3})$.

EXAMPLE 4.11

Find the intervals on which $f(x) = \dfrac{x^2}{x^2 - 4}$ is increasing and decreasing.

SOLUTION 4.11

$$f'(x) = \frac{(x^2 - 4)(2x) - (x^2)(2x)}{(x^2 - 4)^2}$$

$x^2 \qquad - \qquad x^2 - 4$

$2x \qquad\qquad 2x$

$$f'(x) = \frac{-8x}{(x^2 - 4)^2} \qquad\qquad \text{Simplify.}$$

Set the numerator equal to 0 to find where $f'(x) = 0$.

$-8x = 0$ Solve for x.

$x = 0$ $x = 0$ is a critical number.

Set the denominator equal to 0 to find where $f'(x)$ is undefined.

$(x^2 - 4)^2 = 0$ Set the denominator equal to 0.

$x^2 - 4 = 0$ Take the square root of both sides.

$x^2 = 4$ Add 4 to both sides.

$x = \pm 2$ Take the square root of both sides.

Note that $x = \pm 2$ are not critical numbers (they are vertical asymptotes), but they provide points on the number line about which the function may change from increasing to decreasing or vice-versa. Because the denominator is always positive when $x \neq \pm 2$, check the sign of $-8x$.

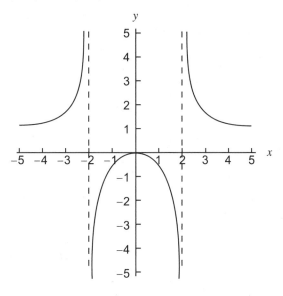

$-8x$ $+$ $|$ $-$ $|$ $+$

-2 2

$f(x)$ is increasing on $(-\infty, -2)$ and $(-2, 0)$.

$f(x)$ is decreasing on $(0, 2)$ and $(2, \infty)$.

EXTREMA

Extrema (or **absolute extrema**) of a function are the maximum and/or minimum y-values of the function (also called the **absolute maximum** and **absolute minimum**).

We are also interested in finding the relative extrema of a function; that is, the maximum or minimum value within an open interval. The following statements provide reasons for the steps we use in finding extrema.

1. A continuous function on a closed interval $[a, b]$ has both an absolute maximum and an absolute minimum.

2. If a function has a relative maximum or relative minimum, it must occur at a critical number.

EXTREMA ON A CLOSED INTERVAL

If the function $f(x)$ is continuous on a closed interval $[a, b]$, we use the following steps to find the absolute maximum and absolute minimum.

1. Find critical numbers; that is, values of x in the domain such that $f'(x) = 0$ or $f'(x)$ is undefined.

2. Evaluate f at each critical number.

3. Evaluate $f(a)$ and $f(b)$.

4. The largest value from Steps 2 and 3 is the absolute maximum, and the smallest is the absolute minimum.

EXAMPLE 4.12

Find the absolute maximum and minimum for $f(x) = x^3 - 4x^2 + 1$ on $[-1, 5]$.

SOLUTION 4.12

We found the critical numbers for $f(x)$ in Example 4.9 at $x = 0$ and $x = \dfrac{8}{3}$. Proceed to Step 2.

$f(0) = 0^3 - 4(0)^2 + 1 = 1$ Evaluate f at each critical number.

$f(\dfrac{8}{3}) = (\dfrac{8}{3})^3 - 4(\dfrac{8}{3})^2 + 1 = -\dfrac{229}{27} \approx -8.5$

$f(-1) = (-1)^3 - 4(-1)^2 + 1 = -4$ Evaluate f at the endpoints of the interval, $x = -1$ and $x = 5$.

$f(5) = (5)^3 - 4(5)^2 + 1 = 26$

The absolute maximum of 26 occurs when $x = 5$ and the absolute minimum of $-\dfrac{229}{27}$ occurs when $x = \dfrac{8}{3}$.

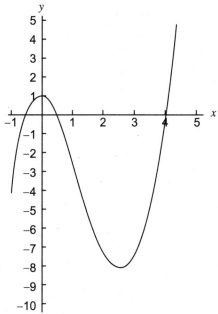

Note from Example 4.12 that an absolute maximum or minimum may occur at either an endpoint of the closed interval *or* a critical number.

EXAMPLE 4.13

Find the absolute maximum and minimum for $f(x) = \sin x$ on $[0, \pi]$.

SOLUTION 4.13

$f'(x) = \cos x$ Find $f'(x)$.

$\cos x = 0$ Set $f'(x) = 0$.

$x = \dfrac{\pi}{2}$ $\dfrac{\pi}{2}$ is a critical number.

$f(\dfrac{\pi}{2}) = \sin \dfrac{\pi}{2} = 1$ Evaluate f at the critical number and each endpoint.

$f(0) = \sin 0 = 0$

$f(\pi) = \sin \pi = 0$

Thus, the absolute maximum of 1 occurs at $x = \dfrac{\pi}{2}$, and the absolute minimum of 0 occurs at $x = 0$ and $x = \pi$.

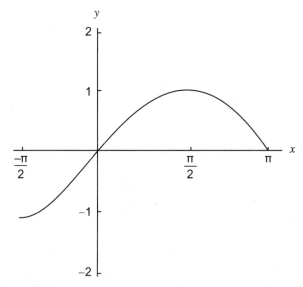

Note from Example 4.13 that extrema are y-values, not x-values.

4.4 THE FIRST AND SECOND DERIVATIVE TEST AND CONCAVITY

The next section makes use of the first and second derivative of a function to determine features of the graph of a function. We begin with finding relative extrema and then intervals where the graph is concave up and down. This section concludes with using the second derivative test for finding relative extrema.

RELATIVE EXTREMA

When a function is *not* defined on a closed interval, we are not guaranteed an absolute maximum and minimum. We can, however, find **relative extrema** using the First Derivative Test. The **First Derivative Test** states that if the sign of the first derivative changes beside a critical number, *c,* then *f(c)* is a relative maximum or minimum. The following steps apply when *f* is a continuous function on an open interval, differentiable except possibly at a critical number.

1. Find $f'(x)$.
2. Find critical numbers; that is, where $f'(c) = 0$ and where $f'(c)$ is undefined.
3. Draw a number line, dot in the critical number(s), and determine the sign of $f'(x)$ in each region.
4. Use the following guides to determine whether $f'(c)$ is a relative maximum or minimum.

sign of $f'(x)$ + | – *f(c)* is a relative maximum.
 c

sign of $f'(x)$ – | + *f(c)* is a relative minimum.
 c

sign of $f'(x)$ – | – + | + *f(c)* is neither a relative maximum nor minimum.
 c or *c*

EXAMPLE 4.14

Find the relative extrema for $f(x) = x^3 - 4x^2 + 1$.

SOLUTION 4.14

You found the critical numbers for this continuous function in Example 4.9. You found the following sign changes for $f'(x)$.

sign of $f'(x)$ + | – | +
 0 8/3

The First Derivative Test tells us that:

$x = 0$ is a relative maximum Sign change + to –.

$x = \dfrac{8}{3}$ is a relative minimum Sign change – to +.

When $x = 0$, $f(0) = 1$ is a relative maximum.

When $x = \dfrac{8}{3}$, $f(\dfrac{8}{3}) = -\dfrac{229}{27}$ is a relative minimum.

(See graph accompanying Example 4.11.)

EXAMPLE 4.15

Find the open intervals on which $f(x) = 3x^4 - x^3 - 24x^2 + 12x$ is increasing or decreasing and find all relative extrema.

SOLUTION 4.15

$f'(x) = 12x^3 - 3x^2 - 48x + 12$	Find $f'(x)$.
$12x^3 - 3x^2 - 48x + 12 = 0$	Set $f'(x) = 0$ to find critical number(s).
$3x^2(4x - 1) - 12(4x - 1) = 0$	Factor by grouping.
$(4x - 1)(3x^2 - 12) = 0$	Factor by grouping.
$4x - 1 = 0$ or $3x^2 - 12 = 0$	Set each factor equal to 0 and solve.

$$x = \frac{1}{4} \qquad x = \pm 2$$

sign of $f'(x)$ – + – + Determine the sign of $f'(x)$ in each region.

$$-2 \quad 1/4 \quad 2$$

$f(x)$ is increasing on $(-2, \frac{1}{4})$ and $(2, \infty)$.

$f(x)$ is decreasing on $(-\infty, -2)$ and $(\frac{1}{4}, 2)$.

$f(-2) = -64$ is a relative minimum. Sign changes – to +.

$f(\frac{1}{4}) = \frac{383}{256}$ is a relative maximum. Sign changes + to –.

$f(2) = -32$ is a relative minimum. Sign changes – to +.

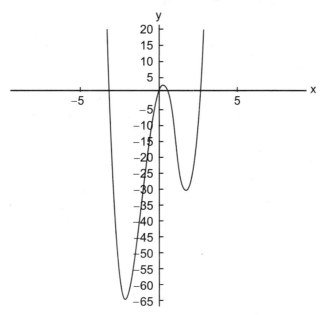

CONCAVITY

When the graph of a function $f(x)$ lies above its tangent lines, $f(x)$ is concave upward. When the graph of $f(x)$ lies below its tangent lines, $f(x)$ is concave downward. It may also help to think of "holding water" (concave up) or "pouring water" (concave down). Because a function is concave up when $f''(x) > 0$ and concave down when $f''(x) < 0$, we can use the following steps to determine the concavity of a differentiable function.

1. Find $f''(x)$.
2. Find x values where $f''(x) = 0$ and where $f''(x)$ is undefined.
3. Draw a number line, dot in values found in Step 2, and determine the sign of $f''(x)$ in each region.
4. The function is concave upward where $f''(x) > 0$ and concave downward where $f''(x) < 0$.

EXAMPLE 4.16

Determine the intervals where $f(x) = x^3 - 4x^2 + 1$ is concave upward and downward.

SOLUTION 4.16

$f'(x) = 3x^2 - 8x$	Find $f'(x)$.
$f''(x) = 6x - 8$	Find $f''(x)$.
$6x - 8 = 0$	Set $f''(x) = 0$
$x = \dfrac{8}{6} = \dfrac{4}{3}$	Solve for x.

Sign of $f''(x)$ $\quad \underline{\quad - \quad | \quad + \quad}$

Dot in $x = \dfrac{4}{3}$. Find the sign of $f''(x)$ in each region.

4/3

$f(x)$ is concave downward on $(-\infty, \dfrac{4}{3})$.

$f(x)$ is concave upward on $(\dfrac{4}{3}, \infty)$.

EXAMPLE 4.17

Determine the intervals where $f(x) = \dfrac{1}{x^2 - 4}$ is concave upward or downward.

SOLUTION 4.17

$f(x) = (x^2 - 4)^{-1}$	Rewrite $f(x)$.
$f'(x) = -1(x^2 - 4)^{-2}(2x)$	Use the Chain Rule.
$f'(x) = -2x(x^2 - 4)^{-2}$	Simplify.

$f''(x) = (x^2 - 4)^{-2}(-2) + (-2x)(-4x(x^2-4)^{-3})$ $-2x$ $+$ $(x^2-4)^{-2}$

-2 $-2(x^2-4)^{-3}(2x)$

$f''(x) = -2(x^2-4)^{-3} [(x^2-4) + x(-4x)]$ Factor.

$f''(x) = -2(x^2-4)^{-3}(-3x^2-4)$ Simplify.

$f''(x) = \dfrac{2(3x^2+4)}{(x^2-4)^3}$ Simplify.

$f''(x) = 0$ when the numerator equals 0.

$2(3x^2 + 4) = 0$ Set $f''(x) = 0$.

$3x^2 + 4 = 0$ Solve for x.

$x^2 = -\dfrac{4}{3}$ This has no real solutions.

$f''(x)$ is undefined when the denominator equals 0.

$(x^2 - 4)^3 = 0$ Set denominator $= 0$.

$x^2 - 4 = 0$ Solve for x.

$x = \pm 2$

sign of $f''(x)$ $+$ $-$ $+$ Determine the sign of $f''(x)$ in each region.

-2 2

$f(x)$ is concave upward on $(-\infty, -2)$ and $(2, \infty)$.
$f(x)$ is concave downward on $(-2, 2)$.

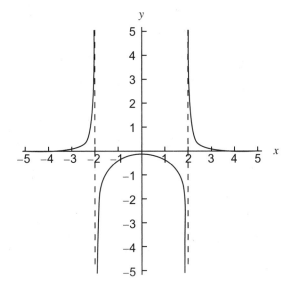

INFLECTION POINTS

The point where a function changes from being concave upward to concave downward or vice versa is called an **inflection point.** The procedure for finding inflection points is the same as the procedure for finding intervals of concavity. Be careful to determine whether the x-values where the concavity changes are in the domain of $f(x)$.

EXAMPLE 4.18

Find the inflection point(s), if any, for each function.

a) $f(x) = x^3 - 4x^2 + 1$

b) $f(x) = \dfrac{1}{x^2 - 4}$

c) $f(x) = \tan x$ on $\left(-\dfrac{\pi}{2}, \dfrac{\pi}{2} \right)$

SOLUTION 4.18

a) The graph of $f(x) = x^3 - 4x^2 + 1$ follows.

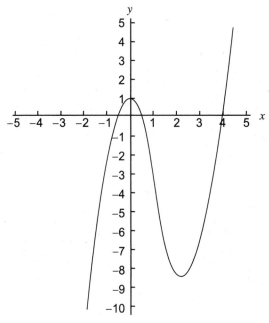

Returning to Example 4.15, we know

sign of $f''(x)$ $\xleftarrow{\quad - \;\vdots\; + \quad}$
 $\scriptstyle 4/3$

Thus, the concavity changes at $x = \dfrac{4}{3}$. The inflection point is

$(\dfrac{4}{3}, f(\dfrac{4}{3})) = (\dfrac{4}{3}, -\dfrac{101}{27})$

b) Returning to Example 4.16, we know

sign of $f''(x)$

However, $x = -2$ and $x = 2$ are not x-values for inflection points, because the denominator of $f(x) = \dfrac{1}{x^2 - 4}$ does not include -2 and 2. (These are vertical asymptotes for the graph.) There are no inflection points for $f(x)$.

c) $f'(x) = \sec^2 x$ Find the first derivative.

 $f''(x) = 2\sec x \sec x \tan x$ Find the second derivative using the Chain Rule.

 $= 2\sec^2 x \tan x$ Simplify.

 $\tan x = 0$ Set the second derivative equal to 0. Because $\sec x \neq 0$, we consider only where $\tan x = 0$.

 $x = 0$ In the given interval, only $x = 0$ is a possible solution.

Sign of $f''(x)$

Thus, $(0, f(0)) = (0, \tan 0) = (0, 0)$ is an inflection point on $\left(-\dfrac{\pi}{2}, \dfrac{\pi}{2}\right)$. A graph is shown in the following figure.

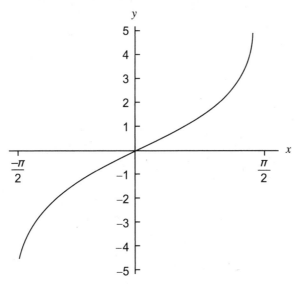

SECOND DERIVATIVE TEST

An alternate technique exists for finding relative extrema. This technique is based on the Second Derivative Test. To find relative extrema using the **Second Derivative Test**:

1. Find $f'(x)$.
2. Find $f''(x)$.
3. Solve $f'(c) = 0$.
4.

 a) If $f''(c) > 0$, then $f(c)$ is a relative minimum

 b) If $f''(c) < 0$, then $f(c)$ is a relative maximum.

 c) If $f''(c) = 0$, return to the First Derivative Test to analyze $f(c)$.

EXAMPLE 4.19

Use the Second Derivative Test to find the relative extrema for each function.

 a) $f(x) = 2x^4 + 3x^3 - 1$

 b) $f(x) = \sin x + \cos x$ on $[0, 2\pi]$

 c) $f(x) = x^5 - x^4 + 1$

SOLUTION 4.19

a) $f(x) = 2x^4 + 3x^3 - 1$

$f'(x) = 8x^3 + 9x^2$	Find $f'(x)$.
$f''(x) = 24x^2 + 18x$	Find $f''(x)$.
$8x^3 + 9x^2 = 0$	Set $f'(x) = 0$.
$x^2(8x + 9) = 0$	Factor.
$x = 0$ or $x = -\dfrac{9}{8}$	Solve.
$f''(0) = 24(0)^2 + 18(0) = 0$	Find $f''(0)$.
$f''(-\dfrac{9}{8}) = 24(-\dfrac{9}{8})^2 + 18(-\dfrac{9}{8}) = \dfrac{81}{8}$	Find $f''(-\dfrac{9}{8})$.

Because $f''(0) = 0$, the Second Derivative Test fails.

First Derivative Test:

Because there is no sign change, $(0, -1)$ is neither a relative maximum nor a relative minimum.

Because $f''\left(-\dfrac{9}{8}\right) > 0$, $(-\dfrac{9}{8}, -2.07)$ is a relative minimum.

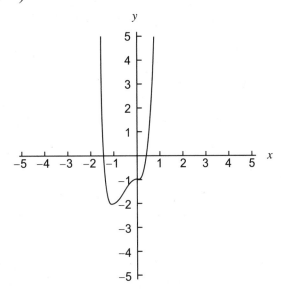

b) $f(x) = \sin x + \cos x$

$f'(x) = \cos x - \sin x$	Find $f'(x)$.
$f''(x) = -\sin x - \cos x$	Find $f''(x)$.
$\cos x - \sin x = 0$	Set $f'(x) = 0$.
$\cos x = \sin x$	Add $\sin x$ to both sides.
$\dfrac{\cos x}{\cos x} = \dfrac{\sin x}{\cos x}$	Divide by $\cos x$.
$1 = \tan x$	Use $\dfrac{\sin x}{\cos x} = \tan x$.
$x = \dfrac{\pi}{4}, \dfrac{5\pi}{4}$	The $\tan x$ is positive in QI and QIII.

$$f''\left(\dfrac{\pi}{4}\right) = -\sin\dfrac{\pi}{4} - \cos\dfrac{\pi}{4} = -\dfrac{\sqrt{2}}{2} - \dfrac{\sqrt{2}}{2} = -\sqrt{2}$$

$$f''\left(\dfrac{5\pi}{4}\right) = -\sin\dfrac{5\pi}{4} - \cos\dfrac{5\pi}{4} = -\left(-\dfrac{\sqrt{2}}{2}\right) - \left(-\dfrac{\sqrt{2}}{2}\right) = \sqrt{2}$$

Because $f''\left(\dfrac{\pi}{4}\right) < 0$, $(\dfrac{\pi}{4}, \sqrt{2})$ is a relative maximum.

Because $f''\left(\dfrac{5\pi}{4}\right) > 0$, $(\dfrac{5\pi}{4}, -\sqrt{2})$ is a relative minimum. The graph is as follows.

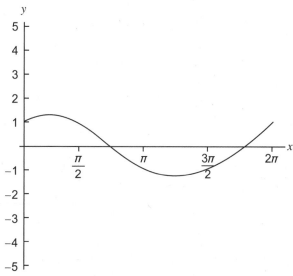

c) $f(x) = x^5 - x^4 + 1$

$f'(x) = 5x^4 - 4x^3$	Find the first derivative.
$f''(x) = 20x^3 - 12x^2$	Find the second derivative.
$5x^4 - 4x^3 = 0$	Set the first derivative equal to 0.
$x^3(5x - 4) = 0$	Factor.
$x = 0$ or $x = \dfrac{4}{5}$	Set each factor equal to 0 and solve.
$f''(0) = 20(0)^3 - 12(0)^2 = 0$	The test fails.

$f''(\dfrac{4}{5}) = 20(\dfrac{4}{5})^3 - 12(\dfrac{4}{5})^2 = 2\dfrac{14}{25}$ $f''(\dfrac{4}{5}) > 0.$

Because the second derivative at $x = \dfrac{4}{5}$ is positive, the function has a relative minimum at $(\dfrac{4}{5}, \dfrac{2869}{3125})$. Because $f''(0) = 0$, we use the First Derivative Test:

$$\text{sign of } f'(x) \quad \underline{\qquad + \quad \vdots \quad - \qquad}$$

$$0$$

By the First Derivative Test, $f(0) = 1$ is a relative maximum. Although a graph follows, it is difficult to see the relative extrema. If you have access to technology, try to view the relative maximum by zooming in.

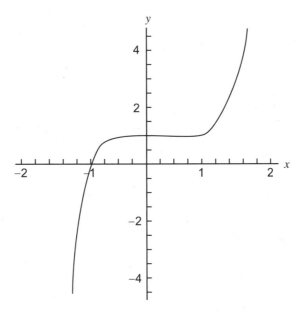

4.5 LIMITS AT INFINITY AND INFINITE LIMITS

The next section presents the language and techniques for finding limits as x approaches positive or negative infinity and for finding infinite limits, that is, where y approaches positive or negative infinity.

LIMITS AT INFINITY

The topic of horizontal asymptotes is studied in precalculus courses. We can now examine that topic using limit notation. If a function $f(x)$ approaches a y-value L as x approaches positive infinity, we write

$$\lim_{x \to \infty} f(x) = L$$

We call $y = L$ a horizontal asymptote of $f(x)$. If a function $f(x)$ approaches a y-value of N as x approaches negative infinity we write

$$\lim_{x \to -\infty} f(x) = N$$

and $y = N$ is a horizontal asymptote for $f(x)$. We use the following procedure to evaluate limits as x approaches positive or negative infinity (and find horizontal asymptotes).

To evaluate limits at infinity

1. Divide each term in the numerator and denominator by the highest power of x in the denominator.

2. Use the fact that the limit of a constant divided by a rational power of x as x approaches infinity equals 0 (and $\lim\limits_{x \to -\infty} \dfrac{c}{x^r} = 0$ provided x^r is defined for $x < 0$ and $r > 0$) to evaluate each limit within the numerator and denominator.

EXAMPLE 4.20

Find each limit,

a) $\lim\limits_{x\to\infty} \dfrac{4x-1}{x^2-9}$

b) $\lim\limits_{x\to\infty} \dfrac{3x-1}{2x+5}$

c) $\lim\limits_{x\to\infty} \dfrac{x^3+4x+1}{x^2+2}$

SOLUTION 4.20

a) $\lim\limits_{x\to\infty} \dfrac{4x-1}{x^2-9} = \lim\limits_{x\to\infty} \dfrac{\dfrac{4x}{x^2}-\dfrac{1}{x^2}}{\dfrac{x^2}{x^2}-\dfrac{9}{x^2}}$ Divide each term by x^2.

$= \lim\limits_{x\to\infty} \dfrac{\dfrac{4}{x}-\dfrac{1}{x^2}}{1-\dfrac{9}{x^2}}$ Simplify.

$= \dfrac{0-0}{1-0} = \dfrac{0}{1} = 0$ Evaluate each limit.

b) $\lim\limits_{x\to\infty} \dfrac{3x-1}{2x+5} = \lim\limits_{x\to\infty} \dfrac{\dfrac{3x}{x}-\dfrac{1}{x}}{\dfrac{2x}{x}+\dfrac{5}{x}}$ Divide each term by x.

$= \lim\limits_{x\to\infty} \dfrac{3-\dfrac{1}{x}}{2+\dfrac{5}{x}}$ Simplify.

$= \dfrac{3-0}{2+0} = \dfrac{3}{2}$ Evaluate each limit.

c) $\lim\limits_{x\to\infty} \dfrac{x^3+4x+1}{x^2+2} = \lim\limits_{x\to\infty} \dfrac{\dfrac{x^3}{x^2}+\dfrac{4x}{x^2}+\dfrac{1}{x^2}}{\dfrac{x^2}{x^2}+\dfrac{2}{x^2}}$ Divide each term by x^2.

$= \lim\limits_{x\to\infty} \dfrac{x+\dfrac{4}{x}+\dfrac{1}{x^2}}{1+\dfrac{2}{x^2}}$ Simplify.

$= \lim\limits_{x\to\infty} \dfrac{x}{1}$ Evaluate each limit.

Because the x increases without bound, this limit does not exist.

EXAMPLE 4.21

Find the horizontal asymptote(s) for each function.

a) $f(x) = \dfrac{4x-1}{x^2-9}$

b) $f(x) = 3 + \dfrac{x}{x-1}$

SOLUTION 4.21

a) In Example 4.19, we found that the $\displaystyle\lim_{x\to\infty}\dfrac{4x-1}{x^2-9} = 0$, which also means that $y = 0$ is

the horizontal asymptote for the graph of the function. In precalculus, this value was found by comparing the highest power in the numerator to the highest power in the denominator. Because $1 < 2$, we concluded that the horizontal asymptote was $y = 0$.

b) $\displaystyle\lim_{x\to\infty}\left(3 + \dfrac{x}{x-1}\right) = \lim_{x\to\infty}3 + \lim_{x\to\infty}\dfrac{x}{x-1}$ Find the limit as x approaches ∞.

$= 3 + \displaystyle\lim_{x\to\infty}\dfrac{\dfrac{x}{x}}{\dfrac{x}{x}-\dfrac{1}{x}}$ The limit of a constant is the constant.

Divide by the highest power of x in the denominator.

$= 3 + \dfrac{1}{1-0} = 3 + 1 = 4$ Simplify. $\dfrac{x}{x} = 1$ and $\displaystyle\lim_{x\to\infty}\dfrac{1}{x} = 0$.

Thus, $y = 4$ is the horizontal asymptote. The graph is shown below, with the horizontal asymptote shown as a dotted line.

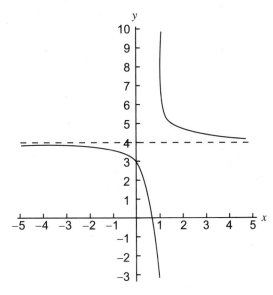

EXAMPLE 4.22

Find each limit.

a) $\lim\limits_{x \to -\infty} \dfrac{3x+5}{x-2}$

b) $\lim\limits_{x \to -\infty} \dfrac{x^2+6x}{x^3-1}$

SOLUTION 4.22

a) $\lim\limits_{x \to -\infty} \dfrac{3x+5}{x-2} = \lim\limits_{x \to -\infty} \dfrac{\dfrac{3x}{x}+\dfrac{5}{x}}{\dfrac{x}{x}-\dfrac{2}{x}}$ Divide each term by x.

$= \lim\limits_{x \to -\infty} \dfrac{3+\dfrac{5}{x}}{1-\dfrac{2}{x}}$ Simplify.

$= \dfrac{3+0}{1-0} = 3$ Evaluate each limit and simplify.

b) $\lim\limits_{x \to -\infty} \dfrac{x^2+6x}{x^3-1} = \lim\limits_{x \to -\infty} \dfrac{\dfrac{x^2}{x^3}+\dfrac{6x}{x^3}}{\dfrac{x^3}{x^3}-\dfrac{1}{x^3}}$ Divide each term by x^3.

$= \lim\limits_{x \to -\infty} \dfrac{\dfrac{1}{x}+\dfrac{6}{x^2}}{1-\dfrac{1}{x^3}}$ Simplify.

$= \dfrac{0+0}{1-0} = \dfrac{0}{1} = 0$ Evaluate each limit and simplify.

INFINITE LIMITS

We use the definition of an infinite limit to help describe when the *y* values of a function increase or decrease without bound as the *x* values approach some number *c*. The following list presents the various situations and associated notation.

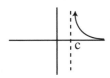

$$\lim_{x \to c^+} f(x) = +\infty$$ $$\lim_{x \to c^-} f(x) = \infty$$ $$\lim_{x \to c^-} f(x) = +\infty$$

$$\lim_{x \to c^-} f(x) = -\infty$$ $$\lim_{x \to c} f(x) = \infty$$ $$\lim_{x \to c} f(x) = -\infty$$

These infinite limits occur around vertical asymptotes; that is, where the denominator of a function is *not* a factor of the numerator and equals 0. We can often use reasoning to find these limits. Study Example 4.23.

EXAMPLE 4.23

Find each limit.

a) $\displaystyle \lim_{x \to 1^+} \frac{5}{x-1}$

b) $\displaystyle \lim_{x \to 1^-} \frac{5}{x-1}$

c) $\displaystyle \lim_{x \to 1} \frac{5}{x-1}$

d) $\displaystyle \lim_{x \to 2^+} \frac{4x}{(x-2)^2}$

e) $\displaystyle \lim_{x \to 2^-} \frac{4x}{(x-2)^2}$

f) $\displaystyle \lim_{x \to 2} \frac{4x}{(x-2)^2}$

SOLUTION 4.23

a) We reason in the following manner: As x approaches 1 from the right, $x - 1$ will be positive. The numerator is always positive. Thus,

$$\lim_{x \to 1^+} \frac{5}{x-1} = +\infty.$$

b) As x approaches 1 from the left, $x - 1$ will be negative. The numerator is always positive. Thus,

$$\lim_{x \to 1^-} \frac{5}{x-1} = -\infty.$$

c) Because the limit from the right (see Part a) and the limit from the left (see Part b) are not equal, $\lim_{x \to 1} \dfrac{5}{x-1}$ does not exist.

d) & e) As x approaches 2 from the left or right, $(x - 2)^2$ will always be positive. The numerator will be positive when x approaches 2 from the left or right. Thus,

$$\lim_{x \to 2^+} \frac{4x}{(x-2)^2} = \lim_{x \to 2^-} \frac{4x}{(x-2)^2} = +\infty.$$

f) Because the limit from the left and the limit from the right both equal $+\infty$, we write

$$\lim_{x \to 2} \frac{4x}{(x-2)^2} = +\infty.$$

4.6 GRAPHING USING THE TOOLS OF CALCULUS

We can now put all our techniques for analyzing graphs of functions together to draw a sophisticated graph. We can summarize the various graphing aids which can be used to sketch a function. This list is not meant to be memorized, but to act as a guide to help you prepare a sophisticated graph of a function.

1. Find the domain of $f(x)$.
2. Find the x-intercept(s) and the y-intercept.
3. Check for symmetry with respect to the y axis and origin.
4. Dot in horizontal and vertical asymptotes.
5. Find relative extrema.
6. Find intervals where $f(x)$ is increasing and decreasing (use the first derivative) and where $f(x)$ is concave upward and downward (use the second derivative).
7. Note any points of inflection.

EXAMPLE 4.24

Sketch the graph of $f(x) = (x - 1)^2(x + 2)$.

SOLUTION 4.24

Step 1: The domain is all real numbers, because this is a polynomial function.

Step 2: If $y = 0$, $(x - 1)^2 (x + 2) = 0$ means $x = 1$ or $x = -2$.

 If $x = 0$, $f(0) = (0 - 1)^2 (0 + 2) = 2$.

 The x-intercepts are 1 and -2.

 The y-intercept is 2.

Step 3: Replacing x with $-x$ does not yield an equivalent equation, so $f(x)$ is not symmetric with respect to the y axis. Replacing x with $-x$ and y with $-y$ does not yield an equivalent equation, so $f(x)$ is not symmetric with respect to the origin.

Step 4: No asymptotes, because this is a polynomial function.

Step 5: $f'(x) = (x + 2)(2)(x - 1) + (x - 1)^2$

 $f'(x) = (x - 1)(2x + 4 + x - 1)$

 $f'(x) = (x - 1)(3x + 3)$

 $f'(x) = 0$ when $x = 1$ and $x = -1$.

We find increasing and decreasing intervals and relative extrema with the first derivative:

Sign of $f'(x)$

 $f(x)$ is increasing on $(-\infty, -1)$ and $(1, \infty)$.

 $f(x)$ is decreasing on $(-1, 1)$.

 $(-1, f(-1)) = (-1, 4)$ is a relative maximum.

 $(1, f(1)) = (1, 0)$ is a relative minimum.

Step 6: It's easier to multiply out $f'(x)$ before finding $f''(x)$.

 $f'(x) = (x - 1)(3x + 3) = 3x^2 - 3$

 $f''(x) = 6x$

 $f''(x) = 0$ when $x = 0$

 Sign of $f''(x)$

$$- \quad | \quad +$$
$$0$$

 $f(x)$ is concave downward on $(-\infty, 0)$.

 $f(x)$ is concave upward on $(0, -\infty)$.

Step 7: $(0, f(0))$, $= (0, 2)$ is an inflection point.

Putting all this information together we have:

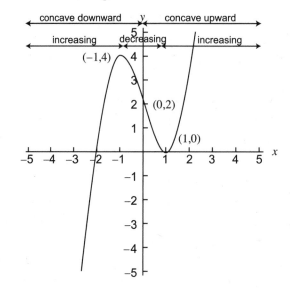

EXAMPLE 4.25

Sketch the graph of $f(x) = \dfrac{x}{x^2 - 4}$.

SOLUTION 4.25

Step 1: To find the domain, set the denominator equal to 0 to find restricted values.

$x^2 - 4 = 0$

$x^2 = 4$

$x = \pm 2$

The domain is all real numbers *except* -2 and 2.

Step 2: If $y = 0$, $x = 0$

If $x = 0$, $y = 0$

$(0, 0)$ is the *x*-intercept and *y*-intercept.

Step 3: Replacing x with $-x$ and y with $-y$ yields an equivalent equation, so $f(x)$ is symmetric with respect to the origin.

Step 4: There are vertical asymptotes at $x = 2$ and $x = -2$. To find horizontal asymptotes, check the limit of $f(x)$ as x approaches positive and negative infinity.

$$\lim_{x \to \infty} \frac{x}{x^2 - 4} = \lim_{x \to \infty} \frac{\dfrac{x}{x^2}}{\dfrac{x^2}{x^2} - \dfrac{4}{x^2}} = \lim_{x \to \infty} \frac{\dfrac{1}{x}}{1 - \dfrac{4}{x^2}} = \frac{0}{1 - 0} = 0$$

$\lim\limits_{x \to -\infty} \dfrac{x}{x^2 - 4}$ also equals 0, so $y = 0$ is a horizontal asymptote for the function.

Step 5: $f'(x) = \dfrac{(x^2-4)(1)-x(2x)}{(x^2-4)^2}$

$f'(x) = \dfrac{-x^2-4}{(x^2-4)^2}$

Note that there are no critical numbers. The numerator can never equal 0, and the values in the denominator that cause $f'(x)$ to be undefined occur at the vertical asymptotes. We must still check the sign of the first derivative around –2 and 2.

Sign of $f'(x)$

$$-\quad|\quad -\quad|\quad -$$
$$\qquad\;-2\qquad\; 2$$

$f(x)$ is decreasing on $(-\infty, -2)$, $(-2, -2)$ and $(2, \infty)$.

There are no maximums or minimums, because there are no critical numbers.

Step 6:

Use the Quotient Rule to find $f''(x)$.

$f''(x) = \dfrac{(x^2-4)^2(-2x)-(-x^2-4)(4x)(x^2-4)}{(x^2-4)^4}$

$f''(x) = \dfrac{-2x(x^2-4)[(x^2-4)+(-x^2-4)(2)]}{(x^2-4)^4}$ Factor.

$f''(x) = \dfrac{-2x(x^2-4)(-x^2-12)}{(x^2-4)^4}$ Simplify.

$f''(x) = \dfrac{2x(x^2+12)}{(x^2-4)^3}$ Reduce.

$f''(x) = 0$ when $2x(x^2 + 12) = 0$, which is only true when $x = 0$, because $x^2 + 12$ cannot equal 0. $f''(x)$ is undefined when $(x^2 – 4) = 0$, which is when $x = \pm2$.

Sign of $f''(x)$

$$-\quad|\quad +\quad|\quad -\quad|\quad +$$
$$\quad-2\quad\;0\quad\;+2$$

$f(x)$ is concave upward on $(-2, 0)$ and $(2, \infty)$.

$f(x)$ is concave downward on $(-\infty, -2)$ and $(0, 2)$.

Step 7: Because the sign of $f''(x)$ changes when $x = 0$, $(0, 0)$ is an inflection point. Note that $x = -2$ and $x = 2$ cannot be x-coordinates of inflection points, because they are not in the domain of $f(x)$.

Putting all this information together we have the following graph:

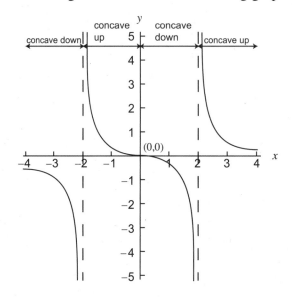

4.7 APPLICATIONS INVOLVING MAXIMUMS AND MINIMUMS

Applications involving maximums and minimums generally contain information to form two equations. One of these equations will be the function whose maximum or minimum we seek. The other equation should relate the variables in such a way that we can solve for x or y. A general procedure is outlined as follows:

1. Draw and label a sketch, as necessary. Identify what each variable represents.

2. Write an equation that represents what is to be maximized or minimized. This equation will be in the form $F = $ ------, where F is the name you choose for your function.

3. Write an equation that relates the variables from F. Solve this equation for x or y.

4. Substitute for x or y in F.

5. Find extrema by finding F', then critical numbers, and using the First or Second Derivative Tests.

6. Answer the original question, using appropriate units of measurement (feet, inches, and so on).

EXAMPLE 4.26

Find two positive numbers whose sum is 56 and whose product is a maximum.

SOLUTION 4.26

Let x = one number; y = other number	Identify what each variable represents.
$P = xy$	Let P represent the product.
$x + y = 56$	Write an equation that relates x and y.
$y = 56 - x$	Solve for y.
$P = x(56 - x)$	Substitute into P.
$P = 56x - x^2$	Simplify.
P'	Find P'.
$56 - 2x = 0$	Find critical numbers.
$x = 28$	

$P'' = -2$ which means $x = 28$ is a maximum.
(Second derivative < 0 implies maximum)
If $x = 28$, $y = 56 - x = 56 - 28 = 28$.

The two numbers are 28 and 28. Answer the original question.

EXAMPLE 4.27

A farmer wishes to enclose two identical adjacent rectangular areas, each with 400 square feet of area. What dimensions should be use to minimize the amount of fencing required?

SOLUTION 4.27

Draw a sketch and label the sides.

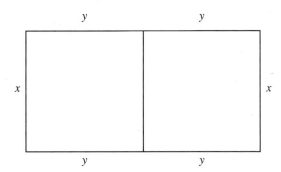

Then we know

$xy = 400$	Enclosed area of each is 400 sq. ft.
$F = 3x + 4y$	Let F equal the amount of fencing.
$F = 3x + 4\left(\dfrac{400}{x}\right)$	$xy = 400 \Rightarrow y = \dfrac{400}{x}$
$F = 3x + 1{,}600x^{-1}$	Simplify F.
$F' = 3 - 1{,}600x^{-2}$	Find F'.
$F' = \dfrac{3x^2 - 1{,}600}{x^2}$	$x^{-2} = \dfrac{1}{x^2}$. Get a common denominator.

Find critical numbers:

$3x^2 - 1,600 = 0$ Set the numerator equal to 0.

$x = \pm \sqrt{\dfrac{1,600}{3}}$

$x = \pm \dfrac{40}{\sqrt{3}}$

$x^2 = 0$ Set denominator equal to 0.

$x = 0$

Neither 0 nor $-\dfrac{40}{\sqrt{3}}$ can be the answer, because neither makes sense for the length of a side.

Let's check $x = \dfrac{40}{\sqrt{3}}$ in the Second Derivative Test:

$F'' = \dfrac{x^2(6x) - (3x^2 - 1600)(2x)}{x^4}$ Use the Quotient Rule.

$F'' = \dfrac{6x^3 - 6x^3 + 3,200x}{x^4}$ Simplify.

$F'' = \dfrac{3,200}{x^3}$ Reduce.

$F''\left(\dfrac{40}{\sqrt{3}}\right) > 0 \Rightarrow x = \dfrac{40}{\sqrt{3}}$ is a minimum.

When $x = \dfrac{40}{\sqrt{3}}$, $y = \dfrac{400}{\frac{40}{\sqrt{3}}} = 10\sqrt{3}$.

The dimensions are $\dfrac{40}{\sqrt{3}}$ feet by $10\sqrt{3}$ feet or approximately 23 feet by 17 feet.

SUMMARY

This chapter contained three important applications of derivatives: related rates, graphing, and maximum-minimum word problems. We found maximums and minimums using the First Derivative Test (find critical numbers, test for sign changes on either side of them) and the Second Derivative Test (find critical numbers, substitute them into the second derivative, if $f''(c) < 0$, c is a maximum and if $f''(c) > 0$, c is a minimum). The following chapters focus on integration and you will find that your skills with derivatives are essential to success with integration.

TEST YOURSELF

1) Use implicit differentiation to find the derivative with respect to time.

 a) $A = \dfrac{\sqrt{3}}{4}s^2$

 b) $V = s^3$

 c) $S = 4\pi r^2$

 d) $C = 2\pi r$

 e) $A = \dfrac{1}{2}bh$ (Hint: Use Product Rule.)

2) Oil spills into a lake in a circular pattern. If the radius of the circle increases at a rate of 6 inches per minute, how fast is the area of the spill increasing at the end of 1 hour? Give your answer in ft^2/ min.

3) Air is being pumped into a spherical balloon at a rate of 4 cubic inches per minute. Find the rate of change of the radius when the radius is 8 inches.

4) A 10-foot ladder is leaning against the wall of a house. The base of the ladder slides away from the wall at a rate of 3 inches per second. How fast is the top of the ladder moving down the wall when the base is 5 feet from the wall?

5) A weather balloon is released 20 feet from an observer. It rises at a rate of 4 feet per second. How fast is the angle of elevation changing when the balloon is 20 feet high?

6) The sides of a cube increase at a rate of 2 cm per minute. How fast is the volume changing when the sides are 10 cm long?

7) Sand falls onto a conical pile at a rate of 10 cubic inches per minute. If the diameter of the base of the cone is three times the height of the cone, how fast is the height increasing when the radius is 1 foot? (Hint: Note the different units.)

8) Find the differential, dy, for each function.

 a) $y = 2x^4 - 3x^2 + 4$

 b) $y = (x^2 + 6x)^4$

 c) $y = x\cos 2x$

 d) $y = \dfrac{2x}{x^2 + 1}$

9) Use differentials to approximate.

 a) $\sqrt{4.2}$

 b) $\sqrt{3.8}$

10) Find the intervals on which the function is increasing and decreasing.

 a) $f(x) = x^4 - 2x^2 + 1$

 b) $f(x) = \dfrac{2x^2}{4x^2 - 1}$

 c) $f(x) = \dfrac{1}{3}x^3 - x^2 - 3x$

 d) $f(x) = \sqrt{2x - 1}$

11) Find the absolute maximum and minimum on the indicated closed interval.

 a) $f(x) = x2 + 2x - 1$ on $[-2, 2]$

 b) $f(x) = 2\cos x$ on $[0, 3\pi/2]$

 c) $f(x) = \dfrac{1}{3}x^3 + \dfrac{7}{2}x^2 + 10x$ on $[-3, 0]$

12) Find the relative extrema for each function.

a) $f(x) = \dfrac{1}{3}x^3 + x^2 - 3x + 2$

b) $f(x) = \dfrac{x-3}{2x+1}$

c) $f(x) = \dfrac{1}{4}x^4 - x^3 - \dfrac{1}{2}x^2 + 3x$

13) Determine the intervals where the function is concave upward and concave downward.

a) $f(x) = \dfrac{1}{12}x^4 - \dfrac{1}{2}x^3 - 5x^2$

b) $f(x) = \dfrac{4x}{x-2}$

c) $f(x) = \dfrac{2}{3}x^3 - \dfrac{7}{2}x^2 - 4x$

14) Find the inflection point(s), if any, for each function.

a) $f(x) = \dfrac{1}{12}x^4 - \dfrac{1}{2}x^3 - 5x^2$

b) $f(x) = \dfrac{4x}{x-2}$

c) $f(x) = \dfrac{2}{3}x^3 - \dfrac{7}{2}x^2 - 4x$

15) Use the Second Derivative Test to find the relative extrema for each function.

a) $f(x) = \dfrac{1}{3}x^3 - 2x^2 - 5x$

b) $f(x) = \sqrt{3}\sin x + \cos x$ on $[0, 2\pi]$

16) Find each limit.

a) $\displaystyle\lim_{x\to\infty} \dfrac{x+4}{x^2-1}$

b) $\displaystyle\lim_{x\to\infty} \dfrac{6x+1}{2x-5}$

c) $\displaystyle\lim_{x\to\infty} \dfrac{2x^2-4x+1}{x-3}$

17) Find each limit.

a) $\displaystyle\lim_{x\to-\infty} \dfrac{2x-1}{x+4}$

b) $\displaystyle\lim_{x\to-\infty} \dfrac{x^3-2x^2+4x+2}{x^2-1}$

18) Find each limit.

a) $\displaystyle\lim_{x\to 2^+} \dfrac{x}{x-2}$

b) $\displaystyle\lim_{x\to 2^-} \dfrac{x}{x-2}$

c) $\displaystyle\lim_{x\to-1^+} \dfrac{x-4}{(x+1)^2}$

d) $\displaystyle\lim_{x\to-1^-} \dfrac{x-4}{(x+1)^2}$

19) Use all the graphing skills developed to sketch each graph. Note the relative extrema, inflection points, asymptotes, increasing and decreasing intervals, and concave upward and downward intervals.

a) $f(x) = \dfrac{1}{4}x^4 - x^3 - 2x^2$

b) $f(x) = \dfrac{x^2+1}{x^2-4}$

20) Find two positive numbers whose sum is 108 and whose product is a maximum.

21) A farmer wishes to enclose three identical adjacent rectangular areas, each with 900 square feet of area. What dimension should be used to minimize the amount of fence required?

22) A box for children's Valentine's Day cards is to be made from a square piece of paper, 12 inches on each side. Equal squares are cut from each corner, and then the sides are turned up to form a box. What is the maximum volume of the box?

TEST YOURSELF ANSWERS

1)

a) $\dfrac{dA}{dt} = \dfrac{\sqrt{3}}{2}\, s\, \dfrac{ds}{dt}$

b) $\dfrac{dV}{dt} = 3s^2\, \dfrac{ds}{dt}$

c) $\dfrac{dS}{dt} = 8\pi r\, \dfrac{dr}{dt}$

d) $\dfrac{dC}{dt} = 2\pi\, \dfrac{dr}{dt}$

e) $\dfrac{dA}{dt} = \dfrac{1}{2} b\, \dfrac{dh}{dt} + \dfrac{1}{2} h\, \dfrac{db}{dt}$

2) 30π ft²/min

3) $\dfrac{1}{64\pi}$ in/min

4) $(-\sqrt{3}\,)$ in/sec

5) 0.1 rad/sec

6) 600 cm³/min

7) $\dfrac{5}{72\pi}$ in/min

8)

a) $(8x^3 - 6x)dx$

b) $8(x + 3)(x^2 + 6x)^3\, dx$

c) $(\cos 2x - 2x\sin 2x)\, dx$

d) $\dfrac{-2x^2 + 2}{(x^2 + 1)^2}\, dx$

9)

a) 2.05

b) 1.95

10)

a) increasing $(-1, 0)$ and $(1, \infty)$; decreasing $(-\infty, -1)$ and $(0, 1)$

b) increasing $(-\infty, -1/2)$ and $(-1/2, 0)$; decreasing $(0, 1/2)$ and $(1/2, \infty)$

c) increasing on $(-\infty, -1)$ and $(3, \infty)$; decreasing on $(-1, 3)$

d) increasing on $\left(\dfrac{1}{2}, \infty\right)$

11)

a) absolute maximum $(2, 7)$; absolute minimum $(-1, -2)$

b) absolute maximum $(0, 2)$; absolute minimum $(\pi, -2)$

c) absolute maximum $(0, 0)$; absolute minimum $(-2, -26/3)$

12)

a) relative maximum $(-3, 11)$; relative minimum $(1, 1/3)$

b) no relative extrema

c) relative maximum $(1, 7/4)$; relative minimum $(-1, -9/4)$ and $(3, -9/4)$

13)

a) concave upward $(-\infty, -2)(5, \infty)$; concave downward $(-2, 5)$

b) concave upward $(2, \infty)$; concave downward $(-\infty, 2)$

c) concave upward $(7/4, \infty)$; concave downward $(-\infty, 7/4)$

14)

a) $(-2, -14\frac{2}{3})$; $(5, -135\frac{5}{12})$

b) no inflection points

c) $(7/4, -14.14583)$

15)

a) relative maximum $(-1, 8/3)$; relative minimum $(5, -33\frac{1}{3})$

b) relative maximum $(\pi/3, 2)$; relative minimum $(4\pi/3, -2)$

16)

a) 0

b) 3

c) does not exist

17)

a) 2

b) does not exist

18)

a) $+\infty$

b) $-\infty$

c) $-\infty$

d) $-\infty$

19)

a)

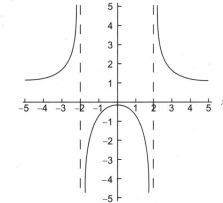

b)

20) 54 and 54

21) Each pen should be $10\sqrt{6}$ feet by $15\sqrt{6}$ feet or approximately 24.5 feet by 36.7 feet.

22) 128 cubic inches

Integrals

In this chapter, we reverse the process of differentiation. Then we use this new process to find areas bounded by functions and the x-axis. Because this process requires differentiation, you may need to review parts of Chapter 3 as you work through this chapter.

5.1 ANTIDERIVATIVES

Just as multiplication and factoring are reverse processes, so are differentiation and **antidifferentiation.** The notation

$$\int f(x)\,dx$$

is read "the integral of $f(x)$". You need both the integral symbol \int and dx to imply integration. Study the following table, which relates differentiation and integration.

Function	Derivative	Integral
$f(x) = \dfrac{1}{2}x^2$	$D_x\left[\dfrac{1}{2}x^2\right] = x$	$\int x\,dx = \dfrac{1}{2}x^2 + C$
$f(x) = \sin x$	$D_x[\sin x] = \cos x$	$\int \cos x\,dx = \sin x + C$
$f(x) = \dfrac{1}{3}x^3$	$D_x[\dfrac{1}{3}x^3] = x^2$	$\int x^2\,dx = \dfrac{1}{3}x^3 + C$

Note that $D_x\left[\dfrac{1}{2}x^2 + 6\right] = D_x\left[\dfrac{1}{2}x^2 + 4\right] = D_x\left[\dfrac{1}{2}x^2 + C\right]$ for C, a constant, because the derivative of a constant is 0. Thus, when we integrate, we write $+ C$ (plus a constant) to account for any constant that may have been present in the original function.

Just as we had formulas for finding derivatives, we have formulas for reversing the process to find integrals. There are books filled with integration formulas derived from theorems. We concentrate on the following few. You must memorize this list.

$$\int 0\,dx = 0 + C$$ The integral of 0 is a constant.

$$\int k\,dx = kx + C$$ The integral of a constant is the constant times x plus a constant.

$$\int kf(x)\,dx = k\int f(x)\,dx$$ The integral of a constant times a function is the constant times the integral of the function.

$$\int [f(x) \pm g(x)]\,dx = \int f(x)\,dx \pm \int g(x)\,dx$$ The integral of a sum or difference is the sum or difference of the integrals.

$$\int u^n\,du = \frac{u^{n+1}}{n+1} + C, n \neq -1$$ Power Rule.

$$\int \cos u\,du = \sin u + C$$

$$\int \sin u\,du = -\cos u + C$$

$$\int \sec^2 u\,du = \tan u + C$$

EXAMPLE 5.1

Find each integral.

a) $\int 6\,dx$

b) $\int x^6\,dx$

c) $\int (x^3 + x^2)\,dx$

d) $\int 5x^{-2}\,dx$

SOLUTION 5.1

a) $\int 6\,dx = 6x + C$ The integral of a constant is the constant times x plus a constant.

b) $\int x^6\,dx = \frac{x^{6+1}}{6+1} + C$ Use the Power Rule. Add 1 to the original exponent and divide by that sum.

$$= \frac{x^7}{7} + C$$

c) $\int (x^3 + x^2)\, dx = \int x^3\, dx + \int x^2\, dx$ The integral of a sum is the sum of the integrals.

$= \dfrac{x^{3+1}}{3+1} + C_1 + \dfrac{x^{2+1}}{2+1} + C_2$ Use the Power Rule for each term.

$= \dfrac{x^4}{4} + \dfrac{x^3}{3} + (C_1 + C_2)$ Simplify.

$= \dfrac{x^4}{4} + \dfrac{x^3}{3} + C$ The sum of two constants is written as another constant.

d) $\int 5x^{-2}\, dx = 5\int x^{-2}\, dx$ Factor out the constant.

$= 5\left[\dfrac{x^{-2+1}}{-2+1}\right] + C$ Use the Power Rule.

$= 5\left[\dfrac{x^{-1}}{-1}\right] + C$ Simplify.

$= -\dfrac{5}{x} + C$ Rewrite $x^{-1} = \dfrac{1}{x}$.

Note from Example 5.1c that we write a sum of constants as one constant.

REWRITING TO USE THE POWER RULE

The Power Rule is designed to integrate [function] $^{\text{power}}$. If the given function is not in that form, use exponent laws and/or algebraic techniques to rewrite the function before attempting to integrate.

EXAMPLE 5.2

Integrate.

a) $\int \dfrac{1}{x^3}\, dx$

b) $\int \sqrt{x}\, dx$

c) $\int \dfrac{x^3 + x^4}{x^2}\, dx$

d) $\int \sqrt{x}\,(x^2 + \sqrt{x})\, dx$

SOLUTION 5.2

a) $\int \dfrac{1}{x^3} dx = \int x^{-3} dx$ Use exponent laws to rewrite $\dfrac{1}{x^3} = x^{-3}$.

$= \dfrac{x^{-3+1}}{-3+1} + C$ Use the Power Rule.

$= \dfrac{x^{-2}}{-2} + C$ Simplify.

$= -\dfrac{1}{2x^2} + C$ $x^{-2} = \dfrac{1}{x^2}$.

b) $\int \sqrt{x}\, dx = \int x^{1/2} dx$ Use exponent laws to rewrite $\sqrt{x} = x^{1/2}$.

$= \dfrac{x^{\frac{1}{2}+1}}{\dfrac{1}{2}+1} + C$ Use the Power Rule.

$= \dfrac{x^{3/2}}{\dfrac{3}{2}} + C$ Simplify.

$= \dfrac{2}{3} x^{3/2} + C$ $\dfrac{1}{\dfrac{3}{2}} = 1 \div \dfrac{3}{2} = 1 \cdot \dfrac{2}{3} = \dfrac{2}{3}$.

c) $\int \dfrac{x^3 + x^4}{x^2} dx = \int \left(\dfrac{x^3}{x^2} + \dfrac{x^4}{x^2} \right) dx$ Use $\dfrac{a+b}{c} = \dfrac{a}{c} + \dfrac{b}{c}$.

$= \int (x^1 + x^2)\, dx$ $\dfrac{x^m}{x^n} = x^{m-n}$.

$= \int x^1 dx + \int x^2 dx$ The integral of a sum is the sum of the integrals.

$= \dfrac{x^{1+1}}{1+1} + \dfrac{x^{2+1}}{2+1} + C$ Use the Power Rule.

$= \dfrac{x^2}{2} + \dfrac{x^3}{3} + C$ Simplify.

d) $\int \sqrt{x}\,(x^2 + \sqrt{x})\, dx = \int x^{1/2}(x^2 + x^{1/2})\, dx$ Rewrite radicals using fractional exponents.

$= \int \left(x^{\frac{1}{2}+2} + x^{\frac{1}{2}+\frac{1}{2}} \right) dx$ Use $x^m \cdot x^n = x^{m+n}$.

$= \int (x^{5/2} + x^1)\, dx$ Simplify.

$$= \int x^{5/2} dx + \int x^1 dx$$ The integral of a sum is the sum of the integrals.

$$= \frac{x^{\frac{5}{2}+\frac{2}{2}}}{\frac{5}{2}+\frac{2}{2}} + \frac{x^{1+1}}{1+1} + C$$ Use the Power Rule.

$$= \frac{x^{7/2}}{\frac{7}{2}} + \frac{x^2}{2} + C$$ Simplify.

$$= \frac{2}{7} x^{7/2} + \frac{1}{2} x^2 + C$$ $\dfrac{1}{\frac{7}{2}} = 1 \div \dfrac{7}{2} = 1 \cdot \dfrac{2}{7} = \dfrac{2}{7}.$

INTEGRATING TRIGONOMETRIC FUNCTIONS

At this point, we have integration formulas for sin u, cos u, and sec$^2 u$. If other trigonometric functions occur, we may use identities to rewrite them in a form we can integrate. You may wish to review Section 2.3.

EXAMPLE 5.3

Integrate.

a) $\int 4 \sin x \, dx$

b) $\int (2 \sin x + 3 \cos x) \, dx$

c) $\int \dfrac{1 + \cos x \csc x}{\csc x} \, dx$

d) $\int (4x^3 - \sec^2 x) \, dx$

SOLUTION 5.3

a) $\int 4 \sin x \, dx = 4 \int \sin x \, dx$ Factor out the constant, 4.

$= 4 \, [-\cos x + C_1]$ $\int \sin x \, dx = -\cos x + C$

$= -4 \cos x + 4C_1$ Distribute.

$= -4 \cos x + C$ 4 times a constant is some other constant, so we write

+ C in the answer.

b) $\int (2\sin x + 3\cos x)\,dx = \int 2\sin x\,dx + \int 3\cos x\,dx$ The integral of a sum is the sum of the integrals.

$= 2\int \sin x\,dx + 3\int \cos x\,dx$ Factor out the constants.

$= 2\,[-\cos x] + 3\,[\sin x] + C$ Integrate. Combine all constants and write as C.

$= -2\cos x + 3\sin x + C$ Simplify.

c) $\int \dfrac{1 + \cos x \csc x}{\csc x}\,dx = \int (\dfrac{1}{\csc x} + \dfrac{\cos x \csc x}{\csc x})\,dx$ Use $\dfrac{a+b}{c} = \dfrac{a}{c} + \dfrac{b}{c}$.

$= \int (\sin x + \cos x)\,dx$ Use identities to simplify.

$= -\cos x + \sin x + C$ Integrate each term.

d) $\int (4x^3 - \sec^2 x)\,dx = \int (4x^3\,dx) - \int \sec^2 x\,dx$ The integral of a difference is the difference of the integrals.

$= 4\int x^3\,dx - \int \sec^2 x\,dx$ Factor out the constant.

$= 4\left[\dfrac{x^{3+1}}{3+1}\right] - [\tan x] + C$ Use the Power Rule for x^3 and use $\int \sec^2 x\,dx = \tan x$.

$= 4\,\dfrac{x^4}{4} - \tan x + C$ Simplify.

$= x^4 - \tan x + C$ Reduce.

PARTICULAR SOLUTIONS AND INITIAL CONDITIONS

The general solution to $\int f(x)\,dx$ produces a family of curves, $y = F(x) + C$ where each value of C represents a vertical translation of $y = F(x)$. Differential equations are generally stated in terms of derivatives, $\dfrac{dy}{dx}$ or $f'(x)$, often with sufficient information (called an initial condition or initial value) to find a value for C. One point on the curve is sufficient to find the C value, and the solution is called a particular solution.

EXAMPLE 5.4

Solve the differential equation $\dfrac{dy}{dx} = 2x$ with the initial condition that $y(0) = 4$.

SOLUTION 5.4

$y = \int 2x\,dx$	Find the general solution.
$y = x^2 + C$	Integrate.
$y(0) = 4$ means $y = 4$ when $x = 0$.	Substitute these values into the general solution.
$4 = (0)^2 + C$	Substitute.
$4 = C$	Solve for C.
$y = x^2 + 4$	Write the particular solution that corresponds to the given initial condition.

EXAMPLE 5.5

Solve each differential equation.

a) $\dfrac{dy}{dx} = 3x + 5, y(2) = 3$

b) $\dfrac{dy}{dx} = \sin x, y(\pi) = 2$

SOLUTION 5.5

a) $y = \int (3x + 5)\,dx$	Find the general solution.
$y = \dfrac{3x^2}{2} + 5x + C$	Integrate.
$3 = \dfrac{3(2)^2}{2} + 5(2) + C$	Substitute $x = 2$, $y = 3$.
$3 = 16 + C$	Solve for C.
$C = -13$	
$y = \dfrac{3}{2}x^2 + 5x - 13$	Write the particular solution.
b) $y = \int \sin x\,dx$	Find the general solution.
$y = -\cos x + C$	Integrate.
$2 = -\cos(\pi) + C$	Substitute $x = \pi$, $y = 2$.
$2 = 1 + C$	Solve for C.
$1 = C$	
$y = -\cos x + 1$	Write the particular solution.

5.2 SIGMA NOTATION

Sigma notation is used to develop integration as area under a curve. In this section, we examine the notation, basic properties, and limits involved in sums.

DEFINITION AND NOTATION

The symbol Σ is used as a shorthand notation for addition.

$$\sum_{i=1}^{n} a_i = a_1 + a_2 + a_3 + \cdots + a_n$$

The notation at the bottom of the symbol (here "$i = 1$") means to replace i with consecutive integers starting at 1, and ending with the number on the top of the symbol (here, n). Then add up the terms.

EXAMPLE 5.6

Expand each expression.

a) $\displaystyle\sum_{i=1}^{4} i^2$

b) $\displaystyle\sum_{j=2}^{5} (j + 6)$

c) $\displaystyle\sum_{i=1}^{3} \frac{1}{n}(2i + 3)$

SOLUTION 5.6

a) $\displaystyle\sum_{i=1}^{4} i^2 = (1)^2 + (2)^2 + (3)^2 + (4)^2$

b) $\displaystyle\sum_{j=2}^{5} (j + 6) = (2 + 6) + (3 + 6) + (4 + 6) + (5 + 6)$

c) $\displaystyle\sum_{i=1}^{3} \frac{1}{n}(2i + 3) = \frac{1}{n}(2(1) + 3) + \frac{1}{n}(2(2) + 3) + \frac{1}{n}(2(3) + 3)$

Note that when the index is i, we replace only i with integers. Thus, n remains n in Example 5.6c.

PROPERTIES AND FORMULAS

We use the following summation properties and formulas:

$$\sum_{i=1}^{n} ka_i = k \sum_{i=1}^{n} a_i$$

A constant, k, can be factored out of a summation.

$$\sum_{i=1}^{n} (a_i \pm b_i) = \sum_{i=1}^{n} a_i \pm \sum_{i=1}^{n} b_i$$

The summation of a sum or difference is the sum or difference of the summations.

$$\sum_{i=1}^{n} c = cn$$

The sum of a constant, c, is c times n. (Note: Index must start at 1 to use this formula.)

$$\sum_{i=1}^{n} i = \frac{n(n+1)}{2}$$

Formula for summing consecutive integers.

$$\sum_{i=1}^{n} i^2 = \frac{n(n+1)(2n+1)}{6}$$

Formula for summing squares of consecutive integers.

EXAMPLE 5.7

Find each sum.

a) $\displaystyle\sum_{i=1}^{5} 2i$

b) $\displaystyle\sum_{i=1}^{100} (4i+6)$

c) $\displaystyle\sum_{i=1}^{100} \frac{i^2}{2}$

SOLUTION 5.7

a) $\displaystyle\sum_{i=1}^{5} 2i = 2\sum_{i=1}^{5} i$ 　　　 Factor out the constant, 2.

$= 2(1 + 2 + 3 + 4 + 5)$ 　　 Write out the sum replacing i with integers from 1 to 5.

$= 2(15) = (30)$ 　　　　　 Add.

or

$\displaystyle\sum_{i=1}^{5} i = 2\left(\frac{5(5+1)}{2}\right)$ 　　 Use $\displaystyle\sum_{i=1}^{n} i = \frac{n(n+1)}{2}$.

$= 2\left(\dfrac{30}{2}\right) = 30$ 　　　 Simplify.

b) $\displaystyle\sum_{i=1}^{100} (4i+6) = \sum_{i=1}^{100} 4i + \sum_{i=1}^{100} 6$ 　 Use $\displaystyle\sum (a_i + b_i) = \sum a_i + \sum b_i$.

$\displaystyle = 4\sum_{i=1}^{100} i + \sum_{i=1}^{100} 6$ 　　 Factor out the constant, 4.

$\displaystyle = 4\left[\frac{100(100+1)}{2}\right] + 100\,(6)$ 　 $\displaystyle\sum_{i=1}^{n} c = nc$ for $n = 100$, $c = 6$.

$$= 4 \left[\frac{100\,(101)}{2} \right] + 600 \qquad \text{Simplify.}$$

$$= 20,800 \qquad \text{Multiply, then add.}$$

c) $\displaystyle\sum_{i=1}^{100} \frac{i^2}{2} = \sum_{i=1}^{100} \frac{1}{2} i^2 \qquad$ Rewrite $\dfrac{i^2}{2} = \dfrac{1}{2} i^2.$

$$= \frac{1}{2} \sum_{i=1}^{100} i^2 \qquad \text{Factor out the constant, } \frac{1}{2}.$$

$$= \frac{1}{2} \left[\frac{100\,(100+1)\,(200+1)}{6} \right] \qquad \text{Use the formula for } \sum i^2.$$

$$= \frac{1}{2} \left[\frac{100\,(101)\,(201)}{6} \right] = 169,175$$

These problems can be done with steps similar to those shown (as follows) for the TI-83 Plus graphing calculator or with other models of calculators and software.

To find $\displaystyle\sum_{i=1}^{5} 2i$:

Press 2nd 0 to get into the CATALOG

Arrow down to:

sum (Press enter.

Get into the CATALOG (2nd 0)

Arrow down to:

seq(Press enter.

2x,x,1,5)) Press enter.

30 Answer on screen.

FINDING INFINITE LIMITS OF SUMS

Recall from Section 4.5 that we can find a limit as x approaches infinity by dividing by the highest power of x in the denominator and using $\displaystyle\lim_{x \to \infty} \frac{k}{x^n} = 0$, k a constant. We use that process to find infinite limits of summations.

EXAMPLE 5.8

Find each limit.

a) $\displaystyle\lim_{n \to \infty} \sum_{i=1}^{n} \frac{2i}{n^2}$

b) $\displaystyle\lim_{n \to \infty} \sum_{i=1}^{n} \frac{i^2}{n^3}$

SOLUTION 5.8

a) $\lim\limits_{n\to\infty}\sum\limits_{i=1}^{n}\dfrac{2i}{n^2}=\lim\limits_{n\to\infty}\dfrac{2}{n^2}\sum\limits_{i=1}^{n}i$　　Factor out the constant, $\dfrac{2}{n^2}$.

$=\lim\limits_{n\to\infty}\dfrac{2}{n^2}\left[\dfrac{n\,(n+1)}{2}\right]$　　Use $\sum\limits_{i=1}^{n}i=\dfrac{n\,(n+1)}{2}$.

$=\lim\limits_{n\to\infty}\dfrac{n+1}{n}$　　Reduce $\dfrac{2n}{n^2\cdot2}=\dfrac{1}{n}$.

$=\lim\limits_{n\to\infty}\dfrac{\dfrac{n}{n}+\dfrac{1}{n}}{\dfrac{n}{n}}$　　Divide each term by n^1.

$=\lim\limits_{n\to\infty}\dfrac{1+\dfrac{1}{n}}{1}$　　Reduce.

$=\dfrac{1+0}{1}=1$　　Use $\lim\limits_{n\to\infty}\dfrac{1}{n}=0$.

b) $\lim\limits_{n\to\infty}\sum\limits_{i=1}^{n}\dfrac{i^2}{n^3}=\lim\limits_{n\to\infty}\dfrac{1}{n^3}\sum\limits_{i=1}^{n}i^2$　　Factor out the constant, $\dfrac{1}{n^3}$.

$=\lim\limits_{n\to\infty}\dfrac{1}{n^3}\left[\dfrac{n\,(n+1)(2n+1)}{6}\right]$　　Use the formula for $\sum\limits_{i=1}^{n}i^2$.

$=\lim\limits_{n\to\infty}\dfrac{(n+1)(2n+1)}{6n^2}$　　Reduce $\dfrac{n}{n^3}=\dfrac{1}{n^2}$.

$=\lim\limits_{n\to\infty}\dfrac{2n^2+3n+1}{6n^2}$　　Multiply the numerator.

$=\lim\limits_{n\to\infty}\dfrac{\dfrac{2n^2}{n^2}+\dfrac{3n}{n^2}+\dfrac{1}{n^2}}{\dfrac{6n^2}{n^2}}$　　Divide each term by n^2.

$=\lim\limits_{n\to\infty}\dfrac{2+\dfrac{3}{n}+\dfrac{1}{n^2}}{6}$　　Reduce.

$=\dfrac{2+0+0}{6}$　　Use $\lim\limits_{n\to\infty}\dfrac{3}{n}=0$ and $\lim\limits_{n\to\infty}\dfrac{1}{n^2}=0$.

$=\dfrac{1}{3}$

5.3 APPROXIMATING AREA

Although we can find the area of many figures such as rectangles, trapezoids, circles, and so on, we do not have a formula for finding the area bounded by a curve $y = f(x)$, the x-axis, and the vertical lines $x = a$ and $x = b$. However, we can make use of the formula for the area of a rectangle (length times width) to approximate such an area.

EXAMPLE 5.9

Find the shaded area using **inscribed rectangles** (also called the **lower sum**).

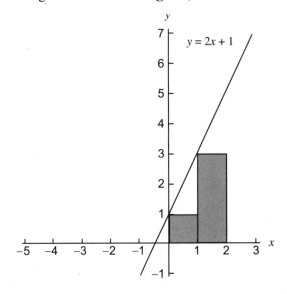

SOLUTION 5.9

Note that each shaded region is a rectangle of width 1. We can find the height of each rectangle by substituting the left endpoint of each interval into $y = 2x + 1$.

For [0, 1], height = $2(0) + 1 = 1$

For [1, 2], height = $2(1) + 1 = 3$

Shaded area = $LW + LW$

Shaded area = $1(1) + 3(1) = 4$

EXAMPLE 5.10

Find the shaded area using **circumscribed rectangles** (also called the **upper sum**).

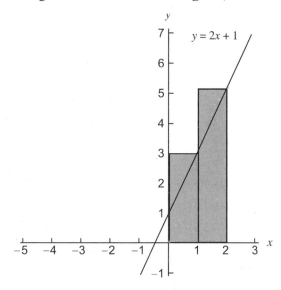

SOLUTION 5.10

These rectangles also have width 1. However, to find the heights, we now must use the right endpoint of each interval.

For [0, 1], height = 2(1) + 1 = 3

For [1, 2], height = 2(2) + 1 = 5

Shaded area = $LW + LW$

Shaded area = 3(1) + 5(1) = 8

The area we are really interested in (below $y = 2x + 1$ between $x = 0$ and $x = 2$) must be more than 4 and less than 8. We can improve our approximation by increasing the number of rectangles.

Here are some guidelines for approximating the area bounded by $y = f(x)$, $x = a$, $x = b$, and above the x-axis, using n rectangles.

1. Find the width of each rectangle using $w = \dfrac{b - a}{n}$.

2. Write out the intervals for each rectangle.

3. Find the length of each rectangle by substituting the left endpoint into $f(x)$ or the right endpoint into $f(x)$ depending on whether you need inscribed or circumscribed rectangles.

4. Multiply length times width to find the area of each rectangle.

5. Find the sum of the areas.

EXAMPLE 5.11

Approximate the area bounded by $f(x) = x^2 + 2$, $x = 1$, $x = 3$, and the x-axis using 4 rectangles of equal width and the left endpoints of each subinterval to find the height.

SOLUTION 5.11

$$w = \frac{3-1}{4} = \frac{2}{4} = \frac{1}{2}$$ Find the width of each rectangle.

The rectangles are on $\left[1, \frac{3}{2}\right], \left[\frac{3}{2}, 2\right], \left[2, \frac{5}{2}\right], \left[\frac{5}{2}, 3\right]$.

Use the left endpoint to find each height (these will be inscribed rectangles):

$f(1) = 1^2 + 2 = 3$ Substitute into $f(x) = x^2 + 2$.

$$f\left(\frac{3}{2}\right) = \left(\frac{3}{2}\right)^2 + 2 = \frac{13}{4}$$

$f(2) = 2^2 + 2 = 6$

$$f\left(\frac{5}{2}\right) = \left(\frac{5}{2}\right)^2 + 2 = \frac{29}{4}$$

Find the area of each rectangle:

$$3\left(\frac{1}{2}\right) = \frac{3}{2} = \frac{12}{8}$$

$$\frac{13}{4}\left(\frac{1}{2}\right) = \frac{13}{8}$$

$$6\left(\frac{1}{2}\right) = 3 = \frac{24}{8}$$

$$\frac{29}{4}\left(\frac{1}{2}\right) = \frac{29}{8}$$ Find the sum of the areas.

$$\frac{78}{8} = \frac{39}{4}$$

By increasing the number of rectangles, we increase the accuracy of our approximation. In fact, if we let the number of rectangles approach infinity ($n \to \infty$), we can actually find the area bounded by the curve, $x = a$, $x = b$, and the x-axis. We follow a procedure similar to the procedure for finding the sum with a finite number or rectangles.

To find the area as ($n \to \infty$):

1. Find the width of each rectangle using $\Delta x = \frac{b-a}{n}$.
2. Find the area of the ith rectangle by finding $f(a + i\Delta x)\, \Delta x$.
3. Find $\lim\limits_{n \to \infty} \sum\limits_{i=1}^{n} f(a + i\Delta x)\, \Delta x$.

EXAMPLE 5.12

Find the area bounded by $f(x) = x^2 + 2$, $x = 1$, $x = 2$ and the x-axis.

SOLUTION 5.12

$\Delta x = \dfrac{2-1}{n} = \dfrac{1}{n}$ | Find the width of each rectangle.

$f(a + i\Delta x) = f(1 + i(\dfrac{1}{n}))$ | Find the height of the ith rectangle.

$= f(1 + \dfrac{i}{n})$ | Simplify.

$= \left(1 + \dfrac{i}{n}\right)^2 + 2$ | Substitute into $f(x) = x^2 + 2$.

$A = \lim\limits_{n \to \infty} \sum\limits_{i=1}^{n} \left[\left(1 + \dfrac{i}{n}\right)^2 + 2\right]\dfrac{1}{n}$ | Find the limit of the areas.

$= \lim\limits_{n \to \infty} \sum\limits_{i=1}^{n} \left[1 + \dfrac{2i}{n} + \dfrac{i^2}{n^2} + 2\right]\dfrac{1}{n}$ | Square the binomial.

$= \lim\limits_{n \to \infty} \sum\limits_{i=1}^{n} \left[3 + \dfrac{2i}{n} + \dfrac{i^2}{n^2}\right]\dfrac{1}{n}$ | Add similar terms.

$= \lim\limits_{n \to \infty} \dfrac{1}{n} \sum\limits_{i=1}^{n} \left[3 + \dfrac{2i}{n} + \dfrac{i^2}{n^2}\right]$ | Factor out the constant, $\dfrac{1}{n}$.

$= \lim\limits_{n \to \infty} \dfrac{1}{n} \left[\sum\limits_{i=1}^{n} 3 + \sum\limits_{i=1}^{n} \dfrac{2i}{n} + \sum\limits_{i=1}^{n} \dfrac{i^2}{n^2}\right]$ | Use $\sum (a_i + b_i) = \sum a_i + \sum b_i$.

$= \lim\limits_{n \to \infty} \dfrac{1}{n} \left[\sum\limits_{i=1}^{n} 3 + \dfrac{2}{n}\sum\limits_{i=1}^{n} i + \dfrac{1}{n^2}\sum\limits_{i=1}^{n} i^2\right]$ | Factor out each constant.

$= \lim\limits_{n \to \infty} \left[\dfrac{1}{n}\sum\limits_{i=1}^{n} 3 + \dfrac{2}{n^2}\sum\limits_{i=1}^{n} i + \dfrac{1}{n^3}\sum\limits_{i=1}^{n} i^2\right]$ | Multiply each term by $\dfrac{1}{n}$.

$= \lim\limits_{n \to \infty} \left[\dfrac{1}{n}(3n)\right] + 1 + \dfrac{1}{3}$ | See Example 5.8.

$= 3 + 1 + \dfrac{1}{3} = \dfrac{13}{3}$ | Add.

Note that the technique shown here uses the right endpoint to find the height of the ith rectangle. It can be shown that either the right or left endpoint can be used (or any point within the interval) to find the height.

5.4 THE DEFINITE INTEGRAL AND THE FUNDAMENTAL THEOREM OF CALCULUS

In this section, we move from the limit of a sum concept to the use of a definite integral, properties of a definite integral, and then return to finding the area bounded by a function and the x-axis on a closed interval.

DEFINITE INTEGRALS

If we partition the interval so that our rectangles are *not* necessarily of equal width, and use any point in the subinterval to find the height of a rectangle, the sum of the areas of the rectangles is called a **Riemann sum.** The limit of this sum as the width of the widest rectangle approaches 0 is called a **definite integral.** Thus,

$$\int_a^b f(x)dx$$

is the definite integral of $f(x)$ from a to b, where a is the lower limit of integration and b is called the upper limit of integration. If $f(x)$ is a continuous, nonnegative function on $[a, b]$ (that is, above the x-axis), then the area bounded by $y = f(x)$, $x = a$, $x = b$, and the x-axis equals

$$\int_a^b f(x)dx.$$

FUNDAMENTAL THEOREM OF CALCULUS

The **Fundamental Theorem of Calculus** is the key to the relationship between indefinite and definite integrals and area under a curve. If we let $F(x) = f'(x)$, we know

$$\int F(x)\, dx = f(x) + C.$$

The Fundamental Theorem of Calculus states

$$\int_a^b F(x)dx = f(b) - f(a),$$

which means that we can find the area bounded by a continuous nonnegative function $y = F(x)$, $x = a$, $x = b$, and the x-axis by integrating $F(x)$, substituting in the upper and lower limits of integration, and subtracting.

EXAMPLE 5.13

Evaluate each definite integral.

a) $\int_1^2 (x^2 + 2)\, dx$

b) $\int_0^3 x^6 dx$

c) $\int_0^4 2\sqrt{x}\, dx$

SOLUTION 5.13

a) $\int_1^2 (x^2+2)\,dx = \left[\dfrac{x^{2+1}}{2+1} + 2x\right]\Big|_1^2$ Integrate.

$= \left[\dfrac{x^3}{3} + 2x\right]\Big|_1^2$ Simplify.

Now substitute $x = 2$, then $x = 1$, and subtract.

$= \left[\dfrac{(2)^3}{3} + 2(2)\right] - \left[\dfrac{(1)^3}{3} + 2(1)\right]$

$= (\dfrac{8}{3} + 4) - (\dfrac{1}{3} + 2)$

$= \dfrac{13}{3}$

b) $\int_0^3 x^6\,dx = \left[\dfrac{x^{6+1}}{6+1}\right]\Big|_0^3$ Integrate.

$= \left[\dfrac{x^7}{7}\right]\Big|_0^3$ Simplify.

$= \dfrac{(3)^7}{7} - \dfrac{(0)^7}{7}$ Evaluate by substituting $x = 3$, then $x = 0$, and subtracting.

$= \dfrac{2187}{7} - 0 = \dfrac{2187}{7}$ Simplify.

c) $\int_0^4 2\sqrt{x}\,dx = 2\int_0^4 x^{1/2}\,dx$ Rewrite \sqrt{x} as $x^{1/2}$. Factor out the constant, 2.

$= 2\left[\dfrac{x^{\frac{1}{2}+1}}{\frac{1}{2}+1}\right]\Big|_0^4$ Integrate using the Power Rule.

$= 2\left[\dfrac{x^{3/2}}{\frac{3}{2}}\right]\Big|_0^4$ Simplify.

$= 2\left[\dfrac{2}{3}x^{3/2}\right]\Big|_0^4$ $\dfrac{1}{3/2} = 1 \cdot \dfrac{2}{3} = \dfrac{2}{3}$.

$= \dfrac{4}{3}\,[\,x^{3/2}\,]\,\Big|_0^4$ Factor out the constant, $\dfrac{2}{3}$.

$$= \frac{4}{3} [4^{3/2} - 0^{3/2}]$$ Substitute $x = 4$, then $x = 0$, and subtract.

$$= \frac{4}{3} (4^{3/2}) = \frac{4}{3} = \frac{32}{3}$$ Simplify. $4^{3/2} = (\sqrt{4})^3 = 2^3 = 8$.

Notice that our answer to Example 5.13a, $\frac{13}{3}$, is the same answer as Example 5.12. That is, we can find the area bounded by $f(x) = x^2 + 2$, $x = 1$, $x = 2$, and the x-axis by evaluating the definite integral

$$\int_1^2 (x^2 + 2)dx.$$

Be careful to realize that this holds true (area = definite integral) only when the function is continuous and nonnegative.

Definite integrals can be approximated with graphing calculators such as the TI-83 Plus. The following steps are for the TI-83 Plus, and most other models have similar steps.

$$\int_1^2 (x^2 + 2)dx:$$

MATH
9 (or arrow down to 9 fnInt (and press enter)
x^2+2,x,1,2) Press enter.
4.33333333 Answer on screen.
MATH This converts a repeating decimal into a fraction.
ENTER
ENTER
13/3

PROPERTIES OF DEFINITE INTEGRALS

There are several definitions, theorems, and properties that can help you evaluate definite integrals.

$$\int_a^a f(x)dx = 0$$

$$\int_a^b f(x)dx = -\int_b^a f(x)dx \text{ for } a > b$$

$$\int_a^b f(x)dx = \int_a^c f(x)dx + \int_c^b f(x)dx \qquad \text{if } f \text{ is integrable on an interval containing } a, b, \text{ and } c.$$

$$\int_a^b kf(x)dx = k\int_a^b f(x)dx$$

$$\int_a^b [f(x) \pm g(x)]dx = \int_a^b f(x)dx \pm \int_a^b g(x)dx$$

Note that the last two properties are restatements of our earlier properties for indefinite integrals.

EXAMPLE 5.14

Evaluate each definite integral.

a) $\int_3^3 (x^3 + 6x^2)\, dx$

b) $\int_2^{-1} x^2\, dx$

SOLUTION 5.14

a) $\int_3^3 (x^3 + 6x^2)\, dx = 0$ There is no need to integrate and evaluate if you realize that the limits of integration are equal.

b) $\int_2^{-1} x^2\, dx = -1\int_{-1}^2 x^2\, dx$ Use $\int_a^b f(x)\, dx = -\int_b^a f(x)\, dx$.

$= -1\left[\dfrac{x^{2+1}}{2+1}\right]\Bigg|_{-1}^2$ Integrate.

$= -1\left[\dfrac{x^3}{3}\right]\Bigg|_{-1}^2$ Simplify.

$= -1\left[\dfrac{(2)^3}{3} - \dfrac{(-1)^3}{3}\right]$ Evaluate.

$= -1\left[\dfrac{8}{3} + \dfrac{1}{3}\right] = -3$

FINDING AREAS USING DEFINITE INTEGRALS

When an area is bounded by a curve that is above the x-axis, below by the x-axis, and the vertical lines $x = a$ and $x = b$, we can set up and evaluate the definite integral in a straightforward manner.

EXAMPLE 5.15

Find the area bounded by the given curve, the x-axis, and the lines $x = a$ and $x = b$.

a) $f(x) = 4x - x^2$, $x = 1$, $x = 3$

b) $f(x) = x^2 - 4x + 5$, $x = 1$, $x = 3$

a) First sketch the region:

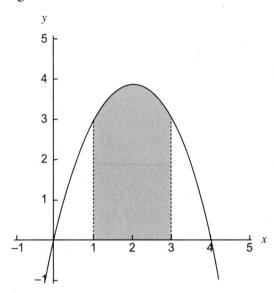

Set up the definite integral:

$$A = \int_1^3 (4x - x^2)\,dx$$

$$= \left[\frac{4x^2}{2} - \frac{x^3}{3} \right]_1^3 \qquad \text{Integrate.}$$

$$= \left[2x^2 - \frac{x^3}{3} \right]_1^3 \qquad \text{Simplify.}$$

$$= (2(3)^2 - \frac{(3)^3}{3}) - (2(1)^2 - \frac{(1)^3}{3}) \qquad \text{Evaluate.}$$

$$= (18 - 9) - (2 - \frac{1}{3}) \qquad \text{Simplify.}$$

$$= \frac{22}{3}$$

b) First sketch the region:

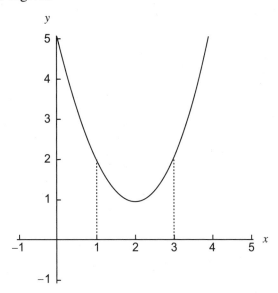

$$A = \int_1^3 (x^2 - 4x + 5)\, dx$$ Set up the definite integral.

$$= \left[\frac{x^3}{3} - 2x^2 + 5x \right]\Big|_1^3$$ Integrate.

$$= \left[\frac{(3)^3}{3} - 2(3)^2 + 5(3) \right] - \left[\frac{(1)^3}{3} - 2(1)^2 + 5(1) \right]$$ Evaluate.

$$= (9 - 18 + 15) - (\frac{1}{3} - 2 + 5)$$ Simplify.

$$= \frac{8}{3}$$

If the area bounded by the curve is *below* the x-axis, the value of the integral will be negative. In this case, use the negative of the integral to find the area. (Note: The area must always be positive, even though an integral may be positive or negative.)

EXAMPLE 5.16

Find the area bounded by the given function, $x = a$ and $x = b$.

a) $f(x) = -x^2$, $x = 0$, $x = 2$

b) $f(x) = \sin x$, $x = \pi$, $x = 2\pi$

SOLUTION 5.16

a) Consider the graph of $f(x) = -x^2$:

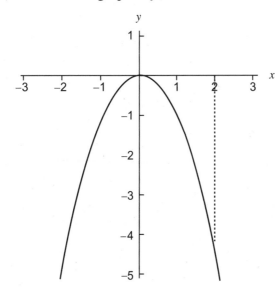

Because the curve is below the x-axis, we use the negative of the integral:

$$A = -\int_0^2 (-x^2)\,dx \qquad\qquad \text{Set up the integral.}$$

$$= +\int_0^2 x^2\,dx \qquad\qquad \text{Factor out the constant, } -1.$$

$$= \left[\frac{x^3}{3}\right]_0^2 \qquad\qquad \text{Integrate.}$$

$$= \frac{(2)^3}{3} - \frac{(0)^3}{3} \qquad\qquad \text{Evaluate.}$$

$$= \frac{8}{3} \qquad\qquad \text{Simplify.}$$

b) Sketch the graph of $f(x) = \sin x$:

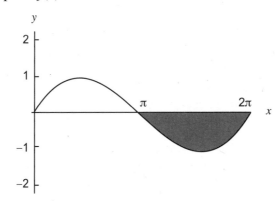

The shaded region is below the *x*-axis.

$$A = -\int_{\pi}^{2\pi} \sin x \, dx \qquad \text{Use the negative of the integral.}$$

$$= -[-\cos x] \Big|_{\pi}^{2\pi} \qquad \text{Integrate.}$$

$$= \cos x \Big|_{\pi}^{2\pi} \qquad \text{Factor out } -1.$$

$$= \cos(2\pi) - \cos(\pi) \qquad \text{Evaluate.}$$
$$= 1 - (-1)$$
$$= 2$$

To use a graphing calculator for Example 5.16b, you must be in radian mode. To use the TI-83 Plus, press MODE, arrow down to RADIAN, and press enter. Use 2nd MODE (to QUIT). To calculate $A = -\int_{\pi}^{2\pi} \sin x \, dx$, type

MATH
9 (or arrow down to 9 and press enter). This enters fnInt (on the screen.
Sin(x),x,π,2π)
ENTER
X (−)1 Multiply times −1.
ENTER
2 Answer on the screen.

If the area bounded by the function is partially above the *x*-axis and partially below, set up separate integrals for each region. Remember to take the negative of each region below the *x*-axis.

EXAMPLE 5.17

Find the area bounded by $f(x) = (x + 2)^2 - 4$, $x = -1$, $x = 2$, and the *x*-axis.

SOLUTION 5.17

A sketch of the region shows that part of the area is below the *x*-axis and part of the area is above the *x*-axis.

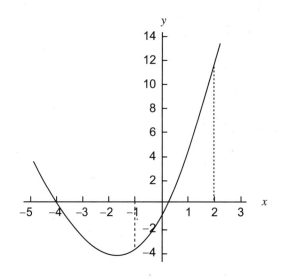

$$A = -\int_{-1}^{0} [(x+2)^2 - 4]dx + \int_{0}^{2} [(x+2)^2 - 4]dx$$

$$= -\int_{-1}^{0} (x^2 + 4x)\, dx + \int_{0}^{2} (x^2 + 4x)\, dx \qquad \text{Simplify.}$$

$$= -\left[\frac{x^3}{3} + 2x^2\right]\Bigg|_{-1}^{0} + \left[\frac{x^3}{3} + 2x^2\right]\Bigg|_{0}^{2} \qquad \text{Integrate.}$$

$$= -\left[(\frac{0^3}{3} + 2(0)^2) - (\frac{(-1)^3}{3} + 2(-1)^2)\right] + \left[(\frac{(2)^3}{3} + 2(2)^2) - (\frac{0^3}{3} + 2(0)^2)\right]$$

$$= -\left[0 - (-\frac{1}{3} + 2)\right] + \left[(\frac{8}{3} + 8) - 0\right]$$

$$= -\left[-\frac{5}{3}\right] + \left[\frac{32}{3}\right]$$

$$= \frac{37}{3}$$

5.5 INTEGRATION BY SUBSTITUTION

In Section 5.1, we stated the basic rules for integration. In this section, we select an appropriate u to make the problem fit one of our formulas. Note that if $u = f(x)$, $du = f'(x)dx$, where du is the differential of u. We begin each problem by selecting u, finding du, and substituting.

EXAMPLE 5.18

Evaluate each integral.

a) $\int (x^2 + 4)^5 (2x)\,dx$

b) $\int (x^3 + x^2)^8 (3x^2 + 2x)\,dx$

c) $\int 3\cos 3x\,dx$

SOLUTION 5.18

a) Let $u = x^2 + 4$ Select u.

 $du = 2x\,dx$ Find du.

 Then $\int (x^2 + 4)^5 (2x)\,dx = \int u^5\,du$ Substitute.

 $= \dfrac{u^6}{6} + C$ Integrate using the Power Rule.

 $= \dfrac{(x^2 + 4)^6}{6} + C$ Substitute for u.

b) Let $u = x^3 + x^2$ Select u.

 $du = (3x^2 + 2x)\,dx$ Find du.

 Then $\int (x^3 + x^2)^8 (3x^2 + 2x)\,dx = \int u^8\,du$ Substitute.

 $= \dfrac{u^9}{9} + C$ Integrate.

 $= \dfrac{(x^3 + x^2)^9}{9} + C$ Substitute for u.

c) Let $u = 3x$ Select u.

 $du = 3\,dx$ Find du.

 Then $\int 3\cos 3x\,dx = \int \cos 3x\,(3dx)$ Rewrite.

 $= \int \cos u\,du$ Substitute.

 $= \sin u + C$ Integrate.

 $= \sin (3x) + C$ Substitute for u.

PRODUCING *DU* FOR THE POWER RULE

In the previous example, *du* was present in each integral. If we are missing a constant factor, we can often produce *du* by multiplying by a form of 1.

EXAMPLE 5.19

Evaluate each integral.

a) $\int (x^2 + 4)^5 \, x \, dx$

b) $\int \sqrt{4x+1} \, dx$

c) $\int \dfrac{x}{(6x^2 + 3)^3} \, dx$

d) $\int 6x^3 (x^4 - 2)^3 \, dx$

SOLUTION 5.19

a) Let $u = x^2 + 4$ Select *u*.

 $du = 2x \, dx$ Find *du*.

We need $2x \, dx$. We have $x \, dx$. Multiply by $\dfrac{2}{2}$:

$$\int (x^2 + 4)^5 \, x \, dx = \int (x^2 + 4)^5 \, \frac{2}{2} x \, dx$$ Multiply by $\dfrac{2}{2}$.

$$= \frac{1}{2} \int (x^2 + 4)^5 \, 2x \, dx$$ Factor out $\dfrac{1}{2}$.

$$= \frac{1}{2} \int u^5 \, du$$ Substitute.

$$= \frac{1}{2} \cdot \frac{u^6}{6} + C$$ Integrate using the Power Rule.

$$= \frac{1}{12} u^6 + C$$ Simplify.

$$= \frac{1}{12} (x^2 + 4)^6 + C$$ Substitute for *u*.

b) $\int \sqrt{4x+1} \, dx = \int (4x+1)^{1/2} \, dx$ Rewrite the integrand.

Let $u = 4x + 1$ Select *u*.

$du = 4 \, dx$ Find *du*.

We have dx. We need $4 \, dx$. Multiply by $\dfrac{4}{4}$:

$$\int (4x+1)^{1/2} \, \frac{4}{4} \, dx$$ Multiply by $\dfrac{4}{4}$.

$$= \frac{1}{4} \int (4x+1)^{1/2} \, 4dx \qquad\qquad \text{Factor out } \frac{1}{4}.$$

$$= \frac{1}{4} \int u^{1/2} \, du \qquad\qquad \text{Substitute.}$$

$$= \frac{1}{4} \frac{u^{3/2}}{3/2} + C \qquad\qquad \text{Integrate using the Power Rule.}$$

$$= \frac{1}{4} \cdot \frac{2}{3} u^{3/2} + C \qquad\qquad \text{Simplify.}$$

$$= \frac{1}{6}(4x+1)^{3/2} + C \qquad\qquad \text{Multiply } \frac{1}{4} \cdot \frac{2}{3} = \frac{1}{6}. \text{ Substitute for } u.$$

c) $\int \dfrac{x}{(6x^2+3)^3} \, dx = \int (6x^2+3)^{-3} x \, dx \qquad$ Rewrite the integrand.

Let $u = 6x^2 + 3$ $\qquad\qquad$ Select u.

$du = 12x \, dx$ $\qquad\qquad$ Find du.

We have $x \, dx$. We need $12x \, dx$. \qquad Multiply by $\dfrac{12}{12}$:

$$= \int (6x^2+3)^{-3} \frac{12}{12} x \, dx \qquad\qquad \text{Multiply by } \frac{12}{12}.$$

$$= \frac{1}{12} \int (6x^2+3)^{-3} \, 12x \, dx \qquad\qquad \text{Factor out } \frac{1}{12}.$$

$$= \frac{1}{12} \int u^{-3} \, du \qquad\qquad \text{Substitute.}$$

$$= \frac{1}{12} \frac{u^{-2}}{-2} + C \qquad\qquad \text{Integrate using the Power Rule.}$$

$$= -\frac{1}{24u^2} + C \qquad\qquad \text{Simplify.}$$

$$= -\frac{1}{24(6x^2+3)^2} + C \qquad\qquad \text{Substitute for } u.$$

d) $\int 6x^3 (x^4 - 2)^3 \, dx$

Let $u = x^4 - 2$ $\qquad\qquad$ Select u.

$du = 4x^3 \, dx$ $\qquad\qquad$ Find du.

We need $4x^3 dx$, not $6x^3 dx$. First, factor out the 6:

$$6\int x^3 (x^4 - 2)^3 dx$$

$$= 6\int \frac{4}{4} x^3 (x^4 - 2)^3 dx \qquad \text{Multiply by } \frac{4}{4}.$$

$$= \frac{6}{4}\int 4x^3 (x^4 - 2)^3 dx \qquad \text{Factor out } \frac{1}{4}.$$

$$= \frac{3}{2}\int u^3 du \qquad \text{Substitute.}$$

$$= \frac{3}{2} \cdot \frac{u^4}{4} + C \qquad \text{Integrate.}$$

$$= \frac{3}{8}(x^4 - 2)^4 + C \qquad \text{Simplify and substitute for } u.$$

PRODUCING *DU* FOR TRIGONOMETRIC FUNCTIONS

Recall our integration formulas involving trigonometric functions:

$$\int \sin u\, du = -\cos u + C$$

$$\int \cos u\, du = \sin u + C$$

$$\int \sec^2 u\, du = \tan u + C$$

Notice that the $\sin u$ and $\cos u$ are raised to an (understood) exponent of 1. The formula for integrating secants requires that the secant be squared. To use these three formulas, u will be the angle of the trigonometric function.

EXAMPLE 5.20

Evaluate each integral.

a) $\int \sin 6x\, dx$

b) $\int \dfrac{\cos \sqrt{x}}{\sqrt{x}}\, dx$

c) $\int \sec^2 (2\pi x)\, dx$

SOLUTION 5.20

a) $\int \sin 6x\, dx$

Let $u = 6x$	Let u equal the angle.
$du = 6dx$	Find du.

We have dx. We need $6dx$. Multiply by $\dfrac{6}{6}$:

$\int \sin 6x\, dx = \int \sin 6x(\dfrac{6}{6})\, dx$ Multiply by $\dfrac{6}{6}$.

$= \dfrac{1}{6}\int \sin 6x\, 6dx$ Factor out $\dfrac{1}{6}$.

$= \dfrac{1}{6}\int \sin u\, du$ Substitute.

$= \dfrac{1}{6}[-\cos u] + C$ Integrate.

$= -\dfrac{1}{6}\cos(6x) + C$ Substitute for u.

b) $\int \dfrac{\cos \sqrt{x}}{\sqrt{x}}\, dx = \int \dfrac{\cos x^{1/2}}{x^{1/2}}\, dx$ Rewrite the integrand.

Let $u = x^{1/2}$ Let u equal the angle.

$du = \dfrac{1}{2}x^{-1/2}\, dx$ Find du.

We have $x^{-1/2}\, dx$. We need $\dfrac{1}{2}x^{-1/2}dx$. Multiply by $\dfrac{2}{2}$.

$= \int \dfrac{\cos x^{1/2}}{x^{1/2}} \cdot \dfrac{2}{2}\, dx$ Multiply by $\dfrac{2}{2}$.

$= 2\int \dfrac{\cos x^{1/2}}{2x^{1/2}}\, dx$ Factor out 2.

$= 2\int \cos u\, du$ Substitute.

$= 2\sin u + C$ Integrate.

$= 2\sin x^{1/2} + C$ Substitute for u.

$= 2\sin \sqrt{x} + C$ The answer may be written in this form.

c) Let $u = 2\pi x$ Let u equal the angle.

$\qquad du = 2\pi dx$ 2π is a constant.

We have dx. We need $2\pi dx$. Multiply by $\dfrac{2\pi}{2\pi}$:

$\displaystyle\int \sec^2(2\pi x)\frac{2\pi}{2\pi}\,dx$ Multiply by $\dfrac{2\pi}{2\pi}$.

$\displaystyle = \frac{1}{2\pi}\int \sec^2(2\pi x)\,2\pi\,dx$ Factor out $\dfrac{1}{2\pi}$.

$\displaystyle = \frac{1}{2\pi}\int \sec^2 u\,du$ Substitute.

$\displaystyle = \frac{1}{2\pi}\tan u + C$ Integrate.

$\displaystyle = \frac{1}{2\pi}\tan(2\pi x) + C$ Substitute for u.

TRIGONOMETRIC FUNCTIONS RAISED TO POWERS

If the exponent on $\sin u$ or $\cos u$ is not 1, the problem may be a form of the Power Rule. In this case, the integrand may appear to be a product involving sines and cosines. Note that in our list of basic integration formulas, *there is no product rule*. Note also that it may help to write $\sin^n x$ as $(\sin x)^n$ to emphasize a power rule integration.

EXAMPLE 5.21

Use substitution to find each integral.

a) $\displaystyle\int \sin^4 x \cos x\,dx$

b) $\displaystyle\int \cos^3 2x \sin 2x\,dx$

SOLUTION 5.21

a) $\displaystyle\int \sin^4 x \cos x\,dx = \int (\sin x)^4 \cos x\,dx$

\qquad Let $u = \sin x$ Select u.

$\qquad\quad du = \cos x\,dx$ Find du.

$\qquad \displaystyle\int (\sin x)^4 \cos x\,dx = \int u^4\,du$ Substitute.

$\qquad \displaystyle = \frac{u^5}{5} + C$ Integrate.

$\qquad \displaystyle = \frac{(\sin x)^5}{5} + C$ Substitute for u.

$$= \frac{1}{5}\sin^5 x + C \qquad\qquad\qquad \text{The answer may be written in this form.}$$

b) $\int \cos^3 2x \sin 2x \, dx = \int (\cos 2x)^3 \sin 2x \, dx$

 Let $u = \cos 2x$ Select u.

 $du = -\sin 2x \, dx$ Find du.

 We have $\sin 2x \, dx$. We need $-2\sin 2x$. Multiply by $\frac{-2}{-2}$.

$$= \int (\cos 2x)^3 \sin 2x \, dx = -\frac{1}{2} \int (\cos 2x)^3 (-2\sin 2x \, dx)$$

$$= -\frac{1}{2} \int u^3 \, du \qquad\qquad\qquad \text{Substitute.}$$

$$= -\frac{1}{2} \cdot \frac{u^4}{4} + C \qquad\qquad\qquad \text{Integrate.}$$

$$= -\frac{1}{8} u^4 + C \qquad\qquad\qquad\quad \text{Simplify.}$$

$$= -\frac{1}{8} [\cos 2x]^4 + C \qquad\qquad \text{Substitute for } u.$$

$$= -\frac{1}{8} \cos^4 2x + C \qquad\qquad \text{The answer may be written in this form.}$$

CHANGING LIMITS OF INTEGRATION

When we use substitution for a definite integral, we may substitute, integrate, replace u, and then evaluate, or we may substitute, integrate, change the limits of integration, and evaluate. By changing the limits of integration, we avoid the step where we substitute for u. Compare the procedure for an example worked by both techniques.

EXAMPLE 5.22

Evaluate $\int_0^1 \frac{2x+4}{(x^2+4x+6)^2} \, dx$ without changing the limits of integration.

SOLUTION 5.22

 Let $u = x^2 + 4x + 6$ Select u.

 Then $du = (2x + 4)dx$ Find du.

$$\int_0^1 \frac{2x+4}{(x^2+4x+6)^2} \, dx = \int \frac{du}{u^2} \qquad \text{Substitute.}$$

$$= \int u^{-2} \, du \qquad\qquad\qquad \text{Simplify.}$$

$$= \frac{u^{-1}}{-1} \qquad\qquad\qquad\quad \text{Integrate.}$$

$$= -\frac{1}{u}$$

Simplify.

$$= -\frac{1}{x^2 + 4x + 6}$$

Substitute for *u*.

$$= -\frac{1}{x^2 + 4x + 6}\Big|_0^1$$

Evaluate.

$$= -\frac{1}{1^2 + 4 + 6} - \left(-\frac{1}{0 + 0 + 6}\right)$$

$$= -\frac{1}{11} + \frac{1}{6} = \frac{5}{66}$$

EXAMPLE 5.23

Evaluate $\displaystyle\int_0^1 \frac{2x + 4}{(x^2 + 4x + 6)^2}\,dx$ by changing the limits of integration.

SOLUTION 5.23

We know $u = x^2 + 4x + 6$ and $du = (2x + 4)dx$. Now we change the limits of integration from *x* values to *u* values.

When $x = 1$, $u = 1^2 + 4(1) + 6 = 11$

When $x = 0$, $u = 0^2 + 4(0) + 6 = 6$

The integral now becomes

$$\int_6^{11} u^{-2}\,du = -\frac{1}{u}\Big|_6^{11}$$

Integrate.

$$= -\frac{1}{11} - \left(-\frac{1}{6}\right)$$

Evaluate.

$$= -\frac{1}{11} + \frac{1}{6} = \frac{5}{66}$$

Of course, both techniques lead to the same correct answer. Generally, it will be up to you to choose the technique you prefer.

SUMMARY

This chapter introduced integration as the inverse process of differentiation. We concentrated on eight basic integration formulas introduced in Section 5.1. We also discussed the application of integration to finding the area bounded by a nonnegative continuous function, the *x*-axis, and two vertical lines. We used the Fundamental Theorem of Calculus to evaluate definite integrals. Finally, we began to examine the use of substitution to help us integrate functions that fit our eight basic formulas after an appropriate substitution.

TEST YOURSELF

1) Find each integral.

 a) $\int 2\,dx$

 b) $\int 3x^4\,dx$

 c) $\int (x^2 - x^3)\,dx$

2) Integrate.

 a) $\int \dfrac{1}{x^5}\,dx$

 b) $\int \sqrt[3]{x^2}\,dx$

 c) $\int \left(\dfrac{2x^2 + x^5}{x}\right)\,dx$

 d) $\int \sqrt[3]{x}(x - \sqrt{x})\,dx$

3) Integrate.

 a) $\int 3\cos x\,dx$

 b) $\int (6\sin x - 2\cos x)\,dx$

 c) $\int (\sec^2 x - 2x)\,dx$

4) Solve the differential equation.

 a) $\dfrac{dy}{dx} = x^{3/2},\, y(4) = \dfrac{4}{5}$

 b) $f''(t) = 32,\, f'(0) = 12,\, f(0) = 4$

 c) $\dfrac{dy}{dx} = 2\cos x,\, y\left(\dfrac{\pi}{2}\right) = 4$

5) Find the indicated sums.

 a) $\displaystyle\sum_{j=1}^{6} (j^2 + 2)$

 b) $\displaystyle\sum_{i=3}^{6} 2i$

 c) $\displaystyle\sum_{i=1}^{3} (i + k)$

6) Use the summation formulas to find each sum.

 a) $\displaystyle\sum_{i=1}^{100} 3i$

 b) $\displaystyle\sum_{i=1}^{100} 2i^2$

 c) $\displaystyle\sum_{i=1}^{200} (2i + 5)$

7) Find each limit.

 a) $\displaystyle\lim_{n\to\infty} \sum_{i=1}^{n} \dfrac{32i}{n^2}$

 b) $\displaystyle\lim_{n\to\infty} \sum_{i=1}^{n} \left(\dfrac{4}{n} + \dfrac{8i}{n^2} + \dfrac{8i^2}{n^3}\right)$

8) Approximate the upper and lower sums using 4 rectangles of equal width.

 a) $f(x) = 2x$, $x = 0$, $x = 4$ and the x-axis.

 b) $f(x) = x^2 + 1$, $x = 1$, $x = 3$ and the x-axis.

9) Use the limit process to find the area bounded by:

 a) $f(x) = 2x$, $x = 0$, $x = 4$ and the x-axis.

 b) $f(x) = x^2 + 1$, $x = 1$, $x = 3$ and the x-axis.

10) Evaluate each definite integral.

 a) $\displaystyle\int_{1}^{3} (2x^2 + 1)\,dx$

 b) $\displaystyle\int_{0}^{1} x^3\,dx$

 c) $\displaystyle\int_{0}^{8} 3\sqrt[3]{x}\,dx$

11) Evaluate each definite integral.

 a) $\displaystyle\int_{-1}^{-1} (2x^3 + 3x + 1)\,dx$

 b) $\displaystyle\int_{1}^{-2} (3x + 1)\,dx$

12) Find the area bounded by the given curve, the x-axis, and the lines $x = a$ and $x = b$.

a) $f(x) = x^2 - 2x + 3$ $x = 1$, $x = 4$.

b) $f(x) = -x^2 - 8x$ $x = -4$, $x = 0$.

13) Find the area bounded by the given function, $x = a$ and $x = b$.

a) $f(x) = x^3$ $x = -2$, $x = 0$.

b) $f(x) = \cos x$ $x = \pi/2$, $x = 3\pi/2$.

14) Find the area bounded by $f(x) = -x^3 - x^2 + 2x$, $x = -2$, $x = 1$.

15) Find the area bounded by

$$f(x) = \frac{1}{2}\sin x \,,\, x = 0, x = 3\pi/2.$$

16) Evaluate each integral.

a) $\int (2x^3 + 5)^4 (6x^2)\, dx$

b) $\int (3x^4 - 2x^3)^{-3} (12x^3 - 6x^2)\, dx$

c) $\int 2\sin 2x dx$

17) Evaluate each integral.

a) $\int \sqrt{2x - 5} dx$

b) $\int x^3(x^4 - 3)^3\, dx$

c) $\int \frac{x^2}{(4x^3 + 1)^5}\, dx$

18) Evaluate each integral.

a) $\int \cos 4x dx$

b) $\int 3\sec^2 2x dx$

c) $\int x\sin(4x^2)\, dx$

19) Use substitution to find each integral.

a) $\int \sin^2 x \cos x dx$

b) $\int \sqrt{\cos 4x}\, \sin 4x dx$

c) $\int \tan^{-4} x \sec^2 x dx$

20) Evaluate, changing the limits of integration when convenient.

a) $\int_0^2 (x^6 + 4x^3)^2\, (6x^5 + 12x^2)\, dx$

b) $\int_0^{\pi/10} \sin^2 5x \cos 5x dx$

TEST YOURSELF ANSWERS

1) a) $2x + C$

 b) $\frac{3}{5}x^5 + C$

 c) $\frac{1}{3}x^3 - \frac{1}{4}x^4 + C$

2) a) $-\frac{1}{4}x^{-4} + C$

 b) $\frac{3}{5}x^{5/3} + C$

 c) $x^2 + \frac{1}{5}x^5 + C$

 d) $\frac{3}{7}x^{7/3} - \frac{6}{11}x^{11/6} + C$

3) a) $3\sin x + C$

 b) $-6\cos x - 2\sin x + C$

 c) $\tan x - x^2 + C$

4) a) $y = \frac{2}{5}x^{5/2} - 12$

 b) $y = 16t^2 + 12t + 4$

 c) $y = 2\sin x + 2y$

5) a) 103

 b) 36

 c) $6 + 3k$

6) a) 15,150

 b) 676,700

 c) 41,200

7) a) 16

 b) 32/3

8) a) 12, 20

 b) 35/4, 51/4

9) a) 16

 b) 32/3

10) a) 58/3

 b) 1/4

 c) 36

11) a) 0 (note limits of integration)

 b) 3/2

12) a) 15

 b) 128/3

13) a) 4

 b) 2

14) 37/12

15) 3/2

16) a) $\frac{1}{5}(2x^3 + 5)^5 + C$

 b) $-\frac{1}{2}(3x^4 - 2x^3)^{-2} + C$

 c) $-\cos 2x + C$

17) a) $\frac{1}{3}(2x - 5)^{3/2} + C$

 b) $\frac{1}{16}(x^4 - 3)^4 + C$

 c) $-\frac{1}{48(4x^3 + 1)} + C$

18) a) $\dfrac{1}{4} \sin 4x + C$

b) $\dfrac{3}{2} \tan 2x + C$

c) $-\dfrac{1}{8} \cos 4x^2 + C$

19) a) $\dfrac{1}{3} \sin^3 x + C$

b) $-\dfrac{1}{6} (\cos 4x)^{3/2} + C$

c) $-\dfrac{1}{3} \tan^{-3} x + C$

20) a) 294,912

b) 1/15

Applications
of Integration

In this chapter, we investigate a few of the applications involving integration. We have already discovered that the area bounded by a curve and the x-axis can be found by integrating the function. We extend this idea to finding the area between two curves, to finding volumes formed by revolving curves about a line, to finding the lengths of curves, and more. The key idea to these problems is to examine a slice of the figure (whether it involves an area, volume, arc length, and so on) and to relate the shape of that slice to figures that are already familiar.

6.1 AREA BETWEEN CURVES

If two functions f and g are continuous, and $f(x) \geq g(x)$, we can find the area bounded above by $y = f(x)$ and below by $y = g(x)$ and by the vertical lines $x = a$ and $x = b$ by

$$\int_a^b [f(x) - g(x)]dx$$

The location of $y = f(x)$ and $y = g(x)$ can be totally or partially above or below the x-axis without affecting the formula. We must be careful that $f(x) \geq g(x)$ on $[a, b]$. We can state some guidelines for finding the area between two curves.

1. Sketch the graph of $y = f(x)$ and $y = g(x)$.
2. If the area is not bounded by $x = a$ and $x = b$, set $f(x) = g(x)$ and solve for the intersection points or use substitution to solve two equations with two unknowns.
3. If vertical slices are bounded above by $f(x)$ and below by $g(x)$, use

$$\text{Area} = \int_{x_1}^{x_2} [f(x) - g(x)]dx$$

4. If horizontal slices are bounded on the right by $f(x)$ and the left by $g(x)$, solve each equation for x, and use

$$\text{Area} = \int_{y_1}^{y_2} \left[f(y) - g(y) \right] dy$$

Note: When using dx slices, remember to use (top minus bottom) to find the height of a slice and x-coordinates for the limits of integration. When using dy slices, remember to use (right minus left) to find the height of a slice and y-coordinates for the limits of integration.

VERTICAL SLICES

To find the area between two curves, we must decide whether to integrate with respect to x or y. When we use vertical slices to subdivide the area, we integrate with respect to x. Study the following example.

EXAMPLE 6.1

Find the area bounded by $f(x) = 3x - 2$ and $g(x) = x^2$.

SOLUTION 6.1

Sketch the graph:

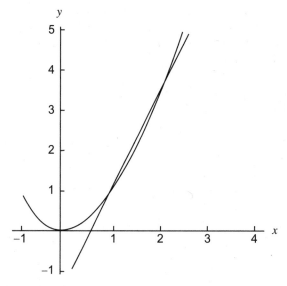

Because the area is bounded by the two curves, we find their intersection points:

$3x - 2 = x^2$	Set $f(x) = g(x)$.
$x^2 - 3x + 2 = 0$	This is a quadratic equation.
$(x - 2)(x - 1) = 0$	Factor.
$x = 2$ or $x = 1$	Set each factor equal to 0 and solve for x.

The points of intersection are $(2, 4)$ and $(1, 1)$.

Because each vertical slice is bounded above by $f(x) = 3x - 2$ and below by $g(x) = x^2$, set up the integral using x-coordinates for the limits of integration:

$$A = \int_1^2 \left[(3x - 2) - (x^2) \right] dx \qquad \text{Use top minus bottom.}$$

$$= \int_1^2 (3x - 2 - x^2) dx \qquad \text{Simplify.}$$

$$= \left. \frac{3x^2}{2} - 2x - \frac{x^3}{3} \right|_1^2 \qquad \text{Integrate.}$$

$$= \left[\frac{3(2)^2}{2} - 2(2) - \frac{(2)^3}{3} \right] - \left[\frac{3(1)^2}{2} - 2(1) - \frac{(1)^3}{3} \right]$$

$$= \left(6 - 4 - \frac{8}{3} \right) - \left(\frac{3}{2} - 2 - \frac{1}{3} \right)$$

$$= \frac{1}{6}$$

Therefore, the area bounded by the two functions is $\frac{1}{6}$.

HORIZONTAL SLICES

When we use horizontal slices to subdivide the area between two curves, we integrate with respect to y. Study the following example.

EXAMPLE 6.2

Find the area of the region bounded by $x = 4 - y^2$ and $y = \frac{1}{2}x - \frac{1}{2}$.

SOLUTION 6.2

Sketch the graph:

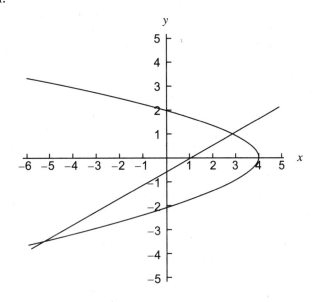

Note that if we try to draw vertical slices, some slices will go from $x = 4 - y^2$ to itself:

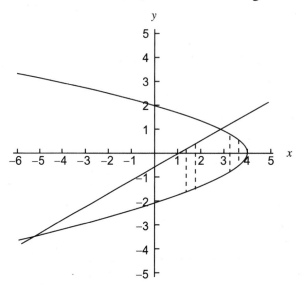

Therefore, we use horizontal slices:

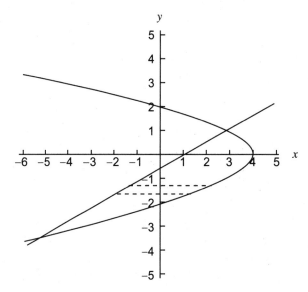

Because both equations are *not* solved for *y,* it will be easier to find the intersection points by substitution:

$y = \dfrac{1}{2}x - \dfrac{1}{2}$

$y = \dfrac{1}{2}(4 - y^2) - \dfrac{1}{2}$ Substitute $x = 4 - y^2$.

$2y = 4 - y^2 - 1$ Multiply by 2 to clear fractions.

$y^2 + 2y - 3 = 0$ Solve the quadratic equation.

$(y + 3)(y - 1) = 0$ Factor.

$y = -3$ or $y = +1$ Set each factor equal to 0 and solve.

The points of intersection are $(-5, -3)$ and $(3, 1)$.

We are using horizontal slices, so we must solve each equation for x:

$$y = \frac{1}{2}x - \frac{1}{2}, \quad x = 4 - y^2 \qquad \text{Solve each equation for } x.$$

$$2y = x - 1$$

$$2y + 1 = x$$

Because each horizontal slice is bounded on the right by $x = 4 - y^2$ and on the left by $x = 2y + 1$, set up the integral using y-coordinates for the limits of integration:

$$A = \int_{-3}^{1} [(4 - y^2) - (2y + 1)]dy$$

$$= \int_{-3}^{1} (-y^2 - 2y + 3)dy \qquad \text{Simplify.}$$

$$= \left[-\frac{y^3}{3} - y^2 + 3y \right]\Bigg|_{-3}^{1} \qquad \text{Integrate.}$$

$$= \left[-\frac{(1)^3}{3} - (1)^2 + 3(1) \right] - \left[-\frac{(-3)^3}{3} - (-3)^2 + 3(-3) \right]$$

$$= \left(\frac{5}{3} \right) - (-9)$$

$$= \frac{32}{3}$$

EXAMPLE 6.3

Find the area bounded by $f(x) = 3x - 2$ and $g(x) = x^2$ using horizontal slices. (Note that this is Example 6.1, reworked with horizontal slices.)

SOLUTION 6.3

We previously found (in Example 6.1) the x-values of the intersection points. Find the limits of integration y_1 and y_2 by substituting into $y = x^2$ (or use $f(x) = 3x - 2$):

If $x = 2$, $y = (2)^2 = 4$ Use as y_2.

If $x = 1$, $y = (1)^2 = 1$ Use as y_1.

Because we are using horizontal slices, solve each equation for x:

$$y = x^2 \qquad\quad y = 3x - 2$$

$$\sqrt{y} = x \qquad\quad \frac{y+2}{3} = x$$

Each horizontal slice is bounded on the right by $x = \sqrt{y}$ and on the left by $x = \dfrac{y+2}{3}$. Set up the integral using y values as the limits of integration:

$$\int_{1}^{4} \left[\sqrt{y} - \left(\frac{y+2}{3} \right) \right] dy$$

$$= \int_{1}^{4} \left(y^{1/2} - \frac{1}{3}y - \frac{2}{3} \right) dy \qquad \text{Simplify.}$$

$$= \left(\frac{2}{3}y^{3/2} - \frac{1}{6}y^2 - \frac{2}{3}y \right) \Big|_{1}^{4} \qquad \text{Integrate.}$$

$$= \left[\frac{2}{3}(4)^{3/2} - \frac{1}{6}(4)^2 - \frac{2}{3}(4) \right] - \left[\frac{2}{3} - \frac{1}{6} - \frac{2}{3} \right] \quad \text{Substitute } y = 4 \text{ and } y = 1.$$

$$= \frac{1}{6}$$

Of course, we found the same area as when we used vertical slices.
To evaluate using the TI-83 Plus, use the following keystrokes:
MATH
fnInt((type 9 or arrow down to fnInt(and press enter)

$$\sqrt{\ } (x) - (1 \div 3)x - (2 \div 3), x, 1, 4)$$

ENTER	Screen shows .1666 . . .
MATH	Convert to a fraction.
ENTER	
ENTER	
1/6	

SETTING UP TWO INTEGRALS

If $f(x) \leq g(x)$ for x in $[a, b]$ but $f(x) \geq g(x)$ for x in $[b, c]$, two integrals will be needed to find the area bounded by the curves on $[a, c]$. A carefully drawn sketch will help you determine which curve is on top.

EXAMPLE 6.4

Find the area of the region bounded by $f(x) = \sin x$, $g(x) = \cos x$, $x = 0$, and $x = \dfrac{5\pi}{4}$.

SOLUTION 6.4

Sketch the graph:

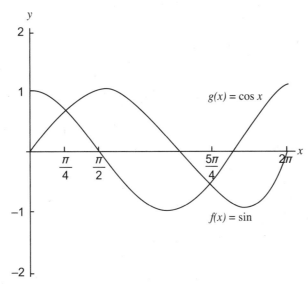

We can find the intersection points on $[0, \frac{5\pi}{4}]$ by setting $f(x) = g(x)$ and solving.

$g(x) = \cos x$

$\sin x = \cos x$ Set $f(x) = g(x)$.

$\dfrac{\sin x}{\cos x} = \dfrac{\cos x}{\cos x}$ Divide both sides by $\cos x$.

$\tan x = 1$ Use $\dfrac{\sin x}{\cos x} = \tan x$.

$f(x) = \sin x$

$x = \dfrac{\pi}{4}$ and $x = \dfrac{5\pi}{4}$ Tan x is positive in quadrants I and III.

Notice that $g(x) = \cos x$ is on top from $\left[0, \dfrac{\pi}{4} \right]$ and that $f(x) = \sin x$ is on top from $\left[\dfrac{\pi}{4}, \dfrac{5\pi}{4} \right]$.

Using vertical slices for both integrals, we have:

$A = \displaystyle\int_0^{\pi/4} [\cos x - \sin x]dx + \int_{\pi/4}^{5\pi/4} [\sin x - \cos x]dx$

$= (\sin x + \cos x) \Big|_0^{\frac{\pi}{4}} + (-\cos x - \sin x) \Big|_{\frac{\pi}{4}}^{\frac{5\pi}{4}}$ Integrate.

$$= \left[\left(\sin\frac{\pi}{4} + \cos\frac{\pi}{4}\right) - (\sin 0 + \cos 0) \right] + \left[\left(-\cos\frac{5\pi}{4} - \sin\frac{5\pi}{4}\right) - \left(-\cos\frac{\pi}{4} - \sin\frac{\pi}{4}\right) \right]$$

$$= \left[\left(\frac{\sqrt{2}}{2} + \frac{\sqrt{2}}{2}\right) - (0+1) \right] + \left[-\left(\frac{-\sqrt{2}}{2}\right) - \left(\frac{-\sqrt{2}}{2}\right) - \left(\frac{-\sqrt{2}}{2} - \frac{\sqrt{2}}{2}\right) \right]$$

$$= \left[\sqrt{2} - 1 \right] + \left[\sqrt{2} + \sqrt{2} \right] \qquad \text{Simplify.}$$

$$= 3\sqrt{2} - 1$$

6.2 VOLUME USING DISKS AND WASHERS

In this section, we use the slicing technique to find the volume of various solids.

SOLIDS OF REVOLUTION

A **solid of revolution** is a solid formed by revolving a plane region about a line. Hold up a piece of paper, revolve it around one edge, and the resulting right circular cylinder is a solid of revolution.

The Disk Method

One method for finding the volume of a solid of revolution is called the **disk method.** After a solid has been formed, imagine slicing through it perpendicular to its axis of revolution. If the slice is a solid disk (think of a CD without a hole), the disk method is an appropriate choice. The formula is based on the formula for the area of a circle, $A = \pi r^2$.

Procedure 1: If the function is revolved about $y = 0$, set up the integral $V = \pi \int_{x_1}^{x_2} [f(x)]^2 \, dx$.

Procedure 2: If the function is revolved about $x = 0$, solve the given function for $x = g(y)$ and set up the integral $V = \pi \int_{y_1}^{y_2} [g(y)]^2 \, dy$.

EXAMPLE 6.5

Find the volume of the solid formed by revolving the region bounded by $f(x) = 4 - x^2$, $x = 0$, $y = 0$ about the x-axis.

SOLUTION 6.5

Because the equation of the x-axis is $y = 0$, we use Procedure 1. We find the limits of integration by sketching the plane region $f(x) = 4 - x^2$ and determining the x-coordinates where the disks begin and end.

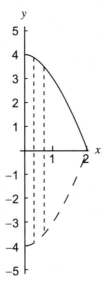

Because the region is bounded by $x = 0$ and intersects the x-axis at $x = 2$, we set up the following integral:

$$V = \pi \int_0^2 (4 - x^2)^2 \, dx$$

$$= \pi \int_0^2 (16 - 8x^2 + x^4) \, dx \qquad \text{Square the function.}$$

$$= \pi \left[16x - \frac{8x^3}{3} + \frac{x^5}{5} \right]\Big|_0^2 \qquad \text{Integrate.}$$

$$= \pi \left[(16(2) - \frac{8(2)^3}{3} + \frac{(2)^5}{5}) - (16(0) - \frac{8(0)^3}{3} + \frac{(0)^5}{5}) \right] \qquad \text{Evaluate.}$$

$$= \pi \left[(32 - \frac{64}{3} + \frac{32}{5}) - (0) \right] \qquad \text{Simplify}$$

$$= \pi \cdot \frac{256}{15} \text{ or } \frac{256\pi}{15}$$

EXAMPLE 6.6

Find the volume of the solid formed by revolving the region bounded by $f(x) = 4 - x^2$, $x = 0$, $y = 0$ about the y-axis.

SOLUTION 6.6

Note that this is the same plane region as in Example 6.5, but now it is revolved about $x = 0$ (the y-axis). The slices are now dy slices (horizontal slices):

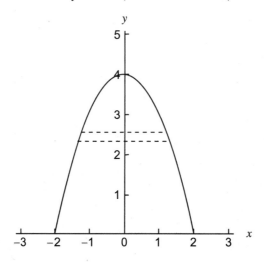

We must solve $y = 4 - x^2$ for x:

$y - 4 = -x^2$	Subtract 4 from both sides.
$-y + 4 = x^2$	Multiply both sides by -1.
$+\sqrt{-y+4} = x$	Take the square root of both sides.

Note that we use only the positive square root, because the original function was defined with $x \geq 0$. Set up the integral using y-coordinates for the limits of integration:

$$V = \pi \int_0^4 \left(\sqrt{-y+4}\right)^2 dy$$

$$= \pi \int_0^4 (-y+4)dy \qquad \text{Squaring the square root removes the radical.}$$

$$= \pi \left[-\frac{y^2}{2} + 4y\right] \bigg|_0^4 \qquad \text{Integrate.}$$

$$= \pi \left[(-\frac{(4)^2}{2} + 4(4)) - (-\frac{0^2}{2} + 4(0))\right] \quad \text{Evaluate.}$$

$$= \pi \left[(8) - (0)\right] \qquad \text{Simplify.}$$

$$= 8\pi$$

EXAMPLE 6.7

Find the volume of the solid formed by revolving the region bounded by $f(x) = 4 - x^2$, $y = 1$, $x = 0$ about $y = 1$.

SOLUTION 6.7

First sketch the plane region:

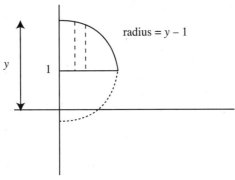

Notice that the radius of a disk is no longer y, but $y - 1$. Because we will be using dx slices, we must express the radius, $y - 1$, in terms of x.

$y - 1 = (4 - x^2) - 1$	Use $y = 4 - x^2$.
$y - 1 = 3 - x^2$	Radius in terms of x.

The limits of integration are from $x = 0$ to where $f(x) = 4 - x^2$ and $y = 1$ intersect:

$4 - x^2 = 1$	Set $f(x) = y$.
$-x^2 = -3$	Solve for x.
$x^2 = 3$	
$x = \pm\sqrt{3}$	Take the square root of both sides.

We will use the positive square root, because we are working in Quadrant I.

$V = \pi \displaystyle\int_0^{\sqrt{3}} (3 - x^2)^2 \, dx$	Set up the integral.	
$= \pi \displaystyle\int_0^{\sqrt{3}} (9 - 6x^2 + x^4) \, dx$	Square the binomial.	
$= \pi \left[9x - 2x^3 + \dfrac{1}{5} x^5 \right]\Bigg	_0^{\sqrt{3}}$	Integrate.
$= \pi \left[\left(9(\sqrt{3}) - 2(\sqrt{3})^3 + \dfrac{1}{5}(\sqrt{3})^5 \right) - 0 \right]$	Evaluate.	
$= \pi \left[9\sqrt{3} - 6\sqrt{3} + \dfrac{9}{5}\sqrt{3} \right]$	Simplify.	
$= \pi \dfrac{24\sqrt{3}}{5}$ or $\dfrac{24\pi\sqrt{3}}{5}$	Add similar terms.	

To use the TI-83 Plus, do the following:

MATH

9 (or arrow down to fnInt(and press enter)

3 – x^2)^2,x,0,$\sqrt{}$ 3)

Enter

x π Multiply times π.

Enter

26.1187 Approximate answer on screen.

The Washer Method

When revolving a region about a line leaves a hole in the slice, we use the **washer method** to find the volume of the solid of revolution:

$$V = \pi \int_{x_1}^{x_2} [(R(x))^2 - (r(x))^2] dx \qquad \text{Revolved about } y = c$$

$$V = \pi \int_{y_1}^{y_2} [(R(y))^2 - (r(y))^2] dy \qquad \text{Revolved about } x = b$$

where R is the length of the outer radius and r is the length of the inner radius.

EXAMPLE 6.8

Find the volume of the solid formed by revolving the region bounded by $f(x) = 4 - x^2$, $y = 1$, $x = 0$ about the x-axis.

SOLUTION 6.8

First sketch the plane region:

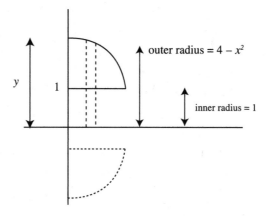

Note that the washers start at $x = 0$ and end at $x = \sqrt{3}$ (see Example 6.6). The volume is then

$$V = \pi \int_0^{\sqrt{3}} \left[(4 - x^2)^2 - (1)^2 \right] dx$$

$$= \pi \int_0^{\sqrt{3}} (16 - 8x^2 + x^4 - 1) dx \qquad \text{Simplify.}$$

$$= \pi \int_0^{\sqrt{3}} (15 - 8x^2 + x^4)dx \qquad \text{Combine similar terms.}$$

$$= \pi \left[15x - \frac{8x^3}{3} + \frac{x^5}{5} \right]_0^{\sqrt{3}} \qquad \text{Integrate.}$$

$$= \pi \left[\left(15\sqrt{3} - \frac{8(\sqrt{3})^3}{3} + \frac{(\sqrt{3})^5}{5} \right) - (0) \right] \qquad \text{Evaluate.}$$

$$= \pi(15\sqrt{3} - 8\sqrt{3} + \frac{9\sqrt{3}}{5}) \qquad \text{Simplify.}$$

$$= \pi(\frac{44}{5}\sqrt{3}) \text{ or } \frac{44\pi\sqrt{3}}{5} \qquad \text{Simplify.}$$

VOLUMES OF SOLIDS WITH KNOWN CROSS-SECTIONS

Formulas for finding the volume of certain solids are generally studied in geometry. For example, the formula for the volume of a right circular cylinder is $V = \pi r^2 h$. When the solid has a cross-section shape whose area is known, we can use slices to find the volume of additional solids.

When cross-sections are taken perpendicular to the x-axis, $V = \int_a^b A(x)dx$

When cross-sections are taken perpendicular to the y-axis, $V = \int_c^d A(y)dy$

where $A(x)$ and $A(y)$ represent the area of a cross-section.

EXAMPLE 6.9

Find the volume of a solid whose base is enclosed by the circle $x^2 + y^2 = 9$ and whose cross-sections taken perpendicular to the x-axis are squares.

SOLUTION 6.9

In the x-y plane, draw the circle $x^2 + y^2 = 9$. Because slices are perpendicular to the x-axis, sketch a typical slice. To find the area of a cross-sectional slice, note that the length of a slice is 2y.

$x^2 + y^2 = 9$	Solve for y.
$y^2 = 9 - x^2$	Subtract x^2 from both sides.
$y = \pm\sqrt{9 - x^2}$	Take the square root of both sides.
$2y = 2\sqrt{9 - x^2}$	2y is the length of a slice.

Because the area of a square is $A = s^2$, we use $A = \left(2\sqrt{9-x^2}\right)^2$ for the area of a cross-section.

$$V = \int_{-3}^{3} \left(2\sqrt{9-x^2}\right)^2 dx \qquad \text{Note you could also use } 2\int_{0}^{3} \left(2\sqrt{9-x^2}\right)^2 dx.$$

$$= \int_{-3}^{3} 4(9-x^2)\,dx \qquad \text{Simplify.}$$

$$= 4\left[9x - \frac{x^3}{3}\right]\Big|_{-3}^{3} \qquad \text{Integrate.}$$

$$= 4\left[(27-9)-(-27+9)\right] \qquad \text{Evaluate.}$$

$$= 144$$

6.3 VOLUME BY SHELLS

Another method for finding volumes of solids of revolution is the **shell method.** Try to imagine sliding a soup can (both ends open, no soup) into the solid of revolution. We find the volume using $2\pi rh$, where r represents the distance from the axis of revolution out to the shell and h represents the height of the shell. We have the following two formulas for the shell method:

$$V = 2\pi \int_{x_1}^{x_2} r(x)h(x)\,dx \qquad \text{Revolved about } x = b$$

$$V = 2\pi \int_{y_1}^{y_2} r(y)h(y)\,dx \qquad \text{Revolved about } y = c$$

EXAMPLE 6.10

Find the volume of the solid of revolution formed by revolving the region bounded by $y = x^2 + 2$, $x = 1$, $x = 0$, and $y = 0$ about $x = 0$ (the y-axis).

SOLUTION 6.10

Sketch the plane region:

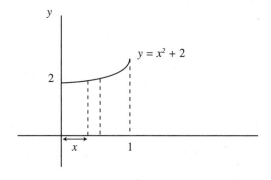

The radius of each shell is x, the height is $h(x) = x^2 + 2$, and the radii of the shells go from $x = 0$ to $x = 1$. The volume is

$$V = 2\pi \int_0^1 x(x^2 + 2)dx \qquad \text{Set up the volume formula.}$$

$$= 2\pi \int_0^1 (x^3 + 2x)dx \qquad \text{Simplify.}$$

$$= 2\pi \left(\frac{x^4}{4} + x^2 \right) \Big|_0^1 \qquad \text{Integrate.}$$

$$= 2\pi \left[(\frac{1}{4} + 1) - (0) \right] \qquad \text{Evaluate.}$$

$$= 2\pi (\frac{5}{4}) = \frac{5}{2}\pi \qquad \text{Simplify.}$$

EXAMPLE 6.11

Find the volume of the solid of revolution formed by revolving the region bounded by $y = x^2 + 2$, $x = 1$, $x = 0$, and $y = 0$ about $x = 2$.

SOLUTION 6.11

Sketch the plane region:

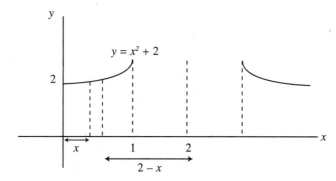

Note that the radius of a shell is now $2 - x$, because the radius must be measured from the axis of revolution (in this case, $x = 2$). The height is still $h(x) = x^2 + 2$, and the radii of the shells go from $x = 0$ to $x = 1$, so the volume is

$$V = 2\pi \int_0^1 (2 - x)(x^2 + 2)dx \qquad \text{Set up the volume formula.}$$

$$= 2\pi \int_0^1 (2x^2 + 4 - x^3 - 2x)dx \qquad \text{Simplify.}$$

$$= 2\pi \left[\frac{2x^3}{3} + 4x - \frac{x^4}{4} - x^2 \right] \Big|_0^1 \qquad \text{Integrate.}$$

$$= 2\pi \left[(\frac{2}{3} + 4 - \frac{1}{4} - 1) - (0) \right] \qquad \text{Evaluate.}$$

$$= \frac{41\pi}{6} \qquad \text{Simplify.}$$

DY SHELLS

If the region is revolved about $y = c$, for c a constant, we need shells with radii that are measured along the y-axis, and heights that must be written in terms of $x = f(y)$. Study the following example.

EXAMPLE 6.12

Find the volume of the solid of revolution formed by revolving the region bounded by $y = \sqrt{x}$, $x = 0$, and $y = 2$ about the line $y = 4$.

SOLUTION 6.12

Sketch the plane region:

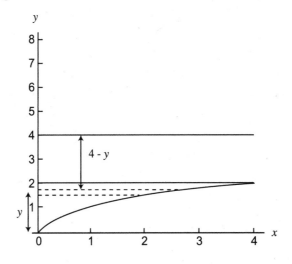

The radii are measured from the axis of revolution ($y = 4$), and so $r(y) = 4 - y$. The height must be given in terms of y, so

$$y = \sqrt{x} \qquad \text{Given function.}$$
$$y^2 = x \qquad \text{Solve for } x.$$

The radii of the shells run from $y = 0$ to $y = 2$, so the volume is

$$V = 2\pi \int_0^2 (4 - y)(y^2) dy \qquad \text{Set up the volume formula.}$$

$$= 2\pi \int_0^2 (4y^2 - y^3) dy \qquad \text{Simplify.}$$

$$= 2\pi \left(\frac{4y^3}{3} - \frac{y^4}{4} \right) \Big|_0^2 \qquad \text{Integrate.}$$

$$= 2\pi \left[(\frac{32}{3} - \frac{16}{4}) - (0) \right] \qquad \text{Evaluate.}$$

$$= \frac{40}{3}\pi \qquad \text{Simplify.}$$

COMPARING THE DISK, WASHER, AND SHELL METHODS

Many of the volumes for solids of revolution can be found by using either method. If a typical slice using one method involves finding a distance from a curve to itself (for either a radius or height measurement), it's generally easier to choose the other method. Sometimes, one method will be more convenient, either because the resulting integral is easier to calculate or because one integral can be used instead of two.

EXAMPLE 6.13

Revolve the indicated region about the indicated line to form a solid of revolution. Then set up the integral to find the volume using the disk, washer, or shell methods.

a) $y = -(x-2)^2 + 4$, $y = 0$ about $y = 0$.
b) $y = -(x-2)^2 + 4$, $y = 0$ about $x = 0$.
c) $y = -x^2 + 4$, $y = 1$, $x = 0$ about $y = 0$.

SOLUTION 6.13

a) Sketch the indicated region.
 Using the disk method:

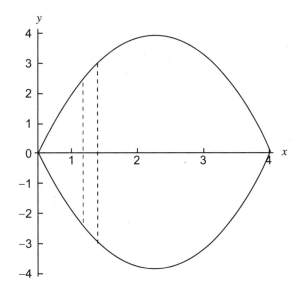

$$V = \pi \int_0^4 [-(x-2)^2 + 4] dx$$

Although the shell method could be used, the height of a shell would be measured from the curve to itself.

b) $y = -(x-2)^2 + 4$, $y = 0$ about $x = 0$

By the shell method:

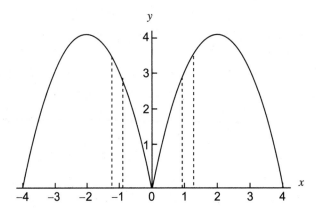

$$V = 2\pi \int_0^4 x(-(x-2)^2 + 4)dx$$

The washer method is not as convenient, because a radius would be measured from the curve to itself.

c) $y = -x^2 + 4$, $y = 1$, $x = 0$ about $y = 0$

By the washer method:

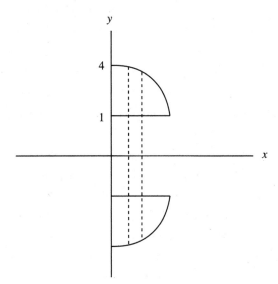

$$V = \pi \int_0^{\sqrt{3}} [(-x^2 + 4)^2 - (1)^2]dx$$

By the shell method:

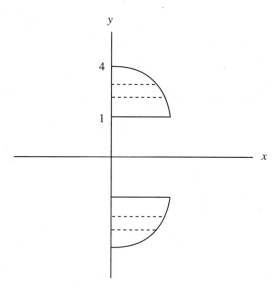

To find $h(y)$, solve $y = -x^2 + 4$ for x

$y - 4 = -x^2$

$4 - y = x^2$

$\sqrt{4-y} = x$ Use the positive square root for the first quadrant curve.

$V = 2\pi \int_1^4 y(\sqrt{4-y})\,dy$

However, you have not yet learned to integrate $y\sqrt{4-y}$, and if you needed a numerical answer, you would have to resort to the washer method. (If you want to check both integrals, use the following formula, a calculator, or appropriate software.)

$$\int y\sqrt{4-y}\,dy = -\frac{2}{3}y(4-y)^{3/2} - \frac{4}{15}(4-y)^{5/2} + C.$$

6.4 LENGTH OF A CURVE

In this section, we restrict our interest to smooth curves of finite length. If the curve is described by $y = f(x)$, $a \le x \le b$, the arc length L is

$$L = \int_a^b \sqrt{1 + [f'(x)]^2}\,dx$$

and if the curve is described by $x = g(y)$, $c \le y \le d$, the arc length L is

$$L = \int_c^d \sqrt{1 + [g'(y)]^2}\,dy$$

The steps to follow to find arc length are:

1. Find the derivative of the given curve.
2. Square the derivative.

3. Add 1 to that square.

4. Write the sum under a square root. You may need to factor and use $\sqrt{(p+q)^2} = p+q$ to simplify before integrating.

5. Integrate.

6. Evaluate.

EXAMPLE 6.14

Find the arc length of $f(x) = x^{3/2} + 2$ on $[1, 4]$.

SOLUTION 6.14

$f(x) = x^{3/2} + 2$	Given function.	
$f'(x) = \dfrac{3}{2}x^{1/2}$	Find the derivative.	
$[f'(x)]^2 = \left[\dfrac{3}{2}x^{1/2}\right]^2$	Square the derivative.	
$= \dfrac{9}{4}x$	Simplify.	
$\sqrt{1+[f'(x)]^2} = \sqrt{1+\dfrac{9}{4}x}$	Add 1 and write the sum under a square root.	
$L = \displaystyle\int_1^4 \sqrt{1+\dfrac{9}{4}x}\,dx$	Set up the integral and use u substitution.	
$= \dfrac{4}{9}\displaystyle\int_1^4 (1+\dfrac{9}{4}x)^{1/2}(\dfrac{9}{4}dx)$	If $u = 1+\dfrac{9}{4}x$, $du = \dfrac{9}{4}dx$.	
$= \dfrac{4}{9}\displaystyle\int u^{1/2}\,du$	Substitute.	
$= \dfrac{4}{9}\cdot\dfrac{2}{3}u^{3/2}$	Integrate.	
$= \dfrac{4}{9}\cdot\dfrac{2}{3}\left[1+\dfrac{9}{4}x\right]^{3/2}\Big	_1^4$	Substitute for u.
$= \dfrac{8}{27}\left[(1+\dfrac{9}{4}(4))^{3/2} - (1+\dfrac{9}{4}(1))^{3/2}\right]$	Evaluate.	
$= \dfrac{8}{27}\left[10^{3/2} - (\dfrac{13}{4})^{3/2}\right]$	Simplify.	

EXAMPLE 6.15

Find the arc length of $f(x) = \dfrac{x^4}{8} + \dfrac{1}{4x^2}$ on $[1, 4]$.

SOLUTION 6.15

$$f(x) = \frac{x^4}{8} + \frac{1}{4x^2}$$

Given function.

$$f'(x) = \frac{1}{2}x^3 - \frac{1}{2}x^{-3}$$

Find the derivative. Use $\dfrac{1}{4x^2} = \dfrac{1}{4}x^{-2}$.

$$= \frac{x^3}{2} - \frac{1}{2x^3}$$

Simplify.

$$= \frac{x^6 - 1}{2x^3}$$

Combine fractions.

$$[f'(x)]^2 = \left(\frac{x^6 - 1}{2x^3}\right)^2$$

Square the derivative.

$$= \frac{x^{12} - 2x^6 + 1}{4x^6}$$

Square the numerator and the denominator.

$$1 + [f'(x)]^2 = 1 + \frac{x^{12} - 2x^6 + 1}{4x^6}$$

Add 1.

$$= \frac{4x^6}{4x^6} + \frac{x^{12} - 2x^6 + 1}{4x^6}$$

Combine fractions using $4x^6$ as LCD.

$$= \frac{x^{12} + 2x^6 + 1}{4x^6}$$

Add the numerators.

$$= \frac{(x^6 + 1)^2}{(2x^3)^2}$$

Factor.

Then arc length, L, is

$$L = \int_1^4 \sqrt{\frac{(x^6 + 1)^2}{(2x^3)^2}}\,dx$$

Write the sum under a square root.

$$= \int_1^4 \frac{x^6 + 1}{2x^3}\,dx$$

Simplify.

$$= \int_1^4 \left(\frac{x^3}{2} + \frac{1}{2x^3}\right)dx$$

Split the fraction.

$$= \left[\frac{x^4}{8} - \frac{1}{4}x^{-2}\right]\Bigg|_1^4$$

$\displaystyle\int \frac{1}{2x^3}\,dx = \frac{1}{2}\int x^{-3}\,dx$.

$$= \left(\frac{(4)^4}{8} - \frac{1}{4(4)^2}\right) - \left(\frac{(1)^4}{8} - \frac{1}{4(1)^2}\right)$$

Evaluate.

$$= (32 - \frac{1}{64}) - (\frac{1}{8} - \frac{1}{4}) \qquad \text{Simplify.}$$

$$= \frac{2055}{64} \text{ or } 32\frac{7}{64} \qquad \text{Simplify.}$$

EXAMPLE 6.16

Set up the integral that represents the arc length of $y = \sin x$ on $[0, \frac{\pi}{2}]$.

SOLUTION 6.16

$y = \sin x$ Given curve.

$y' = \cos x$ Find the derivative.

$(y')^2 = \cos^2 x$ Square the derivative.

$(y')^2 + 1 = \cos^2 x + 1$ Add 1.

$$L = \int_0^{\pi/2} \sqrt{\cos^2 x + 1}\, dx \qquad \text{Set up the integral.}$$

Although this integral cannot be evaluated by techniques presented thus far, we can use the following steps for the TI-83 Plus:

MATH

9 (or arrow down to fnInt (and press enter)

$\sqrt{\ }((\cos(x))^\wedge 2 + 1), x, 0, \pi \div 2)$

ENTER

1.910099 Screen value.

6.5 AREA OF A SURFACE OF REVOLUTION

If we revolve a plane smooth curve about a line, we form a surface of revolution. The formula for finding the area of the surface of revolution makes use of the arc length formulas from Section 6.4. The arc length must be multiplied by $2\pi r$, where r is the distance from the axis of revolution to the curve.

AREA OF A SURFACE OF REVOLUTION

If the curve is given as $y = f(x)$ on $[a, b]$, the area of the surface formed by revolving the curve about a line is

$$S = 2\pi \int_a^b r(x)\sqrt{1 + [f'(x)]^2}\, dx,$$

where $r(x)$ is the distance from the axis of revolution to $f(x)$.

If the curve is given as $x = g(y)$ on $[c, d]$, the area of the surface formed by revolving the curve about a line is

$$S = 2\pi \int_c^d r(y)\sqrt{1 + [g'(y)]^2}\, dy,$$

where $r(y)$ is the distance from the axis of revolution to $g(y)$.

EXAMPLE 6.17

Find the area of the surface formed by revolving $f(x) = x^3$ on [0, 1] about the x-axis.

SOLUTION 6.17

A sketch will help us find $r(x)$:

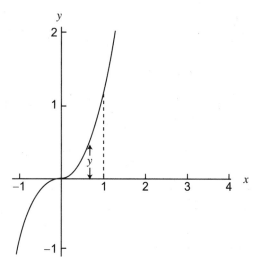

This distance from the x-axis to the curve is y, which equals x^3. Thus,

$$S = 2\pi \int_0^1 x^3 \sqrt{1+(3x^2)^2}\, dx \qquad\qquad f(x) = x^3, f'(x) = 3x^2.$$

$$= 2\pi \int_0^1 x^3 (1+9x^4)^{1/2}\, dx \qquad\qquad \text{Let } u = 1 + 9x^4,\ du = 36x^3 dx.$$

$$= 2\pi \frac{1}{36} \int_0^1 36x^3 (1+9x^4)^{1/2}\, dx \qquad \text{Multiply inside by 36, and outside by } \frac{1}{36}.$$

$$= \frac{\pi}{18} \int u^{1/2}\, du = \frac{\pi}{18} \cdot \frac{2}{3} u^{3/2} \qquad\qquad \text{Use } u \text{ substitution and integrate.}$$

$$= \frac{\pi}{18} \left[\frac{2}{3} (1+9x^4)^{3/2} \right]\Big|_0^1 \qquad\qquad \text{Substitute for } u.$$

$$= \frac{\pi}{27} [(1+9(1)^4)^{3/2} - (1+9(0)^4)^{3/2}] \qquad \text{Evaluate.}$$

$$= \frac{\pi}{27} (10^{3/2} - 1) \qquad\qquad \text{Simplify.}$$

To use the TI-83 Plus, type the following:

MATH

9 (or arrow down to 9 and press enter)

x^3(1+9x^4)^.5,x,0,1)

Enter

x 2 π (π is 2nd ^) Multiply times 2π.

Enter

3.5631 Approximate answer on screen.

EXAMPLE 6.18

Find the area of the surface formed by revolving $x = y^3$, $0 \le y \le 1$ about the y-axis.

SOLUTION 6.18

A sketch will help us find $r(y)$:

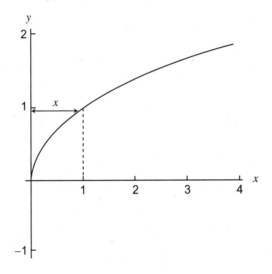

The distance from the y-axis to the curve is x, which equals y^3, so the area of the surface is

$$S = 2\pi \int_0^1 y^3 \sqrt{1+(3y^2)^2}\,dy \qquad g(y) = y^3,\; g'(y) = 3y^2.$$

Notice that this is the exact same integral as Example 6.17, using y rather than x. So,

$$S = \frac{\pi}{27}(10^{3/2} - 1).$$

EXAMPLE 6.19

Set up, but do not evaluate, the integral necessary to find the area of the surface formed by revolving $f(x) = \sin x$ on $[0, \pi/2]$ about the x-axis.

SOLUTION 6.19

We previously found the integral representing the arc length for $y = \sin x$ in Example 6.14. We need only find $r(x)$:

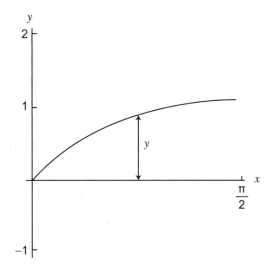

The distance from the x-axis to the curve is y, which equals $\sin x$. So the surface area is

$$S = 2\pi \int_0^{\pi/2} \sin x \sqrt{1 + \cos^2 x}\, dx.$$

6.6 WORK

While you may consider the time and effort you have put into your study of calculus to be work, we will use the definition of work done by a constant force or a continuously varying force described in the following sections.

CONSTANT FORCE

We begin our discussion of work by examining work done by a constant force. In this case, the work done to move an object a distance x by a force F is $W = Fx$.

EXAMPLE 6.20

Find the work done to lift an 80-pound bag of cement 10 feet.

SOLUTION 6.20

The force is represented as 80 pounds. The distance the bag is moved, 10 feet, is x. Thus

$W = Fx$	Formula for work.
$W = (80 \text{ pounds})(10 \text{ feet})$	Substitute.
$W = 800$ foot pounds or 800 ft · lbs.	

VARYING FORCE

A more practical application of the concept of work involves a varying force, such as the work to compress or stretch a spring or the work to move a liquid. In these cases, work is defined as an integral, where $F(x)$ describes the varying force used to move an object from a to b. Thus,

$W = \int_a^b F(x)dx$

SPRINGS

We need **Hooke's Law** to find the force to compress or stretch a spring: $F(x) = kx$, where k is the spring constant (a number that remains constant for our purposes for a given spring), and x is the distance the spring is stretched or compressed from its natural length.

To find work done using springs

1. Find k, the spring constant (if not already given) by substituting a given force F and distance x into $F = kx$ and solving for k.

2. Find the limits of integration by determining the distance over which the work is to be measured.

3. Integrate.

EXAMPLE 6.21

A force of 5 pounds compresses a spring 2 inches from its natural length of 14 inches. Find the work done in compressing the spring a total of 6 inches.

SOLUTION 6.21

$F = kx$	Find k using $F = kx$.
$5 = k(2)$	$F = 5, x = 2$.
$\dfrac{5}{2} = k$	Solve for k.

The spring is to be compressed 6 inches, which means the work starts at a distance of $x = 0$, and ends when $x = 6$. Note that the spring will now be $14 - 6 = 8$ inches long.

$W = \int_0^6 \dfrac{5}{2}x\,dx$	Set up the integral.	
$= \dfrac{5}{4}x^2\Big	_0^6$	Integrate.
$= \dfrac{5}{4}(6^2 - 0^2)$	Evaluate.	
$= 45$ in·lb		

EXAMPLE 6.22

A force of 4 kilograms stretches a spring 2.5 centimeters. How much work must be done to stretch the spring an additional 2 centimeters?

SOLUTION 6.22

$F = kx$ Find k using $F = kx$.

$4 = k(2.5)$ $F = 4, x = 2.5$

$1.6 = k$ $\dfrac{4}{2.5} = 1.6$

The spring is to be stretched an *additional* 2 centimeters, which means we want to find the work done from $x = 2.5$ to $x = (2.5 + 2) = 4.5$.

$W = \displaystyle\int_{2.5}^{4.5} 1.6x\,dx$ Set up the integral.

$= \dfrac{1.6x^2}{2}\Big|_{2.5}^{4.5}$ Integrate.

$= 0.8[(4.5)^2 - (2.5)^2]$ Evaluate.

$= 11.2$ cm·kg

EXAMPLE 6.23

160 joules of work is required to stretch a spring 0.8 meters from its natural length. Find the spring constant and find the work required to stretch the spring an additional 0.4 meters.

SOLUTION 6.23

Note that in this example, you are given the work, which means an integral has already been taken.

$\displaystyle\int_{0}^{0.8} kx\,dx = 160$ We are given work.

$k\dfrac{x^2}{2}\Big|_{0}^{0.8} = 160$ Integrate.

$\dfrac{k}{2}(.8)^2 = 160$ Evaluate the integral.

$k = 500$ Solve for k the spring constant.

Now to find the work required to stretch the spring an additional 0.4 meters, we must integrate from 0.8 to $(0.8 + 0.4) = 1.2$:

$W = \displaystyle\int_{0.8}^{1.2} 500x\,dx$ Set up the integral for work.

$= 250x^2\Big|_{0.8}^{1.2}$ Integrate.

$= 200$ joules Evaluate.

MOVING LIQUIDS

We can find the work done to move a liquid using the same idea as stretching or compressing springs. We must find the force needed to move the liquid, which will generally equal the weight of the liquid times the volume of a typical slice, and the distance the liquid is to move. Note that the limits of integration refer to the initial location of a slice (see Example 6.25).

EXAMPLE 6.24

A cylindrical tank of diameter 16 feet and height of 10 feet is filled with water. Find the work done to pump the water over the top edge of the tank.

SOLUTION 6.24

A sketch will help us visualize the situation:

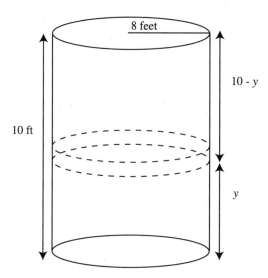

Each slice is a disk whose volume is $\pi r^2 \Delta y$, where Δy is the thickness of a slice. Because the diameter was given as 16 feet, the radius, r, is 8 feet.

$V = \pi(8)^2 \Delta y = 64\pi \Delta y$ ft³

The force needed to move a slice is the weight of a slice. We use 62.4 pounds per cubic foot for the weight of water.

$$F = (62.4 \frac{\text{lb}}{\text{ft}^3})(64\pi\Delta y \text{ ft}^3)$$

$$= 3{,}993.6\pi\Delta y \text{ lb}$$

A slice at height y must move a distance of $10 - y$ feet, so

$$W = \int_0^{10} 3993.6\pi(10 - y)dy \qquad W = \int \text{force} \times \text{distance}$$

$$= 3993.6\pi \int_0^{10} (10 - y)dy \qquad \text{Simplify.}$$

$$= 3993.6\pi \left[10y - \frac{y^2}{2} \right]_0^{10} \qquad \text{Integrate.}$$

$$= 3993.6\pi \left[((10)(10) - \frac{10^2}{2}) - (0) \right] \quad \text{Evaluate.}$$

$$= 199,680 \; \pi \; \text{ft·lb}$$

$$\approx 627,313 \; \text{ft·lb}$$

EXAMPLE 6.25

The same cylindrical tank as in Example 6.24 is filled with liquid weighing 42 lb/ft^3. Find the work done to pump the liquid 6 feet above the top of the tank.

SOLUTION 6.25

Let's begin with a sketch:

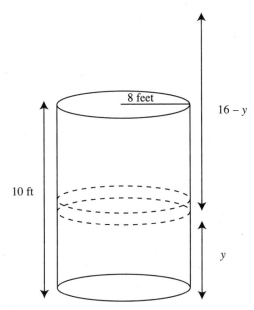

We must change the weight of a slice to 42 lb/ft^3, and the distance each slice must move is now $(16 - y)$. Note that the slices still go from 0 (at the bottom of the tank) to 10 (at the top of the tank).

$$F = (42 \; \text{lb/ft}^3)(64\pi\Delta y \text{ft}^3)$$

$$= 2,688\pi\Delta y \; \text{lb}$$

$$W = \int_0^{10} (2,688\pi)(16 - y)dy \qquad W = \int \text{force} \times \text{distance}$$

$$= 2,688\pi \int_0^{10} (16 - y)dy \qquad \text{Simplify.}$$

$$= 2,688\pi \left[16y - \frac{y^2}{2} \right]\Big|_0^{10} \qquad \text{Integrate.}$$

$$= 2,688\pi \left[((16)(10) - \frac{10^2}{2}) - (0) \right] \qquad \text{Evaluate.}$$

$$= 2{,}688\pi(110) \qquad\qquad \text{Simplify.}$$
$$= 295{,}680\pi \text{ ft·lb}$$
$$\approx 928{,}906 \text{ ft·lb}$$

EXAMPLE 6.26

An open tank has the shape of a right circular cone. The tank has a radius of 5 feet across the top and is 12 feet high. Find the work done to pump the water 4 feet above the top of the tank.

SOLUTION 6.26

Each slice is a disk whose volume varies depending on the height of the slice. Setting up the situation in the *xy*-plane helps you find a relationship between the height of a slice and the radius of a slice:

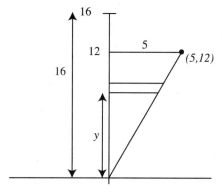

$$m = \frac{12}{5}, y = \frac{12}{5}x \text{ or } x = \frac{5}{12}y \qquad \text{Find the slope of the line, and then the equation of the line.}$$

The radius at a given height is represented by *x*. The volume of a typical slice is:
$$V = \pi r^2 \Delta y$$
$$= \pi\left(\frac{5}{12}y\right)^2 \Delta y \qquad\qquad \text{Use } x = \frac{5}{12}y.$$
$$= \frac{25}{144}\pi y^2 \Delta y \text{ ft}^3 \qquad\qquad \text{Simplify.}$$

The force needed to move a slice is the weight of a slice. We use 62.4 pounds per cubic foot for the weight of water.

$$F = \left(62.4\frac{\text{lb}}{\text{ft}^3}\right)\left(\frac{25}{144}\pi y^2 \Delta y\text{ft}^3\right)$$
$$= \frac{65}{6}\pi y^2 \Delta y\text{lb}$$

A slice at height *y* must move a distance of $16 - y$ feet, so
$$W = \int_0^{12} \frac{65}{6}\pi y^2(16-y)dy \qquad\qquad \text{Set up the integral for work.}$$

$$= \frac{65}{6}\pi \int_0^{12} (16y^2 - y^3)\,dy \qquad \text{Factor out the constant and simplify.}$$

$$= \frac{65}{6}\pi \left[\frac{16y^3}{3} - \frac{y^4}{4} \right]\Big|_0^{12} \qquad \text{Integrate.}$$

$$= 43{,}680\pi \text{ foot-pounds}$$

6.7 FLUID FORCE

Several laws govern working with fluid force. First, the pressure exerted by a fluid on a surface is the same at all points at a given depth (or elevation). Next, the fluid force on a horizontal surface with area A equals the density of the fluid times the depth of the surface times the area of the surface. By considering slices of a submerged vertical surface, we can find the fluid force on the entire surface using

$$F = \delta \int_{y_1}^{y_2} hL\,dy,$$

where δ is the density of the fluid and h is the depth of the fluid at a horizontal slice of length L. The limits of integration are the y-coordinates of the bottom and top of the vertical surface. Some guidelines to solving fluid force problems are as follows:

1. Draw a sketch. Impose x- and y-axes in a convenient place on your sketch.
2. Draw a horizontal slice on your sketch to help determine the depth and length of a slice as indicated by your x- and y-axes.
3. Set up the force integral.
4. Integrate and evaluate.

EXAMPLE 6.27

The vertical end of a tank filled with water has the shape of a rectangle as shown. If the depth of the water is 3 feet, find the total force against the end of the tank. (Note: Use $\delta = 62.4$ pounds per cubic foot.)

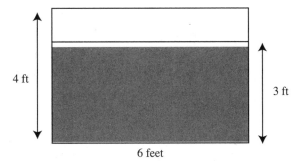

4 ft

3 ft

6 feet

SOLUTION 6.27

Place your *x*- and *y*-axes as follows:

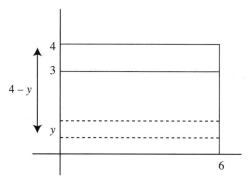

The depth of a slice is $4 - y$.
The length of a slice is 6.
Thus,

$$F = 62.4 \int_0^3 (4 - y)(6)\,dy \qquad\qquad F = \delta \int hL\,dy$$

$$= 62.4 \int_0^3 (24 - 6y)\,dy \qquad\qquad \text{Simplify.}$$

$$= 62.4 \left[24y - 3y^2\right]_0^3 \qquad\qquad \text{Integrate.}$$

$$= 62.4 [(24(3) - 3(3)^2) - 0] \qquad \text{Evaluate.}$$
$$= 2{,}808 \text{ pounds}$$

EXAMPLE 6.28

Find the fluid force on the given vertical plate submerged in water.

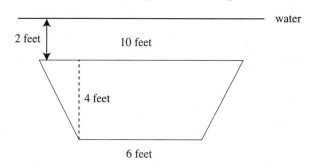

SOLUTION 6.28

Place the x-axis at the water line and the y-axis in the middle of the plate:

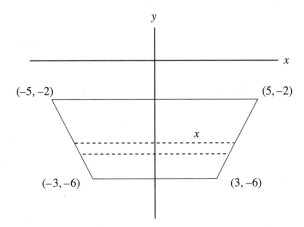

The length of a slice is $2x$. Find an expression for x in terms of y by finding the equation of the line that contains $(5, -2)$ and $(3, -6)$.

$$m = \frac{y_2 - y_1}{x_2 - x_1}$$

$$m = \frac{-2 - (-6)}{5 - 3}$$

$m = 2$ Simplify.

$y - y_1 = m(x - x_1)$.

$y - (-2) = 2(x - 5)$

$y + 2 = 2x - 10$ Simplify.

$y + 12 = 2x$ Solve for x.

$$\frac{1}{2} y + 6 = x$$

The length of a slice is:

$$2x = 2(\frac{1}{2}y + 6) = y + 12$$

Find force:

$$F = 62.4 \int_{-6}^{-2} (-y)(y + 12)dy \qquad\qquad F = \delta \int hL\,dy.$$

$$= 62.4 \int_{-6}^{-2} (-y^2 - 12y)dy \qquad\qquad \text{Simplify.}$$

$$= 62.4 \left[-\frac{y^3}{3} - 6y^2 \right]_{-6}^{-2} \qquad\qquad \text{Integrate.}$$

$$= 62.4 \left[(-\frac{(-2)^3}{3} - 6(-2)^2) - (-\frac{(-6)^3}{3} - 6(-6)^2) \right]$$

$$= 62.4\left[(\frac{8}{3}-24)-(\frac{216}{3}-216)\right]$$

$$= 62.4\left[\frac{368}{3}\right] \approx 7,654.4 \text{ pounds}$$

EXAMPLE 6.29

A swimming pool is 16 feet wide, 60 feet long, 4 feet deep at one end, and 8 feet deep at the other end. Find the fluid force against one of the 60-foot walls when the pool is filled with water.

SOLUTION 6.29

Placing the deep end of the pool along the *y*-axis, we can sketch the following:

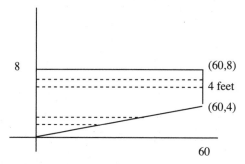

Note that we have two types of slices in our sketch, slices from $0 \le y \le 4$ and slices from $4 \le y \le 8$.

When $0 \le y \le 4$, the length of a slice is *x*. To find an expression for *x* in terms of *y*, find the equation of the line containing (0, 0) and (60, 4):

$$m = \frac{y_2 - y_1}{x_2 - x_1}$$

$$m = \frac{4-0}{60-0} = \frac{4}{60} = \frac{1}{15}$$

$$y - y_1 = m(x - x_1)$$

$$y - 0 = \frac{1}{15}(x - 0)$$

$$y = \frac{1}{15}x \qquad\qquad \text{Simplify.}$$

$$15y = x \qquad\qquad \text{Solve for } x.$$

Thus the fluid force for $0 \le y \le 4$ is

$$F = 62.4\int_0^4 (8-y)(15y)dy \qquad\qquad F = \delta\int hLdy$$

$$= 62.4\int_0^4 (120y - 15y^2)dy \qquad\qquad \text{Simplify.}$$

$$= 62.4[60y^2 - 5y^3]\Big|_0^4 \qquad \text{Integrate.}$$

$$= 62.4\,[(60(4)^2 - 5(4)^3) - (0)] \qquad \text{Evaluate.}$$
$$= 62.4[960 - 320] = 39{,}936 \text{ pounds}$$

When $4 \leq y \leq 8$, the length of a slice is 60 feet and so

$$F = 62.4\int_4^8 (8 - y)(60)\,dy \qquad F = \delta \int hL\,dy$$

$$= 62.4\int_4^8 (480 - 60y)\,dy \qquad \text{Simplify.}$$

$$= 62.4[480y - 30y^2]\Big|_4^8 \qquad \text{Integrate.}$$

$$= 62.4[((480)(8) - 30(8)^2) - (480(4) - 30(4)^2)]$$
$$= 62.4[(3{,}840 - 1{,}920) - (1{,}920 - 480)]$$
$$= 62.4[480] = 29{,}952 \text{ pounds}$$

The total fluid force is the sum of the forces or
$$F = 39{,}936 + 29{,}952 = 69{,}888 \text{ pounds}$$

6.8 MOMENTS AND CENTROIDS

The following section begins with a description of center of mass in one dimension and then extends the concept to two dimensions.

CENTER OF MASS IN ONE DIMENSION

If you've ever played on a seesaw, you know that in order for the seesaw to balance, both the weights and distances from the fulcrum must be "right." The physical law that governs this relationship is

$$m_1d_1 = m_2d_2 \text{ or } m_1d_1 - m_2d_2 = 0$$

Expanding this idea to masses $m_1, m_2, m_3, \ldots m_n$ at respective distance $x_1, x_2, x_3, \ldots x_n$, from the origin, we define the moment about the origin as

$$M = m_1x_1 + m_2x_2 + m_3x_3 + \ldots + m_nx_n$$

and the center of mass as

$$\bar{x} = \frac{M}{m} \text{ where } m = m_1 + m_2 + m_3 + \ldots + m_n$$

EXAMPLE 6.30

Find the center of mass for a system with
$m_1 = 6$ at $x_1 = 3$, $m_2 = 4$ at $x_2 = -5$, and $m_3 = 10$ at $x_3 = 5$.

SOLUTION 6.30

$M = m_1x_1 + m_2x_2 + m_3x_3$ Find the moment.

$M = 6(3) + (4)(-5) + (10)(5)$ Substitute.

$= 18 - 20 + 50 = 48$

$m = m_1 + m_2 + m_3$ Find the total mass.

$m = 6 + 4 + 10 = 20$ Substitute and add.

$\bar{x} = \dfrac{M}{m}$ Find the center of mass.

$\bar{x} = \dfrac{48}{20} = 2.8$ Substitute.

This means the system would balance if we put the fulcrum at $x = 2.8$.

CENTER OF MASS IN TWO DIMENSIONS

We can extend the idea of center of mass if we consider points in a plane rather than points on an x-axis. If we have masses $m_1, m_2, m_3, \ldots, m_n$ at points $(x_1, y_1)(x_2, y_2), (x_3, y_3), \ldots, (x_n, y_n)$, then

$M_y = m_1x_1 + m_2x_2 + m_3x_3 + \ldots + m_nx_n$ Moment about y-axis

$M_x = m_1y_1 + m_2y_2 + m_3y_3 + \ldots + m_ny_n$ Moment about x-axis

$(\bar{x}, \bar{y}) = (\dfrac{M_y}{m}, \dfrac{M_x}{m})$ Center of mass where $m = m_1 + m_2 + m_3 + \ldots + m_n$

EXAMPLE 6.31

Find the center of mass for a system with $m_1 = 5$ at $(2, 3)$, $m_2 = 8$ at $(-3, -1)$, $m_3 = 4$ at $(-1, 6)$, and $m_4 = 3$ at $(1, -2)$.

SOLUTION 6.31

$M_y = m_1x_1 + m_2x_2 + m_3x_3 + \ldots + m_nx_n$ Find the moment about the y-axis.

$M_y = 5(2) + 8(-3) + 4(-1) + 3(1)$

$M_y = 10 - 24 - 4 + 3 = -15$

$M_x = m_1y_1 + m_2y_2 + m_3y_3 + \ldots + m_ny_n$ Find the moment about the x-axis.

$M_x = 5(3) + 8(-1) + 4(6) + 3(-2)$

$M_x = 15 - 8 + 24 - 6 = 25$

$m = m_1 + m_2 + m_3 + m_4$ Find the total mass.

$m = 5 + 8 + 4 + 3 = 20$

$(\bar{x}, \bar{y}) = (\dfrac{M_y}{m}, \dfrac{M_x}{m})$ Find the center of mass.

$(\bar{x}, \bar{y}) = (\dfrac{-15}{20}, \dfrac{25}{20})$ Substitute.

$$(\bar{x}, \bar{y}) = (-\frac{3}{4}, \frac{5}{4}) \qquad \text{Reduce.}$$

PLANAR LAMINA

The previous examples dealt with masses at points on a line or in the plane. Now we can extend the idea of center of mass to thin flat plates with uniform density called **planar lamina.** To find the moments and center of mass, we use the following formulas, where $f(x)$ and $g(x)$ are continuous functions, and the lamina has uniform density δ. If a planar lamina of density δ is bounded by $f(x)$ and $g(x)$, $a \le x \le b$,

$$M_x = \frac{\delta}{2}\int_a^b ([f(x)]^2 - [g(x)]^2)dx \qquad \text{Moment about the } x\text{-axis}$$

$$M_y = \delta\int_a^b x[f(x) - g(x)]dx \qquad \text{Moment about the } y\text{-axis}$$

$$(\bar{x}, \bar{y}) = (\frac{M_y}{m}, \frac{M_x}{m}) \qquad \text{Center of mass.}$$

where $m = \delta\int_a^b [f(x) - g(x)]dx$.

EXAMPLE 6.32

Find the moments and the center of mass for the planar lamina of density δ bounded by $f(x) = \sqrt{x}$ and $g(x) = x^2$.

SOLUTION 6.32

We find where the curves intersect by setting them equal to each other and solving.

$\sqrt{x} = x^2$

$(\sqrt{x})^2 = (x^2)^2$	Square both sides.
$x = x^4$	Simplify.
$0 = x^4 - x$	Get 0 on one side.
$0 = x(x^3 - 1)$	Find the common factor.
$0 = x(x - 1)(x^2 + x + 1)$	Factor the difference of two cubes.
$x = 0$ or $x = 1$	Set each factor equal to 0 and solve.

Find the moment about the x-axis: $(x^2 + x + 1) = 0$ has no real solution for x

$$M_x = \frac{\delta}{2}\int_0^1 [(\sqrt{x})^2 - (x^2)^2]dx \qquad \text{Set up the integral.}$$

$$= \frac{\delta}{2}\int_0^1 (x - x^4)dx \qquad \text{Simplify.}$$

$$= \frac{\delta}{2}\left[\frac{x^2}{2} - \frac{x^5}{5}\right]\Big|_0^1 \qquad \text{Integrate.}$$

$$= \frac{\delta}{2}\left[\left(\frac{1}{2} - \frac{1}{5}\right) - (0)\right] \qquad \text{Evaluate.}$$

$$= \frac{\delta}{2} \cdot \frac{3}{10} = \frac{3}{20}\delta \qquad\qquad \text{Simplify.}$$

Find the moment about the y-axis:

$$M_y = \delta \int_0^1 x[\sqrt{x} - x^2]dx \qquad\qquad \text{Set up the integral.}$$

$$= \delta \int_0^1 (x^{3/2} - x^3)dx \qquad\qquad x\sqrt{x} = x \cdot x^{1/2} = x^{3/2}.$$

$$= \delta \left[\frac{2}{5}x^{5/2} - \frac{x^4}{4} \right]_0^1 \qquad\qquad \text{Integrate.}$$

$$= \delta \left[\left(\frac{2}{5}(1) - \frac{1}{4} \right) - (0) \right] \qquad\qquad \text{Evaluate.}$$

$$= \delta(\frac{3}{20}) = \frac{3}{20}\delta \qquad\qquad \text{Simplify.}$$

Find the mass of the lamina:

$$m = \delta \int_a^b [f(x) - g(x)]dx \qquad\qquad \text{The formula for mass.}$$

$$= \delta \int_0^1 [\sqrt{x} - x^2]dx \qquad\qquad \text{Set up the integral.}$$

$$= \delta \left[\frac{2}{3}x^{3/2} - \frac{x^3}{3} \right]_0^1 \qquad\qquad \sqrt{x} = x^{1/2}. \text{ Integrate.}$$

$$= \delta \left[\left(\frac{2}{3}(1) - \frac{1}{3} \right) - (0) \right] \qquad\qquad \text{Evaluate.}$$

$$= \delta \left[\frac{1}{3} \right] = \frac{1}{3}\delta$$

Now find the center of mass:

$$(\bar{x}, \bar{y}) = (\frac{M_y}{m}, \frac{M_x}{m}) \qquad\qquad \text{The formula for center of mass.}$$

$$(\bar{x}, \bar{y}) = \left(\frac{\frac{3}{20}\delta}{\frac{1}{3}\delta}, \frac{\frac{3}{20}\delta}{\frac{1}{3}\delta} \right) \qquad\qquad \text{Substitute.}$$

$$(\bar{x}, \bar{y}) = (\frac{9}{20}, \frac{9}{20}) \qquad\qquad \frac{3}{20} \div \frac{1}{3} = \frac{3}{20} \cdot \frac{3}{1} = \frac{9}{20}$$

Note that for a planar lamina of uniform density, the density cancels out when finding the center of mass. The center of mass in this situation (uniform density) is also called the **centroid.**

EXAMPLE 6.33

Find the centroid of the region bounded by $f(x) = 3x - 2$ and $g(x) = x^2$.

SOLUTION 6.33

Return to Example 6.1 for a sketch of the region. The intersection points were (1, 1) and (2, 4).

$$M_x = \frac{1}{2}\int_1^2 [(3x-2)^2 - (x^2)^2]dx \qquad \text{Find } M_x.$$

$$= \frac{1}{2}\int_1^2 (9x^2 - 12x + 4 - x^4)dx \qquad \text{Simplify.}$$

$$= \frac{1}{2}\left[3x^3 - 6x^2 + 4x - \frac{1}{5}x^5\right]\Big|_1^2 \qquad \text{Integrate.}$$

$$= \frac{1}{2}\left[(3(2)^3 - 6(2)^2 + 4(2) - \frac{1}{5}(2)^5 - (3(1)^3 - 6(1)^2 + 4(1) - \frac{1}{5}(1)^5)\right]$$

$$= \frac{1}{2}\left[\frac{4}{5}\right] = \frac{2}{5}$$

$$M_y = \int_1^2 x[(3x-2) - x^2]dx \qquad \text{Find } M_y.$$

$$= \int_1^2 (3x^2 - 2x - x^3)dx \qquad \text{Simplify.}$$

$$= \left[x^3 - x^2 - \frac{x^4}{4}\right]\Big|_1^2 \qquad \text{Integrate.}$$

$$= \left[\left((2)^3 - (2)^2 - \frac{(2)^4}{4}\right) - \left(1^3 - 1^2 - \frac{1^4}{4}\right)\right] \qquad \text{Evaluate.}$$

$$= \frac{1}{4} \qquad \text{Simplify.}$$

Finding the mass is equivalent to finding the area,

$$\int_1^2 [f(x) - g(x)]dx = \frac{1}{6} \text{ (from Example 6.1). Thus,}$$

$$(\bar{x}, \bar{y}) = \left(\frac{M_y}{m}, \frac{M_x}{m}\right)$$

$$= \left(\frac{\frac{1}{4}}{\frac{1}{6}}, \frac{\frac{2}{5}}{\frac{1}{6}}\right)$$

$$= \left(\frac{3}{2}, \frac{12}{5}\right)$$

SUMMARY

This chapter presented a few applications of integration. A sketch of the given situation was useful in setting up solutions to the application we studied. A summary of the formulas we used in the chapter follows.

Area between curves: $A = \int_a^b [f(x) - g(x)]dx$

Volume using the disk method: $V = \pi \int_{x_1}^{x_2} [f(x)]^2 dx$ or $V = \pi \int_{y_1}^{y_2} [g(y)]^2 dy$

Volume using the washer method: $V = \pi \int_{x_1}^{x_2} [(R(x))^2 - (r(x))^2]dx$ or

$V = \pi \int_{y_1}^{y_2} [(R(y))^2 - (r(y))^2]dy$

Volume by shells: $V = 2\pi \int_{x_1}^{x_2} r(x)h(x)dx$ or $V = 2\pi \int_{y_1}^{y_2} r(y)h(y)dy$

Length of a curve: $L = \int_a^b \sqrt{1 + [f'(x)]^2}\, dx$ or $L = \int_c^d \sqrt{1 + [g'(y)]^2}\, dy$

Surface area: $S = 2\pi \int_a^b r(x)\sqrt{1 + [f'(x)]^2}\, dx$ or $S = 2\pi \int_c^d r(y)\sqrt{1 + [g'(y)]^2}\, dy$

Work: $W = \int_a^b F(x)dx$

Fluid force: $F = \delta \int_{y_1}^{y_2} h \cdot L\, dy$

Moment about the x-axis: $M_x = \frac{\delta}{2} \int_a^b \left[[f(x)]^2 - [g(x)]^2 \right] dx$

Moment about the y-axis: $M_y = \delta \int_a^b x[f(x) - g(x)]dx$

Center of mass: $(\bar{x}, \bar{y}) = (\frac{M_y}{m}, \frac{M_x}{m})$, where $m = \delta \int_a^b [f(x) - g(x)]dx$

TEST YOURSELF

1) Find the area bounded by $f(x) = \frac{1}{2}x^2$ and $g(x) = -\frac{1}{2}x + 3$.

2) Find the area bounded by $2x - y = 3$ and $x = \frac{1}{3}y^2$.

3) Find the area bounded by $f(x) = x^3 - x$ and $g(x) = 3x$.

4) Find the volume of the solid formed by revolving the region bounded by $f(x) = 1 - x^2$, $x = 0$, $y = 0$, about the x-axis.

5) Find the volume of the solid formed by revolving the region bounded by $f(x) = 1 - x^2$, $x = 0$, $y = 0$, about the y-axis.

6) Find the volume of the solid formed by revolving the region bounded by $f(x) = 1 - x^2$, $y = \frac{1}{2}$, $x = 0$, about $y = \frac{1}{2}$.

7) Find the volume of the solid formed by revolving the region bounded by $f(x) = 1 - x^2$, $y = \frac{1}{2}$, $x = 0$, about the x-axis.

8) Find the volume of the solid of revolution formed by revolving the region bounded by $y = x^3 + 3$, $x = 1$, $x = 0$ and $y = 0$ about $x = 0$.

9) Find the volume of the solid of revolution formed by revolving the region bounded by $y = x^3 + 3$, $x = 1$, $x = 0$ and $y = 0$ about $x = 1$.

10) Find the volume of the solid of revolution formed by revolving the region bounded by $y = x^3$, $x = 0$, $y = 1$ about the line $y = 2$.

11) Find the volume of a solid whose base is enclosed by the circle $x^2 + y^2 = 9$ and whose cross-sections taken perpendicular to the x-axis are semicircles.

12) Set up the integral to find the volume of the solid of revolution formed by revolving the region bounded by $y = \sqrt{x - 2}$, the lines $y = 0$ and $x = 4$ about the y-axis.

13) Set up the integral to find the volume of the solid of revolution formed by revolving the region bounded by $y = \sqrt{x - 2}$, the lines $y = 0$ and $x = 4$ about the line $x = 4$.

14) Find the volume of a solid whose base is enclosed by the circle $x^2 + y^2 = 9$ and whose cross-sections taken perpendicular to the x-axis are semicircles.

15) Find the volume of a solid whose base is enclosed by the circle $x^2 + y^2 = 9$ and whose cross sections taken perpendicular to the x-axis are equilateral triangles.

16) Find the distance between the points $(2, 3)$ and $(5, 11)$ by using (a) the distance formula and (b) integration (show the integral).

17) Find the arc length of $f(x) = \frac{1}{2}x^{3/2} - 1$ on $[0, 1]$.

18) Find the arc length of $f(x) = 4x + 2$ on $[1, 3]$. (Check this using the distance formula.)

19) Find the arc length of $f(x) = \frac{1}{6}x^3 + \frac{1}{2x}$ on $[1, 2]$.

20) Set up the definite integral that represents the arc length of $y = \cos x$ on $[0, \pi]$.

21) Find the area of the surface of revolution formed by revolving $f(x) = 4x + 2$ on $[1, 3]$ about the x-axis.

22) Find the area of the surface of revolution formed by revolving the region bounded by $x = 4\sqrt{y}$, $0 \le y \le 4$ about the y-axis.

23) Set up the integral to find the area of the surface of revolution formed by revolving $y = \cos x$ about the x-axis on the interval $\left[0, \dfrac{\pi}{4}\right]$.

24) Set up the integral to find the area of the surface of revolution formed by revolving $y = \tan x$ about the x-axis on the interval $\left[0, \dfrac{\pi}{4}\right]$.

25) Set up the integral to find the area of the surface of revolution formed by revolving $y = \tan x$ about the y-axis on the interval $\left[0, \dfrac{\pi}{4}\right]$.

26) Find the work done to lift 100 pounds 5 feet.

27) A force of 20 pounds compresses a spring 4 inches from its natural length of 12 inches. Find the work done in compressing the spring a total of 8 inches.

28) A force of 8 kilograms stretches a spring 4.6 centimeters. How much work must be done to stretch the spring an additional 3 centimeters?

29) Twenty six foot-pounds of work is required to stretch a spring 6 inches from its natural length.
a) Find the spring constant.
b) Find the work required to stretch the spring an additional 6 inches.

30) A cylindrical tank of diameter 12 feet and height of 15 feet is filled with water. Find the work done to pump the water over the top edge of the tank.

31) A cylindrical tank of diameter 12 feet and height of 15 feet is filled with liquid weighing 24 lb/ft³. Find the work done to pump the liquid 1 foot above the top of the tank.

32) An open tank has the shape of a right circular cone as shown below. The tank has a radius of 5 feet across the top and is 12 feet high. Find the work done to pump the water to the top of the tank.

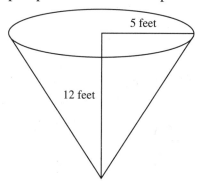

33) An open rectangular tank has a base 6 feet by 8 feet and a height of 4 feet and contains liquid weighing 56 pounds per cubic foot. Find the work done to pump the liquid to the top of the tank.

34) An open rectangular tank has a base 6 feet by 8 feet and a height of 4 feet and contains liquid weighing 56 pounds per cubic foot. Find the work done to pump the liquid 2 feet above the top of the tank.

35) An open rectangular tank has a base 6 feet by 8 feet and a height of 4 feet and contains water. Find the work done to fill the tank with water through a hole in the base if the water source is at the base. (Hint: If the source is at the base, the distance a slice must move is y.)

36) The vertical end of a tank filled with water has the shape of a rectangle as shown. If the depth of the water is 5 feet, find the total force against the end of the tank. Use $\delta = 62.4$ pounds per cubic foot.

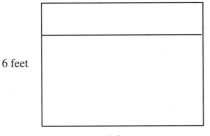

6 feet

8 feet

37) Find the fluid force on the given vertical plate submerged in water.

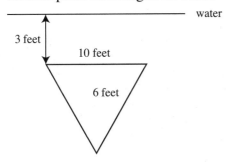

water

3 feet

10 feet

6 feet

38) A swimming pool is 10 feet wide, 75 feet long, 3 feet deep at one end, and 6 feet deep at the other end. Find the fluid force against one of the 75 foot walls when the pool is filled with water.

39) Find the center of mass for a system with $m_1 = 8$ at $x_1 = 4$, $m_2 = 5$ at $x_2 = -1$, and $m_3 = 12$ at $x_3 = -4$.

40) Find the center of mass for a system with $m_1 = 10$ at $(3, 4)$, $m_2 = 4$ at $(-1, -6)$, $m_3 = 5$ at $(2, -4)$, and $m_4 = 1$ at $(-2, 3)$.

41) Find the moments and the center of mass for the planar lamina of density δ bounded by $f(x) = x + 6$ and $g(x) = x^2$.

TEST YOURSELF ANSWERS

1) $\dfrac{125}{12}$

2) $\dfrac{81}{16}$

3) 8

4) $\dfrac{8}{15}\pi$

5) $\dfrac{1}{2}\pi$

6) $\dfrac{\sqrt{2}}{15}\pi$

7) $\dfrac{7\pi\sqrt{2}}{30}$

8) $\dfrac{17\pi}{5}$

9) $\dfrac{31\pi}{10}$

10) $\dfrac{15\pi}{7}$

11) 72π

12) $2\pi\displaystyle\int_{2}^{4} x\sqrt{x-2}\,dx$

13) $2\pi\displaystyle\int_{2}^{4} (4-x)\sqrt{x-2}\,dx$

14) 72π

15) $18\sqrt{3}$

16)
 a) $\sqrt{73}$

 b) $\displaystyle\int_{2}^{5}\sqrt{1+\dfrac{64}{9}}\,dx = \sqrt{73}$

17) $\dfrac{61}{54}$

18) $2\sqrt{17}$

19) $\dfrac{17}{12}$

20) $\displaystyle\int_{0}^{\pi}\sqrt{\sin^{2}x+1}\,dx$

21) $40\pi\sqrt{17}$

22) $\dfrac{16\pi}{3}[8^{3/2}-8]$

23) $2\pi\displaystyle\int_{0}^{\pi/4}\cos x\sqrt{1+\sin^{2}x}\,dx$

24) $2\pi\displaystyle\int_{0}^{\pi/4}\tan x\sqrt{1+\sec^{2}x}\,dx$

25) $2\pi\displaystyle\int_{0}^{\pi/4}x\sqrt{1+\sec^{2}x}\,dx$

26) 500 ft·lb

27) 160 inch pounds

28) approximately 31.8 cm·kg

29)
 a) $k = 208$

 b) 78 foot-pounds

30) $252{,}720\pi$ ft·lb or approximately 793,943 ft·lb

31) $110{,}1604\pi$ ft·lb or approximately 346,078 ft·lb

32) $18{,}720\pi$ foot-pounds

33) 21,504 foot-pounds

34) 43,008 foot-pounds

35) 28,672 foot-pounds

36) 8,736 pounds

37) 9,360 pounds

38) 49,140 pounds

39) $-\dfrac{21}{25}$

40) $\left(\dfrac{17}{10}, -\dfrac{1}{20}\right)$

41) $M_x = \dfrac{250}{3}\delta$

 $M_y = \dfrac{125}{12}\delta$

 $(\bar{x}, \bar{y}) = \left(\dfrac{1}{2}, 4\right)$

Index